# Art and Obscenity

# Art and...

Contemporary art can be difficult. Reading about it doesn't need to be. Books in the *Art and...* series do two things.

Firstly, they connect art back to the real stuff of life – from those perennial issues like sex and death that trouble generation after generation to those that concern today's world: the proliferation of obscene imagery in the digital age; our daily bombardment by advertising; dubious and disturbing scientific advances.

Secondly, *Art and...* provides accessible theme-based surveys which energetically explore the best of contemporary art. *Art and...* avoids rarefied discourse. In its place, it offers intelligent overviews of art - and the subjects of art  - that really matter.

*Forthcoming:*
Art and Death *Chris Townsend*
Art and Sex *Gray Watson*

# Art and Obscenity

Kerstin Mey

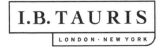

I.B. TAURIS
LONDON · NEW YORK

Published in 2007 by I.B.Tauris & Co Ltd
6 Salem Road, London W2 4BU
175 Fifth Avenue, New York NY 10010
www.ibtauris.com

In the United States of America and in Canada distributed by
Palgrave Macmillan, a division of St Martin's Press
175 Fifth Avenue, New York NY 10010

PB ISBN 978 1 84511 235 6
HB ISBN 978 1 84511 234 9

A full CIP record for this book is available from the British Library
A full CIP record for this book is available from the Library of Congress

Library of Congress catalog card: available

Typeset in Agfa Rotis by Steve Tribe, Andover
Printed and bound in Great Britain by TJ International, Padstow

# Contents

# Illustrations

# Acknowledgements

It was Susan Lawson, contemporary arts editor at I.B.Tauris, whose initial idea and invitation brought this project about. Her unfaltering trust in my ability to critically discuss the operations of obscenity in contemporary art, her sympathetic support and rigorous editing have been invaluable for the realisation of this book. My debt to Susan Lawson is immense. Likewise I am very grateful to Steve Tribe for his astute copy-editing.

The research for this book was made possible by a research grant from the British Academy that enabled me to venture beyond the UK to look for and compile material on obscenity in different cultural contexts.

I am grateful for the assistance I have received from the librarian at the Museum of Modern Art in New York, and from Morag Henderson, at the library Duncan of Jordanstone College of Art and Design, University of Dundee in the tracing of significant and at times inconspicuous cultural resources for the discussion of the obscene.

Short-term study leave granted by Fine Art Research of the School of Fine Art, Duncan of Jordanstone College of Art and Design, University of Dundee; and by the Research Institute Art and Design, and by Interface: Centre for Research in Arts, Technologies and Design, both of the School of Art and Design, University of Ulster, has enabled me to progress with the book at crucial points in time.

As the subject matter required me to draw on a wide range of cultural resources, some of them beyond my immediate area of competence, I used colleagues, students and conferences to test out my ideas and arguments. I would like to thank all of them but in particular Jonathan Robertson, Suzanna Chan, the MFA students at the School of Art and Design, University of Ulster, and Yvonne Spielmann, Meike Kroenke and students at the Media Research Institute, Hochschule der Künste Braunschweig, as well as Barbara Petschan.

Alison Rowley's acute and perceptive comments have been instrumental for thinking through the cultural and social implications of obscene representations particularly in terms of the gaze, and gender and class inscriptions.

Without Chérie Driver, the book would have had hardly any illustrations. I am entirely grateful to her for the tireless research, acquisition and annotation of the visual material for this publication as well as for reading and commenting perceptively and encouragingly on the first draft of this manuscript.

I would also like to thank all the artists represented in this book and their dealers and/or representing organisations for their generous support in terms of making images available and in giving permission for their reproduction here.

Last but by far not least, I am deeply indebted to Stephen and Rupert Benjamin for being there for me when the going got tough, for their lavish patience and all the time and space to think they have given over to me to write this book. Without them I could not have done it.

# Introduction

Lust is always criminal.
*Peter Gorsen*[1]

The 1995 portrait of the Moors murderer Myra Hindley by British painter Marcus Harvey produced from numerous children's handprints caused outrage when it was put on public display at the Royal Academy in London in 1997 as part of the exhibition *Sensation: Young British Artists from the Saatchi Collection*. When the show went to the Brooklyn Museum in New York in 1999, Chris Ofili's *The Holy Virgin Mary* (1996) and many other seemingly 'beastly' and 'blasphemous' works sparked political and religious outrage there, as well as iconoclastic impulses: the urge to damage or destroy images. Not only is the 1998 Turner Prize winner's Virgin rendered in an abstracted and sparklingly decorative and cartoon-like fashion as a black woman, but the painting is also adorned with clippings of pornographic details and was propped up on two clumps of elephant dung, one labelled Virgin and the other Mary. Some religious believers regarded the picture as highly obscene. Since then, quite a few more feathers have been ruffled by contemporary artists. Many of Tate Modern's recent Turner Prize exhibitions have stirred up considerable controversy. Tracey Emin's *My Bed* (1998–1999) in 1999 and the Chapman brothers' *Insult to Injury*, *Sex* and *Death* in 2003 are perhaps the most prominent cases that have scandalised British society because of their explicit sexual and/or excessively violent overtones. But then, provocation and shock have been part and parcel of western art from the modern period onwards – testing, pushing and expanding the established aesthetic parameters closely linked to intellectual, religious, ethical and legal concerns of the time.

And it is more than just the realm of art that has been pervaded and affected by images and objects that cause offence. Recently, the public exposure of photographs and

video footage of American and British soldiers torturing and thus deeply humiliating Iraqi detainees in newspapers, on television and the Internet was compared to sadomasochist porn.[2]

Obscenity and pornography look like birds of a feather, though they are not fully congruent. Like a cuckoo, they roost in the boughs of art and the undergrowth of the plantation that is culture. More or less camouflaged, notions of obscenity permeate – to a greater or lesser degree – the sites of cultural production and consumption of contemporary society, especially where these intersect with society's ethical imperatives and legal frameworks.

What actually is obscenity? Obscenity is a valorising cultural category of relatively recent origins that is applied to representations to denote, generally speaking, their indecent and vulgar, dirty and lewd, gross and vile and thus morally corrupting and potentially illicit character. The obscene then functions as the other of the aesthetic, where it intersects with moral standards and the law.

Obscenity does not reside in the content-form dialectics of the cultural product per se, whether it is an artwork or a press photograph, but in the discursive context, that is in the way it is discussed publicly, in relation to its production, circulation and reception. No object or event is obscene in itself. Obscenity is an argument about the qualities, public exposure and traffic of an object or event. It is an evaluation of its effects. As an argument, obscenity is closely bound up with the segregation between high and low culture and their modes of production, and the private/public dichotomies that lie at the foundations of bourgeois society. As a cultural category, the obscene emerged with the establishment of means of mass reproduction of texts and images, and therefore their increased promulgation and accessibility in the public arena (and the perceived need for their regulation).

As all arguments do, the obscene depends on the concrete circumstances in which it is developed and fought out. Like the aesthetic – to adopt a common phrase – obscenity lies in the eye of the beholder. And as obscenity is not restricted to the visual domain but concerns literature, poetry and pop music, for instance, notions of the obscene are developed as a matter of interpretation and agreement in relation to respective cultural domains, the dominant value systems in society and its underlying social, political, economic and technological conditions.

Obscenity as the 'dark' side of established cultural categories has been employed in practices of representation as a potent instrument of transgression and resistance against dominant social norms and hierarchies, and oppressive regimes of discipline and control. As the other of art it is inextricably linked to the functions of the latter. Art has come to serve as a projection screen for ideas, thoughts and processes, and no longer performs as a window onto the world, a microcosm that represents the macrocosm outside itself. It exists as a potent experimental field with fluid and dynamic parameters within the public domain. Those parameters are defined by elaborate and layered discursive networks, channels of public mediation and debate that – like a spider – ensnare art. The discourses of art history

and art criticism, public and private art collections, art education, art theory and the media keep it suspended and elevated in the aesthetic sphere. Yet, as social practice, art does not exist in an ivory tower, rather it is osmotically embedded and enmeshed in the cultural make-up of society at large.

With the immense mobility and fluidity of images across different cultural territories due to the accelerated production and circulation of images by the new digital (multi)media technologies, art has not only become more exposed and visible, though this may sound like a contradiction in terms; it also competes with huge increase of images produced in other cultural domains. Its influence on other cultural productions may have increased too, but so has its own permeability for visual material and effects that have their origin in other cultural areas such as film, advertisement, animation, the World Wide Web, fashion and the decor of every day life. In fact, the rapid advance of imaging, and information and communication technologies has blurred and eroded previously relatively stable delineations of cultural domains, their constitutive discursive networks and social control with the help of legal instruments. All this has impacted on the power of images, on their economies and mechanisms, on the way they are disseminated, consumed and regulated, how they function as means of communication and knowledge production.

What, then, is this book about? It is not a book that seeks to determine and establish the meaning of obscenity in relation to visual art production or the workings of censorship. The former would require, first, the impossible task of also defining 'art' as an opposite of obscenity. Yet to attempt an essentialist definition of art and its manifestations is an extremely treacherous affair, particularly in the complex and dynamic contemporary situation. Secondly, it would necessitate the (momentary) abstraction of the operational and dynamical terms of the obscene and the aesthetic from those critical factors that constitute the pragmatic environment in which they enfold their meaning and potential.

This book aims to trace central arguments and decisive aspects that mark the relationship between art and obscenity in the West from a contemporary perspective. The terrain for this thematic enquiry is the cultural situation of global capitalism that suggests that there are very few cultural limits and taboos left intact that can still be transgressed or resisted. Instead, almost any area and aspect of culture has been commodified – not least sex and violence – incorporated into the mainstream, aestheticised, appropriated and thus neutralised. And this includes to a large extent apparent countercultural currents and gestures of dissent.

Drawing on a selection of examples from across recent and contemporary western visual arts and engaging in a close reading of aesthetic strategies, the chapters map out the complex territory in which the obscene operates vis-à-vis the aesthetic. It considers the codes, conventions and technological and media aspects of visual or multimedia representation as factors that exert a significant influence on the modes of production and consumption, and on the cultural circulation of still and moving images, of authorship and agency. Those historical and cultural media conditions inform what is judged to be situated within or out of the bounds of the aesthetic, and how that in turn shapes the

understanding of the category of the obscene, its applications and their repercussions for the parameters of art.

Implicit in the following discussions of visual art practices that have been regarded to be (too) graphic, carnal, crude or smutty, and thus potentially morally corrupting and in need of regulation or prohibition, are theoretical reflections and ideological currents in which the aesthetic-obscene relation is meandering and entangled.

The format of this publication dictates an exploration of the relation between art and obscenity in a concentrated and compact manner by looking at key aspects and moments. A complete overview of that extensive field is beyond its scope. And, as art and obscenity are relational categories informed by subjective judgements, so is this text. My views as author are inevitably present in the theoretical perspectives employed, in the particular (audio)visual works and debates I have chosen to engage with and my critical stance in relation to them. Yet, it is hoped that this book will open up new and other vistas for thought and debate on how the aesthetic and the obscene are incessantly rewritten through vibrant, fluid and hybrid cultural practices through dynamic conditions and rules of representation.

# Chapter 1

# 'I Know It When I See It'

## On the definition and history of the category of the obscene

> After having immured themselves with everything that was best able to satisfy
> the senses through lust ... the plan was to have described to them, in the
> greatest detail and in due order, every one of debauchery's extravagances,
> all its divagations, all its ramifications, all its contingencies ... There is simply
> no conceiving degree to which man varies them when his imagination grows
> inflamed.
> *Marquise de Sade¹*

Let's begin with the question: what is obscene? Generally speaking, obscene signifies something that offends or outrages, because it defies accepted standards of decency, civility or modesty. Obscenity is connected to feelings of repulsion and disgust. Within the context of the law, it is regarded as something that has the tendency to morally corrupt or deprave.

The obscene has often been used synonymously with the pornographic and in close alignment with indecency. Yet, crucially, there are significant differences between obscenity and pornography. 'Obscenity' covers a far broader area than sexually explicit and alluring representations seeking to gratify the desires of the flesh that come under the term of pornography. 'It is also applied to the unacceptable horrors of everyday life: the obscenity of war, poverty, wealth, racism, murder ... obscenity most often connotes excess, violence and transgression.'²

There is an important link between obscenity and taboo. Anchored in the prevalent historical notion of public morality and cultural customs, every society places certain areas of human practice and modes of conduct off-limits, marking them as forbidden and guarding

them vigilantly as taboos. Enforced social prohibition applies particularly but not exclusively to matters of sexual engagement: incest, i.e. the sexual intercourse between very close relatives such as brother and sister; paedophilia, the sexual abuse of children; necrophilia, the sexual interaction with dead bodies. Transgressions of such taboos, which also include cannibalism, are considered obscene in the sense of abhorrent, repugnant and objectionable.

The term 'obscene' has been linked to the Greek term *ob skene* ('off stage'), as violent acts in Greek theatre were committed away from the eyes of the audience: offstage, behind the scenes. Descending into the Latin *obscensus* in the sixteenth century, this sense was kept alive, coming to mean that something should be kept 'out of public view'.[3] Then, it was mainly used in a legal context to describe expressions that deviate from prevalent norms especially of 'sexual morality'; and it was applied as a characteristic particularly when obscene representations were employed as a means to criticise religious and/or political authority, for instance, in the context of carnival and caricature. Only in 1857 did the term enter the authoritative *Oxford English Dictionary*.

Definitions, connotations and pragmatic applications of the term have differed over time and still vary in and between cultures, communities and amongst individuals. The varying use of the term obscenity and the criteria for its definition in the history of western culture reveal important aspects of the changing concept(s) and attitudes beneath it. As a value category its common associations with the 'off-the-scene', with social norms, manners and customs, with official culture or art and jurisdiction prove equally significant.

In relation to the offstage, or off-the-scene, obscenity came to cover those aspects of cultural (life) practices and processes that should remain hidden from public view like sexual intercourse, urination and defecation. Expressing an aesthetic aversion – the horrible and repulsive – its concept is inextricably linked to the gradual emergence of a private-public dichotomy as a feature of a developing bourgeois society and the onset of modernity in the fifteenth century. It is interwoven with the establishment of a historically dynamic, socially and culturally defined faceted sense of shame and modesty related to bodily functions and sexual matters. Those evolving norms of social conduct and their display were highly inflected by hegemonic gender and racial relations and informed by the morals of the time.[4] There is an 'aesthetic alliance of the culturally and historically defined sense of shame with the ideal of beauty – the uninhibited representation offends the shame and soils the beautiful', as Georges Bataille, the French writer, anthropologist and philosopher, has argued with regard to the transgressiveness of the erotic act.[5] The exclusion of sexuality from aesthetics is anchored in the Cartesian split between body and mind that has been confounding for western thought for centuries. It is undeniable that the Church had an intensely formative and long-lasting influence on this constellation in the Judaeo-Christian societies in and beyond Western Europe. For the emerging and established bourgeois culture there, 'just-sublimation' and aestheticisation gained primacy, at least officially, rather than an unqualified permission of sensual pleasures and carnal lust. But then, capitalist culture, as the German philosopher Marx so aptly analysed, is fundamentally defined by double standards.

Walter Kendrick, an American specialist in English Literature, observes that obscenity as a cultural phenomenon and discursive category concurs with the emergence of the 'secret museum' in the late eighteenth and early nineteenth centuries, i.e. those hidden archives of material barred from free public access, be it indexes of restricted material or 'uncatalogued holdings' or locked rooms. It lies at the centre of the regulation of cultural consumption on socially defined moral and legal grounds. The British Lord Chief Justice, Sir Alexander Cockburn, proclaimed in 1868:

> I think the test of obscenity is this, whether the tendency of the matter charged as obscenity is to deprave and corrupt those whose minds are open to such immoral influences, and into whose hands a publication of this sort may fall.[6]

In terms of its performative dimension, i.e. in the way it 'works' in the use of language, the obscene does not only denote act(ion)s or objects that 'inspire disgust' and moral depravation. The term does not merely signify that something is shifted beyond the accepted social and cultural norms for the articulations of carnal desires, and libidinal drives – those psychic and emotional energies that are associated with instinctual biological energies. The term obscenity is itself constituted through the performance of public/legal/ cultural discourse around those objects and actions in tandem with gradually emerging and expanding, and increasingly sophisticated, mass-communication and information networks: print media, broadcasting, and the Internet.

The obscene in the context of official jurisdiction is located in the field of cultural representation, be it text, visual, audiovisual or multimedia material. More precisely, it is situated at the interface of the domains of the aesthetic, the legal and the moral, and it is constructed through the public debates and mediations of these value systems. In other words, nothing is obscene per se. Like the aesthetic, the moral and the legal, the obscene essentially is a value judgement and a cultural category produced through processes of reification. In such a process, an abstract value-inflected idea becomes attached to or embodied in a concrete object/act/event, which, in turn, functions as a precedent, benchmark or test case for the application of the concept to other objects/acts/events.

Throughout its history, however, attempts to establish a clear, watertight and consensual definition of the obscene and what it entails have constantly encountered immense difficulties. The popular statement 'I know it when I see it' conveys a standard attitude in this regard. As received opinion, it has verbally informed judgments in legal cases, where the charge of obscenity has been levelled at objects or acts (and its initiators, producers or exhibitors); and, with that charge, demands for the enforcement or challenge of official censorship measures have been raised. Yet, only in 1964 was it set down in writing for the first time, when US Supreme Court Associate Justice Potter Stewart included this sentiment in his 'concurrence' on a particular disputed motion picture film in a censorship court case, admitting, '"Hard-core pornography" was hard to define, but ... "I know it when I see it".'[7]

This brief remark, on the basis of which the film in question was acquitted, summarises aptly the contested territory and dynamics that are the hallmark of the obscene.

The French philosopher, Michel Foucault, has demonstrated that the process of categorisation is inextricably linked to power and control. It works in the interest of those who impose distinctions and the values these promote and affirm. In the first volume of his unfinished project *The History of Sexuality*, he describes the processes through which sexuality has entered public speech from the Enlightenment period onward:

> There was a steady proliferation of discourses concerned with sex – specific
> discourses, different from one another both by their form and by their object:
> a discursive ferment that gathered momentum from the eighteenth century
> onward.[8]

Foucault emphasises that licit as well as illicit discourses were on the increase at that time. Whilst the 'tightening up of the rules of decorum likely did produce, as a countereffect, a valorization and intensification of indecent speech', its is important to note that the 'discourses concerning sex in the field of exercise of power itself' multiplied:

> an institutional incitement to speak about it [sex], and to do so more and
> more; a determination on the part of the agencies of power to hear it spoken
> about, and to cause it to speak through explicit articulation and endlessly
> accumulated detail.[9]

In Foucault's view, such an incitement was provided through the Catholic 'confessions of the flesh'. In the twentieth century, other forms of discourse and knowledge production, such as psychoanalysis, fuelled this development. Whilst the language for those kinds of reporting on sexual desires and behaviour became increasingly refined and veiled, the scope of depiction expanded significantly too. What the Church had begun was continued by the sciences – psychology, biology, medicine and economics too. Sexuality became not only more and more regulated and controlled through public discourse(s), it also became pathologised – all that in order to impose a form of sexuality in support of a functioning social system.[10] In other words, the category of the obscene is not at all innocent or neutral. It has been subject to political interests and instrumentalisation for the purpose of maintaining or contesting social power and control by social (and religious) group(s), prompting and justifying the device and application of censorship measures. These measures are administered to monitor and suppress cultural practices, expressions and discourses deemed deviant, perverse and pathological, and therefore morally corrupting and potentially socially dangerous or destabilising.

For western society, Foucault attests a gradual substitution of discourses and knowledge produced on sexuality based on elements of erotic arts. *Ars erotica*, that is the self-reflective, autotelic art to induce pleasure 'understood as a practice and accumulated by

experience', was superseded by a *scientia sexualis*, a science of sexuality.[11] The latter can be understood as 'procedures for telling the truth of sex which are geared to a form of knowledge-power strictly opposed to the art of initiations and the masterful secret'.[12] In a civilisation that did not endow itself with a developed, if any, *ars erotica* – unlike other cultures such as China or India – sex(uality) became increasingly exposed to interrogation, interpretation and medicalisation. This included an implantation of sexual perversions for practices outside the accepted heterosexual norm, and varied forms of repression anchored in the establishment of truth(s) values, rather than emotional and physical excitement and fulfilment.[13]

Definitions of the obscene are informed by an assessment of its projected damaging effects on the recipients of actions or objects. The German writer and philosopher Ludwig Marcuse, who concentrates his discussion of the obscene on the pornographic, pronounces that those effects are not just detrimental physiological stimulations, but also 'unhealthy' incentives to the imagination.[14] Such an approach, however, raises the question of who is making that judgement for whom here. Certain social groups where considered to be morally vulnerable and in need of legal protection from the smutty and excessive through the obscenity laws that emerged during the mid nineteenth century across Europe, followed by the USA towards the end of that century. They came from those social sections that were in the process of gaining wider access to and participation in cultural consumption (and production) due to a democratisation of culture: women and the lower classes.[15] The democratisation of culture was founded on advances in industrial production and, in particular, on the new means. Moving on from the fifteenth-century Gutenberg press and forms of manual reproductions such as the wood, engraving or etching to photography and lithography in the nineteenth century enabled a more labour- and cost-efficient mechanical mass reproduction of texts and images, and thus fuelled their broader and 'promiscuous' circulation and accessibility. As Kendrick observes: 'There has never been a society – until our own – in which all representations were available equally to any observer at any time.'[16] This situation produced a greater need for the regulation and control of all representations through a number of interrelated mechanism, including censorship, policies for the funding of art and culture, interventions into the market, etc.

The democratisation of culture has been bound up with an amplification of the cultural divide between high art and popular/folk culture, with the gulf between cultural elitism and mass production/consumption. The modern concept of obscenity is intertwined with the advances in mass reproduction, information and communication. It has assumed a divisive role as a separating force between different areas of culture. It also functions as a gauging support for the polarisations between erotic arts and pornography, high and popular culture, cultural industry and autonomous, elitist art. This dividing function has remained intact despite the growing fluidity and mobility of visual images and objects between different cultural domains such as fine arts and graphic design or advertising, video art and video games, mainstream and independent or art-house film, for example.

When discerning what might be obscene by considering the potential effect of an object/action/event, the context that informs and is informed by its pragmatic dimension and the intentions of its producer(s) with regard to the object/action/event's desired effect play a crucial role. This might be even more applicable for the closely connected category of the pornographic, insofar as the arousal of carnal desires depends on the situation of its incitement. For instance, the explicit representation of sexual organs in the context of sex education and health promotion campaigns relating for instance to sexually transmitted diseases, or the depiction of violence in campaigns against drink-driving as well as the gruesome details of anatomic displays are usually not considered obscene on the basis of their enlightening function. They are seen to predominantly appeal to the intellect rather then to the flesh.

The same may hold true for homoerotic depictions in the context of gay rights publicity that are directed at public enlightenment and advocacy. On the other hand, the showing of lesbian love scenes in magazines for men or in the tabloid press is openly and above all directed at the sensual stimulation of the male readership. In this sense, the pornographic is more aligned with leisure and hedonism rather than with education and enlightenment. For Marcuse, amongst others, the intention of the producer plays a decisive role for the perceived effect of the work, i.e. whether a textual (audiovisual) or multimedia representation was made with the direct intention to arouse or deprave.[17] Yet moving along such a slippery slope immediately raises – by inference – questions regarding the status of the producer and it points to those valorising institutional frameworks, groups and individuals, who have the power to confer such status.

In the educational context, however, 'innocent' intentions or the context of art do not always provide a safeguard against the perceived powerful effects the display of explicit sexuality (and violence) as the example of the *Venus of Willendorf* (30,000–18,000 BC) demonstrates. Although the small limestone artefact would not have been labelled obscene in the context of her origin but rather used ritualistically in the service of a sustained and enhanced fertility, her bold nudity and 'unequivocal sexuality' kept reproductions of the work out of US art textbooks for much of the twentieth century.[18] Such a decision is rooted in a narrow focus on the formal appearance of the *Venus of Willendorf*, rather than on its cultic meaning and application. In other words, definitions of the obscene largely depend on what are deemed to be explicit and excessive representations of sexuality and violence, and on how the meaning and functions of such representations are judged – whether they are considered enlightening, therapeutic and liberating, or detrimental, damaging or depraving. Such an assessment, of course, depends on the (perception of) the respective context(s) of their circulation and thus can vary considerably.

Like any other value judgement, an assessment of the character and quality of a cultural product is inevitably informed by a degree of subjectivity. The verdict of obscenity has been linked not just with a moral condemnation; it has been equated with a denial of any aesthetic values. Therefore, judgements on obscenity usually determine the potential exclusion of the work/act(ion) from the echelon of high art and from the sphere of the

morally acceptable, the legally permitted and thus the intellectually superior. An exclusion from the interface of those domains confines what thus might be considered coarse, gross, filthy or lewd to the margins of official culture, recognition and support. Yet, the offensively indecent, improper or shameless displays that lurk in the seemingly shady and suspect 'backrooms' of mainstream culture do not preclude such material from being subject to commodification and money-spinning consumptive circulation. Quite the opposite: sex and violence sell exceptionally well. They are an integral part of the highly profitable cultural industries as much as they flourish in the 'marshes' of high art. Despite the 'rise of religious and social conservative movements' in the latter part of the twentieth century, particularly in the USA and compounded by an 'antagonistic administration', the market for obscene material of (m)any sorts booms like never before in contemporary culture: 'Pornographic revenues – which can broadly be constructed to include magazines, Internet Web sites, magazines, cable, in-hotel-room-movies, and sex toys – total between 10 and 14 billion dollars annually.'[19] Propelled by the digital revolution and its efficient means and networks of information, communication and (virtual) consumption, as the American attorney and author Frederick S Lane III has vividly demonstrated in his overview text *Obscene Profits: The Entrepreneur of Pornography in the Cyber Age* (2000), it has developed into one of the foremost growth areas of the capitalist economy in the West – if not globally – with unflinchingly robust profits yields.[20] Walter Kendrick sketches out the reasons for the torrential spread of pornography:

> That we are rapidly approaching such a condition [of ubiquitous sexualisation of society] (or have reached it) is the result of complex social transformations: rising literacy, increasing urbanization, and the accelerated enticement to control all things, especially the forbidden, by making them subjects of discourse. Ironically, in the movement toward promiscuous representation, 'pornography' stands not as a roadblock but as an important stage of process – a sort of shadow zone between highly selective darkness and indiscriminate light.[21]

Sex is not only a 'hot' commodity in western culture; society as a whole has become increasingly sexualised. 'Since the 1960s sex in the media – mediated sex – has increased quantitatively as, in qualitative terms, it has become more explicit.'[22] The number of popular television programmes and the amount of print material retracing and reconstructing sexuality, its history/ies, its (specialised) practice(s) and various cultural representations and mediation(s) has been vastly growing over the past decade as has the (moderately) explicit display of sexuality in mainstream films. Linda Williams has suggested that sex has been tamed since the 1970s by becoming more visible in society and moving from off-scene to on-scene. It has gradually come to feature much more prominently in public discourse. She argues, 'If telling all, showing all, has become a national preoccupation, it is because an apparatus of power and knowledge has been at work to organise the

confession of increasingly explicit details of sexual life.'[23] Thus, perhaps not surprisingly, the 1980s and 1990s saw a renewed move towards a 'polarisation and line-drawing' between a 'properly' sublimated and distanced erotic art and untamed and immediate pornography, that was exemplified for instance through the law suits against the exhibition of Robert Mapplethorpe's work in Cincinnati, USA, in 1989, and the fact that 'high-end' art venues that overstepped the line were more rigorously persecuted then low-end porn establishments.[24]

On that note, it is worth bearing in mind that the display of excessive violence and human suffering and demise across a whole range of genres of video and computer games, mainstream (B and A) movies as well as the news and documentary broadcast and print mass media sectors has also become more extensive and intensified since the late 1980s. This has not just occurred in the service of a heightened realism, as could perhaps be argued in regard to an immediate and authentic representation of military conflicts, natural or man-made catastrophes and human suffering, past and present. While western society has been largely sanitised of first-hand experiences of violence as spectacle, such as public hangings or bull fights, scenes of war and disasters, the visibility of and focus on violence and its effective (rather than affective) staging in video and computer games, appears to have amplified proportionally.

Judging by the chronic popularity of hyper-realist blood-splatter films and video games, it seems that viewing expectations and the emotional thresholds of audiences in general have changed during the second half of the twentieth century compared to previous decades, moulded by and moulding emergent imaging technologies and their promise of increasing immediacy, transparency and immersion from the safety of the armchair.

The persistent ambivalence and contestations of the public discourse(s) vis-à-vis considerations of (in)decency and moral depravation become nowhere more obvious than in the nine o'clock 'watershed' on UK television, after which more explicit programmes can be broadcast albeit preceded by obligatory verbal warnings against explicitly sexual images, the representation of violence and/or the offending use of language. Whilst the modest cover-up of wo/men's genitals before the watershed is well established, the veiling of infants' and children's genitalia in documentary programmes seems to be a fairly new development caused by recent, highly publicised incidents of child pornography. The 'f-word', like several other sexually connoted derogative, is still generally bleeped out in public broadcast or asterisked in some of the daily and Sunday newspapers, both broadsheet and tabloid. All this has been put in place to safeguard 'public morality'. Reports on cases of public outrage caused by 'art' incidents such as the 2004 Turner prize display at Tate Modern or censorship interventions like Betsy Schneider's show of photographs of her young daughter in the nude in a London gallery of the same year, continue to probe and affirm the validity, operationality and reinforcement of the category of the obscene. With a continuing 'liberalisation' of mass/global media and the legal frameworks in contemporary western society – though with considerable national differences in direction and emphasis – obscenity as a complex category has not disappeared. The final frontiers between the

licit and the illicit, the moral and the immoral, and the aesthetic and its Other have been re-aligned. Nowadays they run broadly speaking along the lines of paedophilia, necrophilia and cannibalism.[25]

When it comes down to an exacting definition of the obscene in relation to the aesthetic, the difficulties inherent in such endeavour become equally obvious, because obscenity and art are birds of a feather in that both are concerned with representation. Telling the two apart, paradoxically, the difficulty lies not so much with obscenity but with the concept of art, to which it is inextricably linked. In western thought of the modern period, notions of art have been more or less founded on a set of assumptions that concern the location of the aesthetic and its understanding and functions. The former situates the arts, not only the literary but the visual too, in the mind, primarily as the result of the work of the imagination and the intellect, rather then the expenditure of physical labour and the efforts of manual skills. It habitually locates the art and the beautiful in the artwork itself and from there determines what 'good' art is or should be. Closely connected to such a qualitative approach is the notion of the (male) artist as genius, who, endowed with a powerful mind and special talents, translates his ideas into significant material appearance conducive to an aesthetic experience. Generally speaking, the long-held belief that art should be first and foremost beautiful rather then merely convincing and/or original, still lingers today. In other words, only when one can assert what is art, can one assert what it is not, what counts as non-art and/or obscenity.

Obscenity is bound to conventions of representation as much as art of any form is. These cultural codes and rules and the values they are connected with as well as the institutional framework which carry them forth, come tangibly to the fore in and are tied to the shifts and changes that affect our ways of seeing, thinking and judging what is aesthetic and what falls outside of its constantly re-negotiated dynamic and flexible parameters. The relationship between art and obscenity is echoed in the relationship between erotic art and pornography – albeit in a narrower sense. Whilst the erotic describes 'the space of permissible sexual representation', the label art attest aesthetic qualities to material that aims at arousal.[26] Pornography – often considered as the negative Other of erotic arts – maps the territory of sexually explicit representation that is inflected by restrictions, prohibitions and, broadly speaking, the non-aesthetic.

Susan Sontag, amongst others, has proposed to consider the possibility of pornography as art. Situating her argument mainly in the area of literature, she seeks to distinguish between good and bad pornography, the good having artistic value and its own aesthetic rules. Umberto Eco, in his lucid description of what makes a pornographic film, argues that an accumulation of everyday situations, banal (inter)actions and a lot of (narrative) 'coasting' or freewheeling are necessary features to emphasise the sexual deviation. It therefore constitutes an important formal standard of pornography.[27] Repetition and simplicity have been considered key attributes of the pornographic, whilst the complexity and variety of erotic art is often highlighted to affirm its aesthetic credentials and (sublimative) motivations, and distinguish it from the mere titillating of the pornographic.

For sexually explicit images to qualify as erotic art, Edward Lucie-Smith, the prolific writer on art, lists four characteristics in his historical overview, *Erotica*: 'hedonistic, guilt-ridden, boldly critical of society and transgressive for transgression's sake'. He emphasises that 'they combine at least two of these four effects'.[28] Though his list of criteria in its function vis-à-vis western morality and politics of the day looks peculiar and underplays the judgement on grounds of aesthetic criteria and established norms of representation, it echoes common perceptions. The art historian Peter Webb, in his earlier pioneering survey of *The Erotic Arts* (1975), considers erotic arts as vital expressions of sexual freedom and liberation, in which he sees key ingredients for radical social change.[29]

As with the obscene in more general terms, it is impossible to arrive at a value-free definition of either erotic art or pornography. The line between erotic art and pornography and the underlying criteria and categories has always been brittle and historically and socially fluid. From Giorginoe's *Venus Asleep* (1510) and the aggressively sexual and violent imagery of Peter Paul Rubens (1577–1640) to the drawings and paintings of Henri Matisse (1867–1954), Auguste Rodin (1840–1917), Egon Schiele (1890–1918) and Pablo Picasso (1881–1973), what is being labelled erotic art has a long and broad genealogy that can be traced to the heydays of Ancient Greek and Roman cultures. Its parameters and circulation were informed by the increased excavation, reassessment and sanitation of the cultural heritage of Greek and Roman antiquity in the wake of the work of the German scholar on antique art, Johann Joachim Winckelmann, and late eighteenth- and early nineteenth-century classicism. As the modern private-public dichotomy was burgeoning during that period, much of the erotic art production has more or less vivaciously simmered as private undertaking or commissions for private patrons and for restricted, privileged access. Only in the wake of the late 1960s liberation movements and liberalising sexual legislation this area begun to gain wider exposure and debate, gradually and controversially.

There are several key examples of what has become widely accepted as outstanding work in twentieth-century art beyond the confining qualifier of the erotic. Marcel Duchamp (1887–1968) was concerned throughout his life with the erotic in direct relationship to the challenges directed at the conventions of the symbolic order of the visual arts and the role of the artist. His elaborate large glass, *The Bride Stripped Bare by Her Bachelors, Even* (1915–1923) poses as an autoerotic, obscene and pornographic mechanism on a number of levels. This elaborate and 'ironic love-making machine' consists in the lower parts of nine dressmaker's models symbolising the bachelors. A mechanism made up of dust-filled sieves and a chocolate grinder connects those 'malic [male and phallic] moulds' to the upper part of the work, which contains the 'Bride'. It filters the male desire before sending it upwards in the service of sexually (full)filling the female in the virtual – as suggested by the pink cloud in the upper portion. Implicating the viewer in its display through the transparency of the glass, the arrangement subverts a fixed subject-object (viewer-viewed) positioning. The *Large Glass* is an extremely complex work, and entire books have been dedicated to decipher its meaning situating it at the interface of subjective desire and scientific interest.

In *Etant Donnés* ('Given') (1946–1966), which, completely hidden away from publicity, captured the creative interests of the French for more than two decades, Duchamp conceived of an enclosed, secretive environment that invites the singular viewer to experience a disconcerting scene through two holes at eye level drilled roughly into a wooden door that seals off the *mise-en-scène*. Perceivable in three-quarter view only, a life-size model of a nude female with legs splayed towards the viewer/voyeurist lies in the foreground, giving view of her bare-shaven pubis. The woman's head is kept out of sight. In her hand she holds a gas burner whilst her arm is covered with dry twigs. In the background, a naturalistic forested landscape with lake and waterfall enfolds: the seemingly real is (in)fused with the surprisingly illusionistic, the private and the public firmly entangled. This mysterious work refutes any attempt to be clearly read and understood as much as it refuses to be technically reproduced. This installation was only assembled after Duchamp's death based on his instructions, which also form an integral part of the work. It can only be experienced in the here and now, thus foregrounding main aspects that have 'haunted' the foundations of modernist art as much as the concept of the obscene: authenticity, immediacy and the erotic as act and event. Yet paradoxically, both have been inextricably connected to culture's capacity for mechanical/analogue reproduction and its potential to (in)form public discourse and the (trans)formation of social value systems.

During the 1950s, Duchamp produced a number of small sculptural pieces moulded on the genital parts of the body and later cast in bronze. The 'suite' includes *Female Fig Leaf* (1950), *Dard Object* – the cast of a penis – (1951) and *Chastity Wedge* (1954). The *Female Fig Leaf*, a cast which is said to have been moulded from the female mannequin in Duchamp's installation *Etant Donnés*,[30] seems to operate on a par with Duchamp's linguistic puns on a number of levels. Taking the title literally, it functions as veil of the female shame in a way this kind of foliage has traditionally done in the history of western sculpture and painting since the Renaissance, for female and male genitalia alike. The famous sixteenth-century depictions of Adam and Eve by Lukas Cranach or Hans Baldung Grien are a prime example of this convention. But the cover-up in Duchamp's work is taken to extremes where the plaster cast hugs the body and inserts into the crevices of the pudenda. Once removed from its corporeal 'host', it returns to sight what it sought to hide from vision previously, in the reversed form of an imprint in the detached way of the cool metal surface. Instead of masquerading female sexuality the small artefacts places it on-scene as a kind of 'counter-object'. The intimacy of the touch is inscribed in its extreme in these talismans that question the referentiality of the erotic imprints.[31] Confusing concavity and convexity of the sexual part(s), the *Fig Leaf* – like the *Dard-Object* and the *Chastity Wedge* – irritates the viewer in its wilful distance to the conventional representation of female and male sexuality. It remains ambivalent on a formal as well as a material level as the metal contradicts its organic curves and dents, particularly in *Chastity Wedge*, where the bronze segment is embedded in fleshy pink dental plastics alluding ambiguously both to enforced celibacy and penetration, and to the violent and the marked sensual.

The 'doll fetishism' of the German artist Hans Bellmer (1902–1975) implies a 'polymorph perverse exhibitionism' on the part of the artist, which is set against a singular orientation towards the genitals and their predominantly reproductive function. The latter was increasingly promoted as healthy sex life by post-war advertisements and mass media.[32] His grotesque configurations, informed by the influence of Surrealism, are either imaginatively drawn or painted in an antiquated, skilful mannerism, or constructed from parts of dolls' bodies. They invoke a fetishist relation between the sexual(ised) fragments of a female corporeality and the producer/viewer. Nurtured by an obsessive fixation on a model of androgynous love and schizophrenic sensitivities his 'new perverse organisms' seek to communicate sexually with/through the whole body with the aim to banish and dispel anxieties about male subjectivity, wholeness and power.[33] His notorious photographs of a mature female body – his lover Unica Zürn –, which is contorted through severe bondage and captured often in awkward positions, operate in a similar vein.

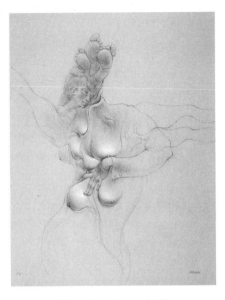

1. Hans Bellmer, *Les crimes de l'amour Titre Attribué: Le sens Commun* (1961).

The proximity of intense sensuality and excessive violence has become a hallmark of Francis Bacon (1909–1992). One of the best-known English painters of the second half of the twentieth century, much of his mature work deals with the depiction of the male figure and features a pronounced attention to emotional turmoil, violent physicality and troublesome sexuality, not in a glorifying but a rather disturbing manner. Often, as in *Three Studies of Figures on Beds* (1972), two men are rendered in 'turbulent and traumatic' interactions, painted with gestural vehemence – twisted, distorted, entangled and yet restlessly dynamic forms spatially entrapped and executed in colours of heightened tension. In an intense and coded manner, Bacon's traditionally executed easel paintings articulate the homoerotic desire that was nourished by the artist's own sexual proclivity and life experience, though this was well shielded from public view during his own lifetime.

The controversial figurative paintings of Balthus (Count Balthasar Klossowski de Rola, 1908–2001) in connection to the secrecy about his personal life have also spurred speculations about the relationship between his images and his own erotic desires and practices. A French artist of Polish extraction, he frequently depicts pubescent girls in strangely static yet deeply suggestive poses. His provocative, voyeuristic scenes infuse

juvenile innocence and attraction with mature erotic knowingness and power. Works such as *The Guitar Lesson* (1934), depicting a young girl and her teacher in a lesbian relationship, or the highly charged *The Room* (1952–1954), where a female adolescent is revealed masturbating, have gained notoriety, along with a range of other images throughout his artistic career that seem pregnant with paedophilic predilections.

Placed within the broad category of erotic art, however, these divisive works have been 'justified'. In their difficult content and potential offensiveness, as works of art they have been underpinned by an 'assertion of form which holds off the collapse into the pornographic'[34] or obscene, and is accommodated amicably as the creation of male 'genius'. Their experience is thus located within the framework of normative contemplation and Kantian disinterestedness. In other words, the works are seen to sublimate libidinal desires and thus move the viewer intellectually and emotionally, rather then to arouse them sexually. Furthermore, their alignment to a patriarchal symbolism that ultimately affirms the oppression and exploitation of women leaves in tact predominant, accepted social power relations. Those image productions have therefore been asserted in their superiority and 'purity,' and entered relatively smoothly into the canon of western high art. Their admittance to this 'exclusive club' has been promoted by and in turn supports their widespread public exhibition and reproduction, profitable acquisition and politely critical discussion safely distanced from charges of obscenity.[35]

More recently, in 2002, London-based Vision On Publishing issued *Porn?* by Tom Hingston, a coffee-table book in a lush and garish pink cover. A year later, the London art publisher Thames and Hudson launched John Waters' and Bruce Hainley's *Art: A Sex Book*. The former, as its unpretentious title promises, is filled with stylish pornographic photography; the second offers a mixture of sexual innuendo and erotic foreplay interspersed with some more candid representations. The Tom Hingston Studio has developed a slick graphic design portfolio that ranges from music – CD covers for Craig David and Nick Cave and the Bad Seeds – to top-end fashion posters and catalogues for Christian Dior, Harvey Nichols and Mandarin Duck and others – to cultural icons such as Robbie Williams and product branding for Absolut Vodka and Penguin Books among others. The studio operates within the creative industries across an expanding spectrum of product types and ranges.

On the premise that '[c]ontemporary art is sex,'[36] Waters and Hainley have brought together illustrations of recent artworks. Bruce Hainley argues, 'Sex is a prime motivator for making contemporary work, even when the art seemingly doesn't have anything to do with sex or nudity. Making art – especially if it's interesting art – is a sexy occupation.'[37] He maps out the territory for their book: 'Shoplifting, trespassing, theft, vandalism, surprise redecoration – these are some of what we present as sexy in this book.'[38] In this spirit they have divided their book into rooms – like a gallery – in which they assemble (images of) works by Jeff Burton and Keith Boadwee, Sarah Lucas and Richard Prince, Richard Kern and Larry Clark, Marlene McCarthy, Andy Warhol, Beth B. and others. Some are more candid or suggestive then others.

Both publications are symptomatic of the contemporary situation, where sex permeates all pores of the cultural fabric. Juxtaposed, they exemplify the fluid boundaries of obscenity at present. Where *Porn?* questions notions of pornography and thus poses the question of what is obscene from the domain of what is widely regarded as popular culture and tickles provocatively the periphery of the high art domain, *Art: A Sex Book* employs the reverse strategy: the film director and the curator situate their compilation within an elitist art context pushing against and traversing confidently its confines. They illustrate the close connection between sex and art, influenced by Freud's theory of sublimation. They also test the limits up to which representations charged with sexual denotations remain aesthetic – when exactly do they slip into the obscene? Both publications demonstrate that the answer does not reside within the content-form dialectics of the visual work per se but in the discursive context of its production, dissemination and consumption.

In other words, obscenity names an argument rather than an object. The appearance of this argument in relation to visual art productions in the second half of the twentieth century and the contemporary situation forms the subject of the following chapters.

# Chapter 2

# Transgressive Rituals

They do not say vulva is the primal form which as such describes the world in all its extent ...

They say it is not for them to exhaust their strength in symbols ... They say they must now stop exalting the vulva. They say they must break the last bond that binds them to a dead culture. They say that any symbol that exalts the fragmented body is transient, must disappear. They, the women, the integrity of the body their first principle, advance marching into another world.

The women say that they perceive their bodies in their entirety. They say that they do not favour any of its parts on the grounds that it was formerly a forbidden object. They say that they do not want to become prisoners of their own ideology.
*Monique Wittig*[1]

Flesh
Flesh
To dismember the flesh,
anal, sado-masochistically
(action of disembowelment
and of laceration)
to better understand the
amorphous zones of the being.
Colour does not appear immediately
as such, but intensifies only
the sensuous zones.
*Hermann Nitsch*[2]

In the early 1960s, a loose grouping of artists gained notoriety in Vienna and beyond through taboo-breaking performative actions. Hermann Nitsch, Otto Muehl, Günter Brus and Rudolf Schwarzkogler were responsible for those highly 'provocative, insurgent and challenging' interventions. Known as the Vienna Action Group or Vienna Actionists, they performed their own bodies or the bodies of friends in highly charged sexual ways on Vienna's streets and in the city's cellar spaces, that is to say, outside of the art establishment's realm, collaboratively as well as individually.[3] In the increasingly politicised climate of the post-war period, the 'sons' sought to break with the social value continuum, and the authoritarianism of the pre-war 'father' generation. Muehl, with male and female collaborators, indulged in opulent material actions. Employing foodstuff, paint, blood and other organic materials, those scripted experiments centred on the manipulation of erogenous body zones and collective sexual 'interchanges'. Nitsch choreographed lengthy, spectacular and exhaustive 'abreact games' in his *Orgy-Mystery (O: M.) theatre.* These performances featured the slaughter of animals, scenes of crucifixion, blood pouring and washing in order to reawaken primordial instincts and desires

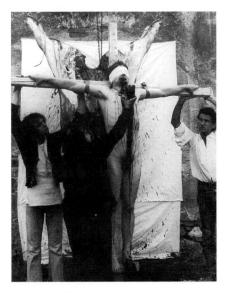

2. Hermann Nitsch, *Das Orgien Mysterien Theater, 50. Aktion, Prinzendorf / The Orgies Mysteries Theatre, 50th Action, Prinzendorf* (1975).

in the service of purification and catharsis. Brus focused obsessively on self-mutilations, corporeal releases and mark-makings, cutting his body, defecating and pissing. In private rituals, Schwarzkogler engaged in auto-destructive actions fixated on a/his corporally and sexually impaired body.

The gestures of the Vienna Action group expressed an iconoclastic attitude directed against the political and cultural extremely conservative establishment and the social instrumentalisation of art. They refused point-blank to continue with a tradition of an art that cements the cracks of society and instead developed a 'Catholicist anarcho-activist practice' that invested heavily in the cathartic, self-cleansing potential of a ritualistic base materialism – unveiling and overcoming the repression and claustrophobic disciplining of libidinal energies. In the face of societal crises and recurring military conflict, they sought to show the brutality and rawness of both reality and authoritarian, imperialist power, rather then translating them into beautiful or sublime aesthetic forms. Following the ethos of Antonin Artaud's *Theatre of Cruelty* and in an acknowledgement of and counter-stance

to sanctioned forms of authoritarian and imperialist violence, Otto Muehl proclaimed: 'Coitus, murder, torture, surgery, the destruction of humans and animals and other objects is the only theatre worth seeing.'[4] The breaking of closely guarded and religiously underpinned taboos, particularly in the way the flesh was staged and the visceral enacted orgiastically, grew out of, extended and intensified their immediate experience of the gestural mark-making of (action) painting.

The procedural and temporal nature of their actions has been preserved through extensive photographic and filmic documentation. In fact, many of their at times extremely perverse and/or cruel stagings were set up as work to camera, which was supported by a strong interest in the moving image among the Austrian film avant-garde as much as by the artists' own familiarity with the pictorial language of the tableaux.[5] In contrast to (other) happening and Fluxus artists, their use of visual media helped to secure their cultural and political 'outrage' a greater exposure, posthumously and yet still somewhat ambiguously. At the time, their concerted onslaughts against the reigning reactionary ideology and authoritarian violence provoked severe crackdowns by Austria's legal apparatus and eventually forced the artists to 'leave': Schwarzkogler committed suicide in 1969, Brus and Nitsch went into exile, and Muehl withdrew into the Austrian countryside to continue his life-art project, shaping an 'egalitarian' and liberal community outside of bourgeois (sexual) economy.[6] The employment of photography, their carefully composed images reveal not only the implication of the operations of art – and obscenity as its Other – in the formation of dominant values and ideologies. It dismantles the myth of elevated and autonomous aesthetics and replaces it with a belief in the directness and authenticity of photography and film, media that, compared to painting, were not only lesser burdened by formal conventions but also underwrote the 'ascending' pornographic (film) industry of the time.

In 1964, Carolee Schneemann (b. 1939) performed *Meat Joy* (fig. 3) to an audience in the Judson Memorial Church in New York. In this space for experimental contemporary

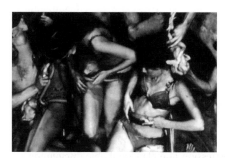

cultural practices, a collaged soundscape enveloped the setting with rock and roll music, Schneemann's recorded voice and noise from the streets of Paris. The artist and her seven fe/male collaborators undressed each other completely, rolled over the floor, wrapped each other in paper and then unwrapped again. They threw paint, dead chicken, fish and sausages at each other: carn(iv)al literally, an orgy of

3. Carolee Schneemann, *Meat Joy* (1964).

the flesh, a sensuous explosion. The objects and materials employed, removed from their common context of use and consumption per se, mark a conscious transgression of 'good taste' and artfulness. Schneemann sought to thematise and valorise embodied

experience and sexuality, employing the language of happening, that is, a procedural structure of simultaneously conjoining events in which the artist's body becomes the primary mark-maker and site, 'constructer and construct' of the work.

Most of Schneemann's work deals above all with the carnal sensuality of the female 'Other', a sensuality that transgresses the boundaries of normative, naturalised gendered roles, moral straightjackets and the socially ingrained conventions of representation of women of the time. The provocation of such exposure has to be understood within a context in which the nudity of the female artist was already offensive enough to justify the levelling of obscenity charges. It was, in comparison to Yves Klein's *Anthropometries* (1960), where 'naked' women 'assisted' the male art genius as print matrixes in the execution of his work, an immense politicised engagement on Schneemann's part. Covered in paint, Klein's female models rolled over the canvas to the direction of the artist dressed in an elegant black suit.[7] Just as painting or sculpture that represents the female nude has become the main theme in art history, as Lynda Nead argues, woman in Klein's performance is being objectified – she remains without agency. This accepted (if not naturalised) ideological and aesthetic (high art) framework of male signifying power makes the life staging of the female nude acceptable. In Klein's actions, woman was controlled by man; in Schneemann's happenings, woman takes control against her objectification and instrumentalisation through the power of man to produce meaning. In Schneemann's work the female body is magnified as a site of cultural representation. In fact, it becomes the pictorial carrier and image at once. Snakes sliding over her naked skin, and symbolic body painting in *Eye/Body* (1963) make explicit references to a (pro-)creative, productive female sexuality drawing on the tradition of the representation of earth and fertility goddesses. Their archetypal matriarchal dimension emphasises female agency beyond a definition of femininity that is reduced to beauty and sex.[8]

The Vienna Actionism and Günther Brus' symbolic self-endangering *Body-Analyses* used the human body as primary aesthetic material visualise to drastically the destruction and real and looming catastrophes of their contemporary society. The same applies to the self-mutilations of American artist Chris Burden (b. 1946) and French artist Gina Pane (1939–1990). Feminist body actions and activism such as the orgiastic and messy melting-into-one of many bodies in Schneemann's *Meat Joy* sought to mobilise energies and stimulate agency through *jouissance*, i.e. the intense (at times painful) sensations and deep pleasure that are derived from merging with the Other, literally and metaphorically. Her performances were directed at the emancipation of women and, through that, at a permanent resolution of social conflict, at liberation and peace. Schneemann's activist and intellectual position as well as her aesthetic strategies informed and were informed by the second-wave American and Western European feminism that emerged during the late 1960s.

In her *Interior Scroll* (1975) performance, a naked Schneemann, with ritualistic paint stripes on her body, pulled a paper scroll out of her vagina that carried a seemingly personal, anecdotal narrative, which the artist subsequently read to the audience. The 'her-

story' – a feminist term coined to mark the writing of alternative histories that focus on women's place in history, on their agency and self-determination – of a 'happy structural film-maker', written in a first-person voice with elements of reported speech, critically tells of 'men's unwillingness to respect work made by women'.[9] The personal truly is political here, as a feminist slogan of that period proclaimed. Moreover, the performance can also be seen as a 'structural attempt' with political intention to rupture and overcome the disciplinary boundaries between everyday life and aesthetics, between art practice, theory and criticism and their locations. It aimed for osmosis of the unsublimated obscene, that is, for non-art, into the realm of high-brow aesthetics. It sought to conjoin practice and reflections within the public production or display of art as a strategy to undermine the argumentative power of external discursive valorisations of the object or process as works of art, as this form of valorisation was seen to be dominated by masculine positions, value hierarchies, institutional frameworks, modes and radii of circulation. Schneemann intended to highlight the concrete cultural situatedness in the here and now of any creative practice and the thoughts and debates about it.

Alongside Schneemann, other female artists who were more or less actively involved in the women's liberation movements during the late 1960s and 1970s sought to challenge and rupture the canonical representation of the female nude, the objectification of the female Other within the patriarchal structures in order to (re)claim women's creative and political agency. Shigeko Kubata's *Vagina Painting* (1965), a mark-making performance with a brush connected to her underpants, commented ironically on the painterly gesture of American Abstract Expressionism, for instance.

Judy Chicago's *Red Flag* (1971) (fig. 4) asserts the creative, signifying potential of woman, but in a way that, with hindsight, ambivalently condenses and restricts identity

to biology. Her infamous *Dinner Party* comprised ninety-nine ceramic plates that where decorated with floral vulva forms, which, in their stylisation and aestheticisation, may have taken inspiration from the paintings of Georgia O'Keefe. Each of the plates, collaboratively produced between 1974 and 1979 by more than four hundred female artists, represents one of ninety-nine women from history. These plates refer to and resist the sanctioned and revered format of the portrait of the face to immortalise exemplary members of the ruling spectrum of society. Instead,

4. Judy Chicago, *Red Flag* (1971).

the work pronounces a transposition of production, material and formal dimension of the work into the 'lesser' arts. The domain of applied arts here locates the contradiction to the male artist-genius model, which is also realised in the collaborative practice of

sharing (though not in the focus on the 'principal' creative agent of the work, that is Judy Chicago, in its art historical reception). Where the representative plates and setting play out men's and women's traditional cultural domains, the bold and colourful charged forms distil social difference to biological essence.

It remains important, however, to stress that the 'explicit body' and the violation of taboos embrace what was at that time – and is still – widely perceived as obscene. The making visible of menstruation, female sexuality and body hygiene, or the pronounced articulation of female sexual desire were not just means for their own ends. Those stagings and gestures, drawing on common notions of obscenity and their patriarchal ideological underpinnings, sought to intervene in the 'social relations of aesthetic production and reception, the social relations of signification', from political, feminist positionings.[10] The threat of censorship, which has loomed large over works of this nature, seems to affirm the potency of those culturally and ideologically transgressive acts. As Schneemann posits:

> The real dilemma of the censor is to corral the imagination and the passage of visceral insights into aesthetic and political contexts. Denying a few photo-graphs an exhibit, cancelling screenings of *Fuses* only heightens our necessary bite and gnaw – only to cut into layers of taboo, denial and projection.[11]

In the wake of the 1968 student revolts in Western Europe and the USA, marked by the Vietnam war and the ensuing liberation movements – sexual, feminist and colonial – artists increasingly turned to the exploration of self, to the experimentation with personal identity and the tracing of subjectivity.

Some artists considered that art has articulated all possible, that there is nothing else to say and, like Gilbert and George, turned to moving life into art and art into life by declaring themselves and their personal relationship(s) as non-commenting, indifferent tabulae rasae. Their work will be discussed later in the book. Numerous female artists, on the other hand, saw that there was still a huge need to critically interrogate art, culture and society.[12]

The new medium of video that emerged in the early 1970s lent itself to the search for new forms and modes of representation, and to the development of innovative strategies of (self-)exploration and performance-based work. It was seen as relatively free of all the baggage of art historical traditions and aesthetic standards.

The Austrian artist Friederike Pezold (b. 1945), for instance, staged her body accentuated by black 'signage' on and over primary and secondary markers of female sexuality in front of a fixed camera. Uncut, the black and white film records in close-up the stylised enacted movement of breasts, thighs, pudenda, mouth and eyes etc. in ten infinitely looped minute-long video pieces. Significantly, the cycle is titled *The New Embodied Sign Language of a Sex according to the Laws of Anatomy, Geometry and Kinetics* (1973–1977), examining the mechanism of the pornographic display as a symbolic rather then voyeuristic 'surface' and the implication of visual representation in the hegemonic production of knowledge.

In the USA, Lynda Benglis (b. 1941) meanwhile moved from a production of sensuous and provocative latex floor pieces during the 1960s to videos reconsidering female sexuality. She also caused a scandal with a full-colour, full-page advertisement in the prestigious art journal *Artforum* in 1974, in which she appeared as a greased nude in sunglasses, aggressively sporting a gigantic dildo. The editors of *Artforum* accompanied Benglis' photograph with an irate letter on how her ad was 'an object of extreme vulgarity ... brutalizing ourselves and ... our readers.'[13] The advert caused such a stir not just because a phallic form was so violently held out by a woman, but because it appeared in the context of a discursive negotiation of modernist art's maintained function to sublimate desires of the flesh and to humanise and cultivate its audience.

The American artist Hannah Wilke (1940–1993) used the medium of video to perform to camera, including a 'slow striptease' behind Marcel Duchamp's *The Bride Stripped Bare by Her Bachelors, Even* in 1976. The disruption between the segregation of what is considered private and what public also underscores her interventions, which in general question and challenge normative assumptions regarding woman's sex and gender roles. This constitutes the political dimension and critical reverberations of her video and photographic performative acts including her latter series *Intra-Venus*. The latter describes the destructive and devastating effects of cancer on her own beautiful body and face, on those ' significant surfaces' in which ruling culture constantly re-inscribes the stereotype of contemporary femininity: beauty, slenderness and youth.

However, Schneemann, Wilke and other women artists, who used their naked bodies in performance, also attracted criticism from feminists. The Americans Lucy Lippard, feminist theorist and critic, and Kristin Stiles, art historian, believed that women using their naked bodies as material and agent in 'body art', particularly when their bodies were beautiful in a way that conformed with prevalent ideals of feminine attractiveness and youth, was producing conflicting messages. They argued that recapturing the female body for the women artists themselves as well as for other women, remains ambiguous, working at least partially to re-inscribe sexual difference and thus to affirm dominant gendered power relations, symbolic structures and value hierarchies.[14]

The 'personal turn' and an inward-looking intercession of individual identity also underpins Vito Acconci performances during the 1970s, albeit from a perspective of a problematised, ambivalent masculinity. In *Seedbed* (1970), the American artist (b. 1940) hid under a ramp in a New York gallery space and masturbated while responding to incoming visitors with his voice. Whilst the act of self-gratification remained off-scene, Acconci's voice indicated to the audience what was happening. The artist's body as theme, material and agent also stands at the centre of the three-part suite *Conversions* (1971), where he engaged in attempts of desired embodied transformations to adopt the positions of the Other: burning off his chest hair, pulling his breasts to develop female breasts; moving around whilst concealing his penis between his legs. In the final part, the penis is kept away from sight by being placed in the mouth of his girlfriend Kathy Dillon, who kneels behind the artist. Not only the penis and the creative powers associated with it disappear

from sight but so, temporarily, does the woman who beholds it. Thus, the wanted and staged metamorphosing into the female body, the Other, actually serves to re-inscribe the creative potential of the penis as phallus, even if a possibility of transferring this signifying attribute to the other is alluded to. In other words, Acconci's bodily endeavour still maintains a conflation of penis with phallus. It asserts in the final analysis that only a body in possession of a penis is capable of signifying and therefore reinforces gender-specific notions of creativity and men's cultural and social power. However, the moment of 'disappearance' and/or transference may signal a crisis in masculine subjectivity during that period without fully replacing the self/other, active/passive, male/female dichotomy.[15]

The Cuban-born artist Ana Mendieta (1948–1985), who developed her practice in the USA, centred the negotiation of her diasporic identity on her body as creative material and agent. In 1972, she undertook a *Facial Hair Transplant*, gluing male facial hair above her upper lip. The act returns Acconci's enacted male/female conversion, whilst at the same time confidentially referring to Marcel Duchamp's bearded *Mona Lisa – LHOOQ –* image of 1919. The body as a prominent site of social and cultural inscription, as the 'boundary between the symbolic order and the real', between 'one sex and the other' becomes a site for experimenting with body politic(s).[16] Where Acconci sought to 'erase' the penis/phallus, Mendieta aimed to acquire it by way of transplanting a substitute marker for the powerful sex, and thus the male art producer. Yet the act functions (only) within the prominent arena of the established symbolic order, within the visual arts. And it is precisely this order of representation that defines what subjectivity means and what such subjective position literally 'entails'.

In 1969, Nancy Grossmann produced *TUF*, which looks like a conventional, full-face fetishist leather mask with metal spikes along the middle parting straps, rivets and buckles leaving an opening for the nose only. On closer inspection, the menacing disguise exposes itself as a head made of tanned and beaten leather: eyelids, lips, etc. This artefact ambivalently occupies a fluid space between flesh and mind, art object – particularly with regard to its mode of display, the plinth – and fetishist artefact with seemingly candid and yet misleading references to deviant sexual practices. It wilfully poses as the latter to exceed the realm of what can be experienced aesthetically. It pretends to imply a hedonistically oriented consumption of art. As such, it stands in juxtaposition to the bourgeois elitist conception of aesthetic sublimation and humanising education that follows on from the tradition of Friedrich Schiller and the eighteenth-century Enlightenment.

During the 1970s, fetishism was 'a key concept for the political aesthetics of modernist-influenced anti-Hollywood cinema' and for feminist theory inflected by a psychoanalytic approach. Fetishism, as Laura Mulvey points out, 'answers a number of conceptual needs'. In her view, those include, amongst others, the

> willing suspension of knowledge in favor of belief; a defense against a male
> misconception of the female body as castrated; the image of femininity as
> fragmented and reconstructed into a defensive surface of perfect sheen; an
> apotheosis of spectacle in consumer capitalism ...

She continues:

> For feminist aesthetics, concepts that made visible a gap between an image
> and the object it purported to represent and thus, a mobility and instability of
> meaning have been a source of liberation.[17]

Nancy Grossmann's seemingly sado-masochist mask does not enable the viewer to place it into a more tolerable and 'secure' context of a clear-cut gendered heterosexist economy. Its foregrounded libidinous gesture remains highly charged and intently ambiguous, exceeding and de-sublimating the aesthetic and moving the work beyond binary oppositions that determine western culture. The contrast with a masculinst, – though perhaps tongue-in-cheek, approach epitomised by the work of Allen Jones of this period could not be greater. His *Figures* (1969), stylised female bodies serving as hat stand, arm chair, coffee table and the like, or his 'costume phantasies' *Waitress coming* (1970) for Stanley Kubrick's film *A Clockwork Orange*, were all inspired by photographs of women in tabloids – à la the page-three girl – or porn magazines. It remains debatable whether they were intended to de-naturalise ironically or defend through counteracting against the proliferating projection of female subservience in the mass media at the time. The Austrian theorist Peter Gorsen notes that they are too deeply 'entrenched in the role of the lonely voyeur as they could be seen in critical contradiction to the normative sexual role of man.' For Gorsen, Jones retreats to a well-recognised fetishist ritual where he wants to 'package women in rubber, lace her in and bound her up so she lies defenselessly at his feet'. At the same time the artist seeks to take on this role himself in order to life out his repressed sadist lust of aggression in a masochist way; that is, he internalises the male-dominated 'phallic woman', a woman with high-heel boots, tight corsage, arm-length gloves and a whip, who dominates and looks down mercilessly on to the man.[18] Yet such a woman is only a stereotyped, interchangeable abstraction of the other within the phallic symbolic order, a variation of culturally predetermined gender roles within the field of tension between the threatening and thus sexually enticing femme fatal and the 'angel in the house'.

Jones's sexist rather then obscene projections are aligned clearly to the former. The British artist Jemima Stehli (b. 1961) has reworked Jones by developing art situations and lens-based work in which she places herself within this tradition of such a masculinist aesthetics. Experimenting with the objectification of women, she has for instance invited male curators, art critics, writers and dealers into a studio situation. There she asked them to use the trigger of the camera to capture moments of their choice whilst she is stripping off her cloths in front of them. The results are photographs that show the artist in different stages of undress with her back to the camera, whilst the men sitting and observing the scene face the objective and thus the viewer. Toying with a good dose of exhibitionism paired with an attitude of self-love (narcissism), Stehli's work lacks a critical distance from the prevailing modes of representing women in art and beyond. The fact that the work is initiated and/or produced by a female artist does not per se add criticality to it.

Painted cut-out-like female figures by John Wesley, Tom Wesselman's *American Nudes* or Mel Ramos and James Rosenquist's eroticised imageries, which objectify women in a pronounced manner, enlarging their sexual 'selling points', all functioned in a similar way. These 'period' pictures of eroticised, clichéd femininity, often unashamedly candid and exploitative, evolve from a sanitised and sterile hedonism of consumption that marked in particular the American version of 1960s and 1970s Pop Art, and found its recycling par excellence in the work of Jeff Koons during the 1990s. Like Jones's work, those paintings suggest a superficial closeness to reality, a degree of satisfaction of projected needs, rather then a critical scrutiny or problematisation of societal phenomena and concerns. The ways of seeing that underwrite those eroticised and often monumentalised portrayals of femininity are already 'filtered' through forms of 'social voyeurism and exhibitionism' in the expanding field of the mass media.[19] Where the obscene pierces through the aestheticisation of form it is reigned in by an accompanying critical discourse that teases out and amplifies the allegedly critical mission of the work and thus makes it fit neatly into the (post-)modernist art model and its spaces.[20]

Pierre Molinier (1900–1976) documented extensively his posing and masquerade that origin in the realm of an authentic (rather then purely enacted) transvestism. The visualisation and aesthetic manipulation of authentic transvestites in Molinier's photomontages and photo-retouches theatricalised his own life experiences and functioned as a negotiation of the social prejudices attached to ambiguous sexuality and the effeminate male. His work, alongside the explorations of Urs Lüthi or Jürgen Klauke during the 1960s and 1970s, was situated within an increasing spectacularisation of society. The public display (and deliberate performance) of people's life practices was delicately embedded in the nexus of visibility and political empowerment, the promotion of diverse cultural experience, individual 'unmasking' as well as, increasingly, calculating (media) exploitation. Molinier's sexually charged stagings as manifest for instance in *Autoportrait avec godemiche* ('Self-portrait with dildo', fig. 5) is densely interwoven with autobiographical externalising and to some extent therapeutic aspects – an 'erotic self-performance' that emulates and interprets female stereotype and feminine gestural patterns without completely losing

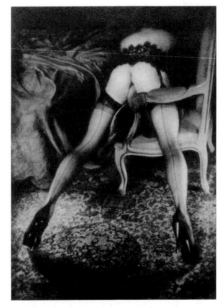

5. Pierre Molinier, *Autoportrait avec godemiche* ('Self-portrait with dildo') (1966).

sight of the 'male origins' of this mimetic manoeuvre. Performed within the context of 'fetishist structures', the markers of maleness – rather then being symbolically amputated or fully veiled – function as sites of resistance against the metamorphosing manipulations of the image.[21] There is a considerable difference in the location and symbolic and psychic intensity of Molinier's act(ion)s compared to the surface-play with feminine fashion styles and accessories in the popular show business of the 1970s glam rock, which followed on from the higher degree of sexual freedom that was attained since the end of the 1960s and anti-authoritarian stances. Moreover, the fact that signifiers of masculinity remain in the picture and can be traced back to its maker has supported the integration of Molinier's work, if somehow troubled, into mainstream art, not unlike the operations of Marcel Duchamp's alter ego Rrose Selavy, manifest amongst others in glamorous photographs taken by the avant-garde photographer Man Ray, in which the artist poses as woman. The title *Rrose Selavy* is also a phonetic pun on words sounding like 'Rose, c'est la vie', which means 'Eros, that's life'. Rebecca Schneider stresses that 'Duchamp's masquerade of the feminine fitted the constructedness, the "made", the authored quality of art. To *put on* a female profile fitted the pattern of the artist making the object – the object being feminine, passive principle, that which is put on or put off.'[22] Molinier's experimental self-representations of his body image have been frequently read not only as individual articulations of his unconscious, but also in proximity to preceding surrealist strategies around André Breton.

The process-based art of Japanese artist Yayoi Kusama (b. 1929) also ventured beyond the 'decorum' of the highbrow space. Notorious for her aggregations of phallic forms that in their proliferation take possession of objects such as a sofa in *Accumulation #2* (1966) and whole interior spaces, her work has been read, supported by the artist's own comments, as a 'psychosomatic' form of expression that evolved from and channelled her mental illness. The insistence on repetition of form like the net-structure, the polka dot or the phallus brings to the fore strong associations especially to women's everyday practices: the dexterity, diligence and perseverance as much as the monotony and boredom that is inherent in many domestic chores and services. Based in New York during the 1960s, she expanded her ritualistic and obsessive repetitive art-making from painting to soft sculpture/object-making. Kusama came to emphasise the processual nature of making by working with environments and then adopting the format and aesthetic strategy of happening. The latter had emerged around the beginning of the decade motivated not only by a resistance to the comprehensive commodification of art, but by the need to contest dominant (aesthetic) value systems and experiment with alternative forms of community akin to earlier stagings of anti-bourgeois protest.

Kusama's *Love Happenings* or *Orgies* of the late 1960s were realised in collaboration with models and volunteers, who moved around in the nude and interacting sensually/ corporally in semi-mirrored studio spaces. The bodies within this theatrical staging provided the canvases for Kusama's polka dot paintings under the eyes of the invited press and audience. Her indoor happenings, which sought to promote an 'overall sexuality

versus a genital sexuality' were complemented by exterior events, naked demonstrations, which Kusama called *Self Obliteration* or *Body Festival*.[23] There, a group of models/dancers congregated in the city, stripped off their clothes and begun to dance through the streets whilst the artist sought to cover their bodies in polka dots. Organised as a publicity stunt and attracting the attention of passers-by, the events would usually come to an end through the intervention of the police.[24] Whilst the media confronted America with the (refracted and filtered) realities of the Vietnam war, art was seen by many artists as an effective instrument to express their resentments and protest against the establishment, the centre of power. Nudity in this situation took on to symbolise love, peace and Nature, opposition to imperialist politics as much as to capitalist consumerism.

In Kusama's practice, the (semi-)public display of nudity became a way of articulating her outrage against the war and, moreover, against patriarchal domination and the pressure of social conformity, which grew out of her formative experience in her native country during the 1930s and 1940s, as well as of her life and work in the West.[25] Her soft objects covered in and swallowed up by masses of aggregated soft phalli made out of fabric has been seen to articulate an 'aggressive will and fantasy' to defy oppressive male power by possessing it symbolically herself.[26] Yet the omnipresence of the phallic form, which in western culture and beyond is over and again remapped on to patriarchal signifying agency, and Kusama's nude posing on and 'immersing' in it also reaffirms the opposite reading in a heightened way: woman's reification as passive Other by the dominant symbolic order. It points to a broader charge that has been placed against activist manoeuvres that challenge the established art/non-art divide. It includes the danger in its placing and negotiation in public discourse of inadvertently reinforcing the existing prevalent aesthetic delineations, symbolic order and value hierarchies.

# Chapter 3

# Abjection
# and Dis-ease

Let me penetrate you. I am the archaeologist of tombs. I would devote my
life to marking your passageways, the entrances and exits of that impressive
mausoleum, your body. How tight and secret are the funnels and wells of
youth and health. A wriggling finger can hardly detect the start of an ante-
chamber, much less push through to the wide aqueous halls that hide womb,
gut and brain.

In the old or ill, the nostrils flare, the eye sockets make deep pools of
request. The mouth slackens, the teeth fall from their first line of defence.
Even the ears enlarge like trumpets. The body is making way for worms.

*Jeannette Winterson[1]*

Abjection ... is merely the instability to assume with sufficient strength
the imperative act of excluding abject things (and that act establishes the
foundation of collective existence.

... The act of exclusion has the same meaning as social or divine
sovereignty, but it is not located on the same level; it is precisely located in
the domain of things and not, like sovereignty, in the domain of persons. It
differs from the latter in the same way that anal eroticism differs from sadism.

*Georges Bataille[2]*

Amanda Coogan (b. 1971) sits on a concrete pavement leaning against a nondescript
brick wall. The photograph frames her – centre-stage, legs bent and spread awkwardly
open – as she wets her white underpants. The image was taken during a live-performance

in Dublin in 2001. *The Fountain* (fig. 6), being conceived as a 'tableau vivant' (living picture) performance, shows the Irish artist passing a considerable amount of water over a period of two and a half minutes, leaving underneath and in front of her a stream of bodily liquid: light ochre and familiarly smelly. The performance suggests a loss of body control and yet could only be staged through the exertion of an extreme corporeal discipline but, more crucially, its photographic documentation may have conjured up images of Andres Serrano's *Piss Christ* (1987) or, from a decade earlier, Robert Mapplethorpe's *Jim and Tom, Sausalito* (1977), where one man urinates into the mouth of another. Yet, equally, Coogan's provocative act has been read as a pertinent commentary on (young) Irish people's 'out-of-control', excessive and transgressive behaviour when out and about in the urban pub/ dance/night club scene.[3]

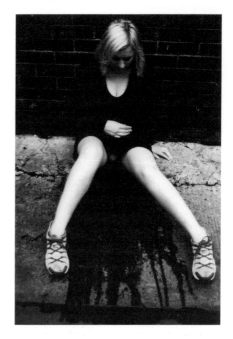

6. Amanda Coogan, *The Fountain* (2001).

Losing control over one's bodily functions and putting the body on display as incontinent, infringes one of the strictly guarded taboos in contemporary sanitised western society, particularly where it concerns women. In *Skirt Stain* and *Queenie* (both 2001) a blood mark below the bottom stains a beige, body-hugging skirt worn by Coogan in situations where she displays and exaggerates stereotypical feminine behaviour. The blood blotch visualises menstruation as signifier of womanhood, a signifier that must remain hidden at all costs. These interventions form part of a continuum in the artist's work that has evolved in the context of recent performance and body art and its concerns with abjection and the abject. Coogan explores this thematic complex in proximity to ideas of sacrilege and the sacred in the broader context of contemporary Irish Catholicism, mythology and history. The work is influenced by the wider legacy of women activists' critical engagement with patriarchal society's rules and prohibitions in general, and in particular with modernist notions of (creative) powers, the male artist-genius, and postmodernist concerns for politics of representation. Her interventions are heavily inflected by Catholic iconography and rituals as much as by popular and high art, media and youth imageries. She has developed her performance practice on the site of parodying attacks on established concepts and traditions (parodic iconoclasm) through 'stagings' that oscillate wilfully between the enticing and the revolting, between debauchery and restraint, between the aesthetic and

the obscene. 'Stigmata' of lust and pain 'appear' and 'unfold' on the artists body. In *Post Heart Break Syndrome* (2002) blood red marks appear between the breast and the shoulder blades of her body; in *Sacred Heart* (2002–2003) a stain expands from in-between her breasts and runs down her abdomen and below; whilst in *Honey Pie* (2001) her pubic area is smothered in honey that runs down her thighs. The close-up photograph of the latter thus invokes the female form as a leaking body that is out of control through dis/ease and/or lust, being agent provocateur and/or victim. In a series of performances including the five-and-a-half-hour *Chocolate Performance* (2000), and the forty-five-minute *Chocolate Cake* (2000), she eats her way through a two-metre runway of chocolate, and, in the shortest time possible, through a sumptuously creamy chocolate cake respectively. The procedure leaves its traces all over her body and dress, covering her in the sticky brown mass (which in itself can be linked to femininity, sensuality and carnal desire) that, again, speaks of a lack of body discipline, of a weakness or absence of control of desire. The dynamics of obsession and overindulgence shifts quickly from a satisfaction of desire – heavily sexually charged (at this stage) – into pain, repulsion and expulsion. These actions are reminiscent of a set of Janine Antoni's performances from the early 1990s, in which the artist (b. 1964) sculpts massive 250-kilogramme cubes of chocolate and lard with her teeth, spitting out the 'chiselled' bites, which subsequently become 'artworks' in themselves.

The framework for such practice has been mapped out in the critical debates by the concept of Abject Art, highlighting food as polluting object and orality as boundary of the self's clean and proper body, and at the same time impinging on the latter.[4] In common usage, 'abject' implies the dejected and miserable, with connotations of humiliation and submission as well as notions of the contemptible, despicable and servile and even that what has been cast out. In popular culture, it runs through women's magazines, practices of dieting and body beautification treatment regimes such as colonic irrigation or liposuction. Ostentatiously, connections between abjection and the abject and obscenity can be made with regard to the public discussion or exhibition of these deeply private practices especially of women.

The term 'Abject Art' came to signify a specific area of body art and identity art. Its emergence as discursive term has been closely connected to the 'turn to the body' during the 1980s and 1990s in the West. It was fuelled by and in turned fuelled feminist, homosexual and post-colonialist concerns within a complex setting of diverse societal developments including the AIDS crisis, the end of the cold war, changes from an imperial to a global capitalism. Notions of 'abjection' have been applied to a range of different aesthetic articulations including some of the photographic work of Andres Serrano, Cindy Sherman, Joel-Peter Witkin and Jo Spence, the installations of Kiki Smith, Mark Quinn or the Chapman brothers, or paintings of Jenny Saville, and performance and video work by Paul McCarthy and Orlan, amongst many others. Those practices continue and expand, reconsider and appropriate aesthetic approaches that were developed earlier in the twentieth century with various intensities and emphases. The former merged performance practices with an activism that concerned identity and body matters in order to place on

the agenda subjective lived and embodied experience and to look at how society and culture have constructed the body.

These practices responded to perceptions of growing instability of personal, collective and national identities and a loss of ideological, social and cultural certainties in the last two decades of the past millennium. Any discussion of some of the influential art practices during this extended period must therefore engage with the term 'abjection' and its operations, and take into account the discursive settings in which it came to the fore and took a firm hold on/in the construction of art historical narratives, art critical debates, exhibition practices and, of course, as potent and ambiguous reference framework for a range of material practices (in the sense of fertiliser or 'backdrop').

What is abjection? The concept of abjection was developed by the French feminist thinker Julia Kristeva, in particular in her psychoanalytic text *Powers of Horror* (1980). Influenced by Georges Bataille, she sees the process of abjection as a crucial 'instrument' in the constitution and maintenance of 'Self', of subjecthood. She argues that becoming a subject is inextricably linked to a primary loss in early childhood. For the child to be aware of itself as a distinct entity, it has to recognise separation from the mother's body. This process occurs in what the French psychoanalyst Jacques Lacan has called the 'mirror stage'. Around the age of six months, a child begins to recognise its reflection in the mirror as its own mirror image and gradually identifies with it. This identification involves feelings of loss of the mother's body, repulsion and disgust, which are necessary for the child to constitute itself as subject, as a Self (I) that is clearly distinguished from 'Other' (you). With this ability, the child enters into the symbolic order of language. In it, it must maintain the stabile bodily boundaries that distinguish it from other subjects. Bodily excretions and intakes of food, drink, etc. cross those boundaries with the external world and potentially threaten the identification and intact limits of the subject. The abject in this complex process of incessant maintenance of self is something that must be excluded, it is neither object nor subject. Kristeva insists that

> refuse and corpses show me what I permanently thrust aside in order to live. These body fluids, this defilement, this shit, are what life withstands ... There, I am at the border of my condition as living being. My body extricates itself, as being alive from that border. Such wastes drop so that I might live, until from loss to loss, nothing remains in me and my entire body falls beyond the limit – cadre [to fall], cadaver.[5]

Kristeva emphasises that 'a lack of cleanliness or health' is not the cause of abjection 'but what disturbs identity, system, order [the law of the Father]. What does not respect borders, positions, rules. The in-between, the ambiguous, the composite.'[6] Ambiguity lies at the core of the abject as it is alien to the subject as constructed in and by the symbolic order, and expelled from it but at the same time intimate with it, having been produced by and in its own body. It traverses from the inside to the outside of its body: a constant reminder

of the exposure and fragility of the body's boundaries and also of the 'temporal passage between the maternal body (again the privileged realm of the abject) and the paternal law'.[7] As such, through expulsion and discharge, the 'not-me' is being constructed; yet abjection 'does not radically cut off the subject from what threatens it'.[8]

Judith Butler in her wide-ranging critique of Kristeva's conception of subject-formation, draws attention to the privileging of the maternal body as the prototype of what has to be abjected.[9] Thus, Kristeva works from the position of an essentialist cultural stereotyping, an innate link between the female sex and motherhood, and 'sanctioned heterosexuality'. Her premise 'fails to acknowledge its own fear of losing that sanction', that cultural legitimacy. 'Her reification of the paternal law not only repudiates female homosexuality, but denies the varied meanings and possibilities of motherhood as a cultural practice'.[10]

However, 'the abjection of self', the separation from the mother's body that generates the 'foundation of its being', is considered to be the fundamental experience of the subject. It drives home that all its objects are 'based merely on the inaugural *loss*' of being part of the mother. Unlike anything else, the 'abjection of self' demonstrates that abjection functions as the recognition of *'want'* on which any 'being, meaning, language or desire is founded'.[11] It is in this context that the knowledge of castration, i.e. the unconscious fear of having one's genitals removed as a punishment for the desire of having sex with a parent, which Freud saw as one of the basic psychic complexes, takes on its particular significance.

Expounding abjection's ambiguous position, Kristeva discusses its close connections to the sacred and perversion, amongst other concepts. With regard to the sacred, Kristeva claims that abjection forms part of all 'religious structurings' and surfaces in rituals concerning 'defilement and pollution' in paganism, and the exclusion of substances linked to food or sexuality, 'the execution of which coincides with the sacred ... The various means of purifying the abject – the various catharses – make up the history of religions, and end up with that catharsis per excellence called art, both on the far and on the near side of art'.[12]

Perversion is related to processes of corruption. The transgression of conventions, rules and prohibitions can only function and being perceived as such through a degree of complicity, of remaining within the framework of accepted law, morality or culture. In terms of art and the discussion of obscenity, that raises a number of crucial questions, which Hal Foster has lucidly asked in *The Return of the Real*:

> Can the abject be represented at all? If it is opposed to culture, can it be
> exposed *in* culture? If it is unconscious, can it be made conscious and remain
> abject? ... Can abject art ever escape an instrumental, indeed moralistic, use
> of the abject? (In a sense this is another part of the question: can there be an
> evocation of the obscene that is not pornographic?)[13]

Furthermore, Foster aptly points to the apparent ambiguities in Kristeva's use of the

concept of the abject in her 'slippage between the operation to abject and the condition of being abject'.[14] The former means to debase, 'to expel, to separate', whilst being abject entails to be revolting, nauseating, and as he argues, to be 'stuck, subject enough only to feel this subjecthood at risk', because by being abject the subject is incapable of abjection, 'and to be completely incapable of abjection is to be dead, which makes the corpse the ultimate (non)subject of abjection'.[15] While the 'operation of abjection' is seen to play such a crucial role in establishing and upholding subjecthood and – as part for the whole – the body social, that which has been abjected, the repulsive, is regarded as threat to those very 'formations'. And if, as Kristeva asserts, abjection functions similarly to corruption, i.e. it is linked to an acknowledgement of and participation in the structures of power and prohibition it seeks to transgress, can the abject then operate to disrupt or subvert those very structures?[16]

The differences between the process of abjection and being abject throw up further doubt about the appropriateness, in fact the possibility of the strategic category of 'Abject Art'. If art is taken as an act of sublimation, the term 'Abject Art' then places abjection and sublimation into proximity, if not equation. Yet the category in its various applications has evolved as a seemingly popular and omnipotent but equally woolly descriptor of critiquing, testing, provocation and resistance. Its use has been aimed at the rupture and/ or subversion of the existing social order, particularly during the period of the 'Culture Wars' in the USA of the 1980s and early 1990s.

The term 'culture wars' was coined to denote a period of intensified conflicts about values signified by education, family, religion, as well as art and politics. It is linked, amongst others, to heated debates about the National Endowment for the Arts (NEA) and the criteria for art supported by it. Propelled by conservative political forces, a number of lawsuits concerning the visual arts were instigated under the broad heading of obscenity. These included the controversial public display of works by Robert Mapplethorpe and Andres Serrano.

Serrano's work during that period has come, in the eyes of the critics, to exemplify 'Abject Art' par excellence, not just through *Piss Christ* (1989), in which he took compelling photographs of a small, ordinary crucifix immersed in his own urine. This apparently incredibly blasphemous act not only pronounces the 'flesh and spirit mystery' that underwrites Catholicism, but also brings to the fore the traditional function of art. Like God's sacrifice of Christ to redeem humankind, art has the task of rescuing and saving it too. Arthur Danto contends that the 'redemptive task of art is not to make ... surplus beauty, but to beautify what is initially as remote from beauty as the emissions of the flesh often are'.[17] The atmospheric *Piss Christ* cibachromes with their baroque tonality, their dramatics of illumination and sense of balanced composition come across as extremely aestheticised.

Yet it is precisely their artful character and fluid surface that highlight – to return to Kristeva's notion of the abject – the exclusion of a substance as a threatening yet definable otherness. This formal strategy offers means and ways of purifying the abject through art,

which serves as a kind of catharsis. By clouding and soiling the crucifix with bodily fluid, Serrano amplifies the logic of approved behaviour, the agreed rules, and thus seemingly self-explanatory, natural(ised) conventions on which the social and religious order is being founded. Simultaneously, his act attacks and defies this symbolic power structure.[18] As Georges Bataille pointed out, 'Transgression does not deny the taboo, but transcends and completes it.'[19] Serrano's *Ejaculate* series of the late 1980s early 1990s, in which he photographically captures his semen at the very moment of 'cum', when the stream of potency spurts out onto a trajectory, operates in an analogous way. At the same time it is saturated with allusions to male creativity and agency per se: the penis, the brush, the pen... they make marks, they signify.

As the process of abjection is initially intimately connected to the mirror-stage, to the entry into paternal law, based on the recognition of a distinct and whole entity in the reflection of the mirror (as opposed to the incoherence of the child's inability to master its own body), it has been situated within the dominant realm of visibility. The abject, the impure and dirty appears first and foremost as stain or a polluting object, as a contaminant on a pure, clean surface. Repulsion is established first and foremost through the sight of the stain/object, rather then its stench, tactile (or audible) qualities and taste. From that angle, notions of 'Abject Art' call into play the operations of the gaze, which shall be sketched out briefly in the following.

Notions of the gaze in its contemporary critical use are closely linked to Lacan's definition of the operations of the gaze within the framework of psychoanalysis. Central to this concept is that the gaze is taken to pre-exist the subject by the external world. The scopic drive is exemplified by Lacan in an account of the ancient tale of a competition between the Greek painters Zeuxis and Parrhasios, who sought to prove their superior talent and skill to each other and the world. Zeuxis painted grapes that deceived even the eyes of the birds. Parrhasios, however, painted a veil on a wall in such a way that Zeuxis felt compelled to ask to see what had been painted behind the veil.[20] With this story, Lacan illustrates the difference between the eye and the gaze, the split between perception and scopic drive. Whilst the eye is 'trapped by the visible', in that story, the gaze is deceived in relation to what may exist behind the curtain, the 'something other behind the surface appearance'[21] which has been screened off by the dominance of the geometrically organised vision. 'In our relation to things, insofar as this relation is constituted by the way of vision, and ordered in the figures of representation, something slips, passes, is transmitted, from stage to stage, and is always to some degree eluded in it – that is what we call the gaze.'[22] The artist 'sets up a dialogue' with what lies behind the picture, the gaze, the object, the real.[23] In other words, the gaze signifies the tension between representation and the real. The real constitutes that which cannot be translated into symbols – the unsayable that remains unconscious beyond even the most perfect illusion: 'the lost object', the visual order of the image, the framework of rules that forms the media interface and the codes that govern any representation operate as an (image) screen. The concept of the gaze stresses that one not only looks at others but that one is looked at from all sides at all

times, that the world around oneself is 'all-seeing'.[24] The gaze is neither embodied vision nor does it operate consciously, yet it manifests itself through the medium of sight and affects the body somatically. The gaze interferes with vision; it distracts it. By irritating the visual field and redirecting focused sight, the gaze destabilises what is being seen, it ruptures the conventions by which it is being seen.

The relationship between the eye and the gaze can be likened to the structure of *anamorphosis* as exemplified in Hans Holbein's famous painting *The Ambassdors* (1533). In his discussion of that work, Lacan challenges the prevalence of a subject-centred, geometrical perspective and the trust in its knowledge-generating power. He alerts us to the empirical fact that 'You never look at me from the place from which I see you.'[25] It is not just the subject that looks at the object; the object looks at the subject too. The image-screen 'mediate[s] the object-gaze for the subject, but it also protects the subject from this object-gaze.'[26] The force of the gaze is seized in the image and cultivated by the conventions of representation. People as meaning-making beings have access to this symbolic order. Their capacity to construct meaning, their attained cultural/visual literacy enables them to mediate, manipulate and control the gaze through the image-screen when producing and consuming pictures.

The unconscious gaze, located in the world and initially unembodied in the subject, is the 'desire of the Other'. The internal world of a person and their external world, individual perception and projection, personal identification and alienation, are bound up with each other not only in a reciprocal psycho-dynamic relationship, but in a social power relationship where class, gender, sex, race, ethnicity, age, ability and geography come into play. Art, within a psychoanalytic framework, can be considered as an act of completion, it 'becomes the other that is desired'.[27] Its aesthetic screen is the boundary where the obscene in its manifold disguises 'loiters' to seep, crack or erupt through it.

The desire of the Other, literally and metaphorically, provides the trope for Serrano's controversial photographic series *History of Sex* (1996). The highly staged, aestheticised and at the same time brutally candid series of cibachromes of bodily exchange pronounces the power of the flesh. By graphically displaying a wide array of sexual transactions and constellations the suit of images tears on the boundaries of normalised sexuality. In *Fisting*, for instance, the naturalised sites and modi for sexual penetration are transgressed. This practice of inserting a fist into the anus – and here it is a woman who does it to a man – runs contrary to the dominance of phallic invasion (of the female body). Working on the basis of extreme trust and patience, fisting produces complex bodily sensation in the person who is subject to such procedure, whilst it at the same time symbolically feminises the body that is subjected to the act. Fisting gives erotic signification to another orifice and thus 'reinscribes the boundaries of the body along new cultural lines'.[28] Such 'deviant' activity undercuts the need for 'fixed sites of corporeal permeability and impermeability' on which the 'construction of stable bodily contours' relies, as Judith Butler argues in her critique of Kristeva's concept of abjection. The spatial distinction of 'interior' and 'exterior' in relation to the body or the subject is established and maintained through a

disciplining cultural discourse and practices. Regimes of body hygiene, sex practices, and table manners for example, are based on differentiations between proper and improper, clean and dirty. Their mastery is mapped on the body and enforced through training from an early age, and 'for the purpose of social regulation':

> The boundary between the inner and the outer is confounded by those excremental passages in which the inner effectively becomes outer, and this excreting function becomes, as it were, the model by which other forms of identity-differentiation are accomplished. In effect, this is the mode by which Others become shit. For inner and outer worlds to remain utterly distinct, the entire surface of the body would have to achieve an impossible impermeability.[29]

Regarding 'non-standard' sexual practices as a kind of 'pollution', and legislating at least against their public display, in itself 'expresses a desire to keep the body intact'. It suggests that the

> naturalized notion of the body is itself a consequence of taboos that render that body discrete by virtue of its stable boundaries. Further, the rites of passage that govern various bodily orifices presuppose a heterosexual construction of gendered exchange, positions, and erotic possibilities. The deregulation of such exchanges accordingly disrupts the very boundaries that determine what it is to be a body at all.[30]

As the physical body in its conception corresponds to the body social, for the body social 'any kind of unregulated permeability constitutes a site of pollution and endangerment.'[31]

The American artist Jeff Koons (b. 1955), in his series *Made in Heaven* (1991), presents a pornographic display depicting himself having sex with his then-wife, former Italian porn model Cicciolina. They show the artist on top, in front and in physical control of his wife as the willing and pleasurable receiver. With their 'money shots' – the extreme close-up of sexual penetration from a central perspective, and the artist's ejaculation on his wife's face for instance – Koons's hardcore images exercise the genre's foundational submission of women in a way that seeks to further aggrandise the self-proclaimed 'most-written-about-artist-in the world' and to propel him into the Olympus of the male artist genius.[32] The silk-screen work in its sugary colouration was published uncensored by Taschen.

Koons and Serrano 'transplant' the usually mass-produced and cheap pornographic images into the expensive, 'sacred' realm of the large-scale, high-resolution and limited edition art photography. Where Serrano's provocative images are initially removed from their conventional sphere of circulation (the magazine shelves or the dark corners of book shops), and consumption (the private devouring and clandestine arousal), Koons's glossy publication seeks to expand the distribution radius and market segment of obscene

material into the traditional domain of the representative art book and its discerning, more often than not well-heeled, buyers. Moreover, their work accentuates the relationship between artist, model, image-taker and technical support team in different but relevant ways that resonate with the production set-up of the porn industry, yet outside the real complex mass production and exploitative economy of this sector.

However, many of the highly public and publicised pictures of Serrano's *History of Sex* are also saturated with strong connotative links to Catholic iconography. They range from the appearance of the cross to a recourse to the motif of 'Madonna and Child', as in *Fisting*. In the latter, there is a strong connection to the earlier photographic image *Heaven and Hell* (1984) that presents the figures of a nude, bleeding woman, whose arms are tied and raised upwards, with a cardinal to her right. Reading the image from left to right, the picture does not just spell out the conflict between the Christian belief that wo-man is made in the image of God, and is therefore sacred, and the Church's traditional view of the body as dirty and shameful. It reverses the traditional gendered and religiously affirmed power relations between women (here equated with heaven) and cleric (equated to hell). Where Serrano's 'base materialism' teases the 'sacred' of both the high aesthetic as well as the religious domain by pushing it towards the abyss of their respective 'Other', it embraces and affirms them at the same time: teasing is a sign of affection here.

The fears of the Other from a male perspective have been crystallised in Serrano's staged photograph of a vagina with teeth, the vagina that bites off and swallows the (erect and penetrating) penis. The vagina is the hidden orifice that castrates 'post-coitus'. Drawing on primal mythology and folklore, the female body, female sexuality is constructed as an untamed and uncanny site of danger and horror not least as it is hidden from sight, out of reach of the eyes as the privileged instrument for western (re)cognition, to grasp the world rationally. Serrano's *Vagina Dentata – Vagina with Teeth*, which is part of his sixteen-cibachrome series *The Interpretation of Dreams* (2001), gives a literal account of this treacherous locus. In profile view, it displays a female labia surrounded by a thick forest of pubic hair from which shark teeth threateningly spring out. Animal-like, it drastically shouts out 'cunt-hate' and 'womb-fear' and provides a masculinist rationale for the social control and disciplining of female sexuality. In conjunction with the series title, the photograph can be read in direct connection with both Sigmund Freud's expositions on the castration complex and Serrano's own fantasies. The hyper-real directness in which the subject matter is represented and the unapologetic confrontation with the paternalist foundations of the gaze leave the viewer alluringly speechless.

Sarah Lucas (b. 1962) has invested the exploration of common stereotypes of anatomic and gender identity with breathtakingly crude humour and panache. Drawing on vernacular, class-defined metaphors and revelling in popular stereotypes, particularly but not exclusively of womanhood, the British artist assembles laconic installations out of objects that are commonly taken to symbolise sexual body parts. In their arrangement, the art historical tradition of the still life is fused with visual puns that carry forth – slap-bang – naturalised notions of sexual identity. In *Au Naturel* (1994), *Two Fried Eggs and*

*a Kebab* (1992) or her series of photographic self-portraits from the 1990s including *Got a Salmon On #3* (1997) and *Chicken Knickers* (1997), the precarious status of woman's subjecthood in the dominant symbolic order of the Father is foregrounded in the way the female artist emulates masculine working-class gender stereotypes in her self-portraits, or exaggerates sexual standardisation and difference in her object ensembles. As the trivial materials and everyday objects employed preserve their initial use and meaning outside of the art context, her three-dimensional work does not facilitate the process of aesthetic sublimation. It yells and provokes.

*Zygotic Acceleration, Biogenetic, Desublimised, Libidinal Model* (1995), one of a number of similar spectacular works by British artists Jake and Dinos Chapman (b. 1960 and 1966 respectively), is concerned with human-human-hybrids. Not the fragmented but the plural body stands at the centre of their life-size sculptures: bodies fused together, and, most shockingly, with primary sexual organs put in (im)possible places. Mouth becomes anus, the nose is transformed into a penis. Bodies are turned upside down so that the mouth takes the place of the vagina. The new and/or additional sex organs defy any anatomical and psychoanalytical truths. The scene is even more grotesque as the figures are modelled on a female pubescent body type and located in the ostensible neutrality of adolescent innocence, if it were not for the tabooed openings of sexual channels. Trendy Nike trainers and fashionable hairstyles not only characterise them historically; these elements also emphasise the nudity and uniformity of the figures. They push the macabre ensemble even firmer into the realm of the strange and outrageous. However, this work is not just a sarcastic illustration of the anticipated threats of the Genome project, of the prospects of cloning and genetic aesthetics. Their multiple-bodied models throw into question the identity and integrity of the corporeal order, the uses of the body's links between inside and outside and the hygienic regimes 'allocated' to them. The indicated physical immaturity of the figure, which contradicts their pronounced and perverse sexualisation, conjures up references to paedophiliac practices. Wilfully transgressing the normative boundaries of 'good taste', the ensemble disturbs aggressively the spectator's somatic equilibrium.

The 'Disgust' works by Cindy Sherman (b. 1954) from the second half of the 1980s, though heavily mediated as two-dimensional glossy photographs, provoke a similar intense reaction in the viewer. In *Untitled #173* (1986), bloody fur, sweets and shiny fat flies sit on undulating, dark and rough(ened) soil. In the uppermost corner of the image, the upper part of a female body is horizontally placed, lying on its side facing the viewer. It is only just squeezed into the format, and recognisable only at a second glance. The body appears externally intact, yet whether it is alive or dead remains ambiguous. *Untitled #175* (1987) displays a mixture of vomit and decaying food stuff, a pair of sunglasses with the reflection of a female figure, who is located outside the picture framework, and yet inside through the 'mirror' image. In *Untitled #177* (1987) the well-rounded bottom of a woman surrounded by prickly holly-leaves and layers of the white soft cotton-lace of an underskirt stares the viewer in the face. The plumb skin is covered in what appears to be boils that are just to burst and release its pus in the direction of the spectator. The scene is overseen

by a woman's face that is situated in the dark of the right-hand corner of the pronounced landscape format. The unsettling image is framed and presented with its double. Yet where the woman's eyes are closed in the right-hand photograph, they are opened wide – monstrously – in the left-hand image. Through these extreme visual pointers, Sherman pronounces the workings of the gendered gaze and its relationship to the body and for the subject. Closely connected to the dynamics of the gaze, she also constructs an intense correlation between woman, the repulsive/abject, and the formless.[33]

Karl Rosenkranz in his *Ästhetik des Häßlichen* ('Aesthetics of the Ugly') (1853) already argues that revulsion is caused by a dissolution of form, which offends one's aesthetic sentiment.[34] Disgust and revulsion, for Rosenkranz, negate the beautiful form of an appearance through a 'no-form' (*Unform*), which originates in physical or moral decay/ decomposition (*Verwesung*).[35] From Kristeva's perspective, repulsion is also connected to the dissolution, but an emphasis is placed on the exposure of its boundaries and confounding ordering structure, and thus the instability of the latter:

> Filth is not a quality in itself, but applies only to what relates to a boundary and, more particularly represents the object jettisoned out of that boundary, its other side, a margin ... the danger of filth represents for the subject the risk to which the very symbolic order is permanently exposed, to the extent that it is a device of discriminations, of differences. But from where and from what does the threat issue? From ... the frailty of the symbolic order itself. A threat issued from the prohibitions that found the inner and outer borders in which and through which the speaking subject is constituted.[36]

and further:

> Excrement and its equivalents (decay, infection, disease, corpse, etc.) stand for the danger to identity that comes from without: The ego threatened by the non-ego, society threatened by its outside, life by death. Menstrual blood on the contrary stands in danger issuing from within the identity (social or sexual); it threatens the relationship with the maternal body.[37]

Whilst Rosenkranz operates with the corrosive effects of the no-form, or the formless in relation to beauty, Kristeva invests into the symbolic value of the polluting, expelled object. The distinction is crucial as it implies a fundamental difference between the formless and the abject. Such argument was forcefully put forward by Rosalind Krauss in reference to Georges Bataille's concept of *informé*. She maintains that the somatic effect of Sherman's 'Disgust' images is generated by the formlessness of the visual field. That is, the represented formless body leads to a dissolution or erosion of the image as 'the site of coherence, meaning, unity, Gestalt, *eidos*'.[38] By doing so, Krauss stresses that the abject and the *informé* mark two different sets of theoretical problems. Whilst

the abject is connected to certain states of physical being and materials that provoke repulsion and shock, the formless points to the level of representation, the dissolution, loss or absence of a recognisable and thus signifying 'gestalt', i.e. a perceptual pattern or structure that possesses the qualities of a whole. Thus the latter does not depend on the materials employed in the representation – a position that is not dissimilar to Rosenkranz's definition.

On the other hand, the materials on display in Sherman's images from the second part of the 1980s are emphasised in their abject-character because there is no form that could provide meaningful confirmation and comfort to the viewer. However, it is important to note that it is the *mise-en-scène* of the female body – displayed or invoked – on which the formless reigns, where its 'materiality' takes over the site. It is noteworthy that Kristeva stresses that in patriarchal social structures those pollutions, that is, impurity in general, are considered to come from the female body. In other words, the female body is seen as a threat to male power (subjecthood), signified through the phallus. Prohibitions and rituals of defilement (whether religious or secularised), which are inextricably linked to the clear separation of the sexes, aimed at keeping at bay woman, who is considered synonymous with the leaking female and especially the maternal body. Thus, the formless female materiality in Sherman's body sits in juxtaposition to the hegemonic form-giving, rational and spiritual power of men, of the patriarchal symbolic order.

Sherman's work perversely recombines images that feature prosthetic body parts, mainly of the sexualised body regions and their orifices including monstrous face masques. Some of these point quite directly to Bellmer's erotic-obsessive *Pouppés* (Dolles). These images map out, challenge and destabilise the conventionalised interior/exterior dichotomy of femininity. In the early 1990s, Sherman focused even more intensely on the reconstruction of female body configurations that are visibly skewed, incomplete and violated. Her prosthetic object in *Untitled #261* (1992) is laid out on sumptuous red silk, along the middle axis of the picture. Where the *mise-en-scène* there lures the viewer in, the unperfected body-entity disrupts the economy of the voyeuristic gaze. Sherman's representations problematise subjecthood based on the binary opposition between the seeing/looking subject and the looked-at object, as much as they show, as Laura Mulvey has persuasively argued, the other side of ideal femininity and of the affirmatively perpetuated constructions of this ideal through mass-reproduced and media images.[39]

This complex set of issues was also drawn on when, a decade later, the South Korean artist Lee Bul (b. 1964) exhibited an installation in the Tony Garnier Halles in Lyon that consisted of freshly caught fish and elaborate costume jewellery. In the summer heat, the fish quickly began to rot and to smell unbearably. The stench of putrefaction that soon filled the large venue overpowered all senses. The beautifying fashionable accessory, which demarcates the territory of idealised femininity, sank into the increasingly formless mess of the disintegrating fish, a smell and materiality that has commonly been aligned with the materiality of woman's body. As a contemporary extension of the seventeenth-century Dutch still-life-tradition, this ephemeral work sent a potent reminder that death is a messy

business and that art or any other symbolic order is under threat and becomes powerless in the face of death. As the horror of the formless and real reign, the Other that is woman conquers the scene.

The powerful threat of vast expanses of female flesh and of corporal formlessness pervades the paintings and photographs of British artist Jenny Saville (b. 1970). Her large-scale canvases of the 1990s concentrate on depictions of voluptuous female nudes individually or in groups. Her theme and her concentration on the tradition of figure painting invoke the classical standards of idealised femininity while, in for instance *Strategy* (1993–1994), *Hem* (1998–1999), and *Matrix* (1999), she breaks them at the same time. Her contorted bodyscapes reject the set of values that underwrite the classical aesthetic ideal rooted in the founding opposition between man and woman: mind/body; form/matter; art/obscenity; beauty/sublime.

Lynda Nead contends convincingly that 'art is defined as the conversion of matter into form.' In the Christian founding myth in which Eve was shaped out of Adam's rib to compensate Adam's 'own insufficiency' – hence the primary opposition between man and woman – Eve is given a supplementary function, 'secondary but threatening since her existence always testifies to the original lack in Adam, the primary term.' As woman has been associated with nature and physicality, art triumphs over the 'threat of the female flesh and the sensual' by transforming it into an ideal form. And thus, the female nude is not 'simply one subject among others' in western art, it is *the* subject, *the* form.'[40]

It crystallises the 'antagonism' between pure material nature and formed, elevated culture. In Saville's monumental nudes, the erupting flesh cannot be contained and disciplined by a defined, significant form. Instead, it cracks through the seams and pierces the boundaries of aesthetic representations to give a glimpse of the threatening netherworld of the obscene.

Whilst the fleshly nature of Saville's corporeal ensembles resonates in the materiality of the paint applied to the canvas, the distorted bodyscapes that she has produced in collaboration with fashion photographer Glen Luchford erase the materiality and form(ing) quality of a textured surface. In the series *Closed Contact* (1995–1996) (fig. 7), Saville

7. Jenny Saville and Glen Luchford, *Closed Contact #4* (1995-1996).

arranges her body on a glass screen and the photographic camera underneath it fixes the condensed, converging and submerging body folds, the out-of-shape *corpus delicti*. It blurs proportions and anatomic details, but crucially the flattening glass erodes confirmed

notions of corporeal space, of inside and outside. The glass screen seems to protect the viewer from the impending horror of an out-of-bounds, a formless and overwhelming, monstrous female body.[41]

The imperfect body and the formlessness of the podgy physique are commonly understood as sure signs of a lack of control and body discipline, a transgression of contemporary collective norms and the power relations they underscore. Ideally 'the lady vanishes', her body should not only be young and blooming, but also be thin, reduced to the anatomical minimum. It is regulated by a manipulative mesh of media discourse, commercial strategies and consumptive or psychic mechanisms that are woven and reinforced by the economic and ideological powers and cultural channels of fashion, cosmetics, health, and so on, industries.

There are pertinent links to the aesthetic representation of the diseased body that is deformed or incomplete, historically and culturally amplified by a thin-lipped puritan ethic (at least in some parts of the UK) that discards dwelling on one's aches and pains as naval-gazing and condemnable vanity. In such a climate, the photography of Jo Spence

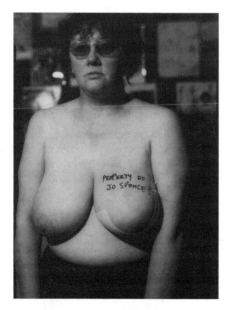

(1934–1992) from the 1980s must have seemed equally shocking, revelatory and revolutionary in and beyond the art domain. Drawing on her experience as a commercial photographer, she begun to explore the power of this imaging technology for the construction and maintenance of gendered and class identities in and beyond art. How she sees herself and how she thinks others perceive her and the complicit role of photographic representation in this complex identification is analysed visually and textually in her early work such as *Family Album* (1979). Here she employs photography as a powerful means to produce reality through the staging of self, reflecting and deconstructing the effect of the photograph on identity-constructions.

The emphasis of Spence's work began to shift when she was diagnosed with breast cancer in 1982. Autobiographical in its direct points of reference, her image-making moved towards a pronounced

8. Jo Spence, *Self-Portrait* (1982), from *Cancer Series* (1982-1984).

therapeutic and didactic approach beginning with her *Cancer-Series* (1982–1984) (fig. 8). Photography takes the function of an instrument with which she sought to articulate the illness and its complex effects on the sufferer. Even more crucially, it served as an active

reflection on institutionalised medicine and the objectification of the patient, especially the female patient, through practices of looking, examination and representation. Her images, particularly those in which she is baring her cancerous and, over time, surgically treated breast(s) and changing anatomy, articulate her own dis-ease with the condition. The difference between the self-projections of a normal or idealised body and the reflection of a corporal identity 'contaminated' by illness, produces images of an Other. The trauma of such experience becomes palpable in the frequent return to the site of the disturbed physical identity, a recurrent photographic capturing of the own, yet other(ed.), body. The representation of the diseased, mutilated and deformed body per se can be considered obscene as well as in proximity to the abject. Obscenity applies in terms of the subject matter as well as with regard to the insertion of extremely intimate details of a devastating illness into the public discourse at a time and in a social climate where cancer in particular was considered unmentionable, privately and even more so publicly. The discomfort and disease of the individual body has long been associated with disorders of the body social.

Situated between art and traditional medical and scientific representations, Spence's work corresponds to notions of the monstrous, and specifically the monstrously feminine. Invoking conventions of medial images of visual symptoms of illness or abnormality in patients highlights the observational powers of the healthy (and usually male) physician's gaze against the void of the patient's counter-projection. In medical photographs, the patient's eyes or face were traditional covered over, the object of scientific interest was kept anonymous and cleansed of key markers of individuality and subjectivity.[42]

The French artist Orlan (b. 1947) has challenged the standards of contemporary ideal femininity by undergoing a series of cosmetic surgeries to reconstruct her face based on a montage of disparate features taken from a number of different female figures in canonical works of art. In *The Reincarnation of Saint Orlan,* her 'conceptual performance project' since 1990, she seeks to attain with the help of the scalpel, skin and bone transplants

the nose of a famous, unattributed School of Fontainebleau sculpture of
Diana, the mouth of Boucher's Europa, the forehead of Leonardo's Mona Lisa,
the chin of Botticelli's venus and the eyes of Gerome's Psyche.[43]

Guided by a computer-generated image in which those alien features are superimposed on Orlan's portrait, the surgeons perform their skill to video camera in an almost carnivalesque set-up. They are surrounded by dancers and music, props and text, supervised by the patient, Orlan. In order to fulfil her role as 'art director', so to speak, the invasive procedures take place under local anaesthetics only. The documentation of the operation (and post-operation recovery), including stills, videos and vials of the material removed from her body are publicly exhibited in galleries and sold. What was in the 1990s still considered a rather private corporeal manipulation by which predominantly women sought to conform to normative beauty, media-promoted gendered roles and socially imposed expectation is brought out on the media screen by Orlan. In her critique of cosmetic surgery as a 'tool

of patriarchal domination through standardization' from within this field of practice, she throws into question those naturalised aesthetic rules as much as the role of (media) representation in engraining those standards into the collective psyche.

At the same time, Orlan's feminist-motivated self-work (*Eigenarbeit*) is to some extent complicit in affirming those norms in the 'operative' refashioning of her face through the form-giving powers of the surgeon, even though her heterogeneous face fails to reach the imposed balanced standards.[44] The obscene comes into play here in transgressing the public-private boundary through the spectacularisation of the body intervention, as much as through the bloody mess that spills over the face in the process of its re-forming, and the temporal disturbance of inside and outside of the body, of the visually significant order, during the procedure.

The discursive fields of art and science intersect in the situating and mediation of Orlan's post-human body art in an analogous way to the self-portrait by Marc Quinn (b. 1964) through which he came to public attention in the context of the London-centred young British artists' hype. *Self* (1991) consists of a head of human blood, his own blood, extracted over a period of time and poured into a silicon mould of his head until the form was filled. To tame the liquid material and achieve a defined form with some sort of permanence that allowed the mould to be removed, the blood needed to be frozen and has to be kept congealed at all times. Therefore the head is placed on a stylish rectangular refrigerating unit that doubles as a plinth: a mixture between minimalist and space-age object. It exploits a pseudo-scientific attitude of experimentation and display married to proven shock tactics. Despite an obvious milking of the well-worn cliché of 'no pain, no gain', the 'sculpted' head fascinates and repels at the same time.

The ingenuity of the work and its aesthetic character – as it self-consciously draws on and yet exceeds the traditional conventions for a portrait bust – beguiles. Repulsion sets in when the material aspect of the work is taken in fully. The sculpted head, rough and rugged, as a nature-mort made from the life-juice of its creator, encompasses life and death. More than Quinn's *Shit Head* (1997), a self portrait made of the artist's excrements, it signifies our own mortality. Both self-portraits, like a number of other works from the 1990s centred on Quinn's own body or skin, symbolically play with the boundaries and integrity of self and the continuous threats to it. The 'disciplining' of the blood into a solid form fully depends on the operation of the refrigerating unit. The formless shit had to be marshalled into shape too, like in Piero Manzoni's 1961 action, where he poured his own faeces into tins (in an edition of nine), labelling them accordingly. It is the signifying power of the male artists by which a meaningful form, an idea is created. Without external force to impose a significant order on the visceral, the heads slip back into an amorphous mess, into excess – notions of the abject and the informé abound. Beneath the surface of his base materialist busts lurks a gendered Other once again.

Quite a number of contemporary artists have employed abject material in the production of visual work, as agent with which to make highly charged marks. Jan Fabre (b. 1958) for instance has repeatedly used his own blood in series of symbolic drawings including

*Ball from my Blood* (1982) and *On ne s'habitue pas à l'art* (2001). The Belgian, for whom drawing constitutes the primary mode of artistic research and the most direct form of expression within a field of practice that spans from sculpture to dance, installation to theatre, applies blood as well as other bodily secretions such as urine and sperm like 'draftsman's ink' as in the compilation of drawings *The Fountain of the World* (1979). The choice of bodily discharge for the act of drawing determines its connotations. These may range from a 'correlation' between drawing and masturbation. There, the role of art as a form of sublimating 'savage impulses' with all its contradictory and debatable implications is highlighted, via affirmative allusions to the clichéd potency of the male creator, to the link between the intensity of suffering on part of the artist and the quality of his work, referencing the romanticist model of art. In any case, by keeping subject matter, style and format of the representation firmly within the convention of art, the transgressive moment on part of the materials employed contributes, perhaps paradoxically. to the 'elevation' of the work beyond the frivolous into the realm of the aesthetic. The same can be said for Keith Boadwee's mark-making actions since 1995. In them, he squirts pigmented paint from his anus onto pristine white canvases or uses his vomit to 'paint'. Yet, since the American artist's 'excretion' streams are non-phallic, unlike the drip-paintings by Abstract Expressionist Jackson Pollock, the association of masculinity with signification is being complicated.

Via Lewandowsky (b. 1963) found in his own urine a significant material to execute *Eight Portraits on Eugenics* (1989). In this series of works, he seeks to uncover those ideological concepts that underscored the construction of a stable East German identity, namely a working-class-defined, sanitised, and intrinsically anti-fascist history. The body takes centre-stage in this group of works, as in his preceding commitment to performance. For six years from the mid 1980s, he was member of the East German Autoperforationsartisten (Auto-Perforation-Artists), a group of art school graduates, who used their own bodies, their biographies and their lived experiences as the primary material for their art and situated their provocative interventions deliberately outside the (already broadened and watered-down) framework of the prevailing Socialist Realist art model. In ritualistic body actions with (at least for this specific context and time) a high shock value, they absorbed themselves in orgiastic, often self-harming carnal actions, live and/or to camera. The group generated those form of self-expression as a deliberate attack against the norms of State art. They sought to illustrate their uncompromisingly disillusioned view of life in a disciplinarian, closed and paralysed society. Their performance work was developed in response to political stagnation and the loss of social utopia.[45] It was a manoeuvre to relieve their emotional pressures, a shock strategy that posed as tangible revolt against the generation of their parents, who had sought harmony and kept quiet in an oppressive situation that led to a splitting of their personalities, a splitting-off of emotions on a collective level. The ongoing contradictions between official claims and everyday experience – constantly reinforced by the hegemonic appropriation and instrumentalisation of the rationalist meta-narrative of Marxism/Leninism – could still be

perceived on a rational level, but the emotional domain would no longer be able to operate as a corrective that allowed for the negotiation and handling of the experience of a social environment in crisis.[46] Such repression leads to the loss of an emotional relationship with one's own body and with the world at large. It has detrimental effects on the structure of self, in that those who have been affected remain dependent on paternalist authority and suffer a lack of self-determination. Beneath the surface of orgy and taboo-breaking, the actions of the Autoperforationsartisten had little in common with the Catholic expending of carnal energies of the Vienna actionists of the 1960s. The rituals of Lewandowsky and Co were intrinsically Protestant in their love-hate-relationship, as the writer Durs Grünbein rightly notes.[47] They had to cause physical injury to themselves to establish order, and at the same time reflected with amazement the comic nature of their own existential situation. They ruptured the silent agreement of the sub-cultural, dissident scene in East Germany, insisting that there was an alternative socialist model to be achieved from within the existing system. Coinciding with the demise of the regime, the Autoperforation artist group dissolved and their members pursued their own careers as artists.

In *Eight Portraits on Eugenics*, images of an 'Other' appear too. This time they are measured, scarred and mutilated bodies produced as symbols for social relations that have been maintained through discipline and surveillance, through penal and repressive systems that keep mind and body under control, individually and collectively.[48] The title invokes the eugenics actions of the Nazi-regime, yet opens up an associative avenue towards a 'posttraumatic statement' on the conditions of a country by then in demise. The predominantly graphic series has evolved from the artist's concept of 'Reproductive Painting', a method through which he has increasingly sought to reduce all traces of a 'personal style' as a means to bring to mind the effects of a totalitarian society on their members. He 'recycles' illustrations from First Aid and science textbooks of the 1920s and 1930s, and enlarges and transposes them onto the canvases. Contours and shadings of eight 'normal' men of various ages and constitutions, who are subject to ambivalent external interventions that vacillate between First Aid and 'corrective' or torturous interventions, are traced onto the canvas. From the top of the canvas, over the black figural structures, urine is poured, staining the image surface to different degrees, screen-like, in an act of defilement.

The defilement of the pristine paper, the pollution of the canvas moves Lewandowsky's work, in some respects not unlike Serrano's, into an ambivalent proximity to the operations of the sacred, and its rituals. Similar to a wide range of other practices within the field of 'Abject Art', his work nurtures a calculated didactic and gendered intention in the space between the aesthetic/obscene and the moral/corrupt.

The performance practices of London-based artist Franko B (b. 1960), and North American artist Ron Athey (b. 1961) are heavily infused with religious rituals, imagery and atmosphere that have their origins in Christian mythology and its cult(s). Self-sacrifice (through bloodletting for instance) and 'religious mortification' are recurrent themes in their work. By acting as surrogate Christ – Franco B, *I miss you* (2000) – or Christian

martyrs – Athey, *Martyrs and Saints* (1992) – they situate their visceral actions where contemporary institutionalised religion has failed, reconnecting ritual and feeling. They test their own physical and emotional limits, the limits of art and what is bearable for the audience. Cutting, stitching and piercing excessively through their skin, bandaging, vein tapping, and (part-)impairing their bodies, both artists inflict extreme physical agony on themselves. Their acute suffering may produce cathartic effects in the spectators and could be considered as impulses for social healing or even redemption.

Such intense physical sensations are not only able to supersede profound psychological pain but may turn into ecstatic pleasure. Exploring the dynamics between pain and pleasure within the framework of ritualistic performance and a proclivity for masochistic practices, both artists attempt to devise an alternative to the gratification of desire based on privileged heterosexual penetration. This is a crucial aspect insofar as they are openly homosexual. Athey is also infected with the AIDS virus, which gives his operations with his own bodily fluids an extra, political and shocking, edge. Following the traits of the 1970s activist premise that the personal is political, their theatrical and performance stagings find their continuation in the tattooing and piercing of their own bodies. Bold and large-scale symbolic figurations increasingly cover their skin, thus transforming their appearance. The ornamentation of their bodies re-inscribes them at the margins of cultural conventions and social regulation. It is noteworthy here that the tattoo around Athey's anus refers to Georges Bataille's anti-bourgeois, transgressive and ecstatic carnival of consumption in *The Solar Anus* (1931).

> The erotic revolutionary and volcanic deflagrations antagonize the heavens.
> As in the case of violent love, they take place beyond the constraints of
> fecundity. In opposition to celestial fertility there are terrestrial disasters,
> the image of terrestrial love without condition, erection without escape and
> without rule, scandal, and terror. Love then screams in my own throat; I
> am the Jesuve, the filthy parody of the torrid and blinding sun. ... The solar
> annulus is the intact anus of her body at eighteen years to which nothing
> sufficiently blinding can be compared except the sun, even though the anus is
> night.[49]

Tattooing, piercing and incisions disrupt notions of fixed im/permeability of the body and interconnected concepts of masculine identity, at least to some degree. They may also extend the 'surface area of erogenous zones'. Although painful initially, such body embellishments may also increase sensual pleasure and open up other forms of sexual expression beyond a fixation on the phallus (and penetration).[50]

However, initiating and enduring seemingly unnecessary and extreme acts of intentional self-harm, do not amount to – or are not acknowledged or accepted as – acts of sacrifice and martyrdom to redeem human kind. Their 'investment' in personal suffering and torment as aesthetic strategy seems to have no immediate and tangible outcomes

for society, and thus could be considered 'obscene'. Franco B's and Ron Athey's highly symbolic performances place trust in the sublimating power of art and its role to reflect and maintain cultural and social order. Yet, they push it to the point where that power fails. Instead the apparent absurdity of human existence, the eruptive forces of being and the hell that is to come, emerge from beneath the surface of their ritualistic engagement. Such insight overwhelms and potentially challenges established meanings.

# Chapter 4

# Violent Images

## Aesthetic Simulations

... in an attempt to understand these girl's I'm filming their deaths. With Torri and Tiffany I use a Minox LX ultra-miniature camera that takes 9.5mmfilm, has a 15 mmf/3.5 lens, an exposure meter and a built-in neutral density filter and sits on a tripod. I've put a CD of the Travelling Wilburys into a portable CD player ...

I start by skinning Torri a little, making incisions with a steak knife and ripping bits of flesh from her legs and stomach ... I keep spraying Torri with Mace and try to cut off her fingers with nail scissors and finally pour acid onto her belly and genitalia, but none of this comes close to killing her, so I resort to stabbing her in the throat and eventually the blade of the knife breaks off in what's left of her neck, stuck on bone, and I stop. While Tiffany watches, finally I saw the entire head off ... I take my cock, purple with stiffness, and lowering Torri's head to my lap I push it into her bloodied mouth and start fucking it, until I come and explode in it ... then I'm sitting in a chair, naked, covered with blood, watching HBO on Owen's TV, drinking a Corona, complaining out loud, wondering why Owen doesn't have Cinemax.
*Bret Easton Ellis[1]*

The New York publishing house Simon and Schuster, who had commissioned Brett Easton Ellis' novel *American Psycho*, refused to print it after women's groups protested against the manuscript. Given the extremely graphic depiction of immensely degrading and horrifyingly brutish violence of the sexual Other and women in particular, such reaction was perhaps not surprising. The manuscript was then taken on by Vintage Books and 'published with much fanfare' in 1991.[2] Attracting the attention of literary critics, being the subject of devoted discussion groups on the Internet, and made into a film, Ellis' work of fiction was embraced by the cultural industry and establishment, and controversially received by the wider public.

The story is narrated in the first person from the perspective of Pat Batman, who is a stockbroker by day. In its description of lifestyle with scant references to historical circumstance, it is firmly anchored in the American metropolitan 'yuppie' world of the late 1980s. The senselessness of the killings and the matter-of-fact style that marks their telling, some with more laconism than others, outrages. The deliberate proximity between material consumption – the entire story is littered with references to branded (luxury) lifestyle products as an ostentatious form of cultural coding – and sex and violence does even more so. And the open misogynist and homophobic attitudes perturb too. The unconstrained relief of psychic tension, the selfish satisfaction of (perverse) desires are not just depicted as banality; here life returns to normal with the same boredom and repetition of shopping and socialising after each murderous event – but in a form of overstated specularisation that, as it 'infiltrates' the domain of 'high' culture, becomes acutely present.

*American Psycho* appears paradigmatic for an intensified specularisation and spectacularisation of violence in the late 1980s and beyond. Quentin Tarantino's cult films *Reservoir Dog* (1992) and *Pulp Fiction* (1994) are both marked by a similar more-real-than-real approach to the depiction of extreme violence. They were joined by a number of other Hollywood films in which more or less sophisticated and equally perfidious transgressions of secular and religiously motivated prohibitions of excess, violence and murder took centre stage. Amongst these are Jonathan Demme's *The Silence of the Lambs* (1991), David Cronenberg's *Crash* (1996) – based on J. G. Ballard's 1973 novel – and David Fincher's *Se7en* (1997).

Whilst the unfathomable degradation, orgiastic torture and perverse butchery that leads to the climax of sexual arousal in Ellis' novel may be reminiscent of the Marquis de Sade's work, the ideology from which both depictions of sexually stirred carnage have sprung is quite different. De Sade (1740–1814), who had opened literature to libertarian, deviant and depraving sexuality in an unprecedented way in works such as *The 120 Days of Sodom* (1785), rejected reason as an ordering force. The continuity of reason is ruptured by outbreaks of violence (and other forms of surplus energy). In opposition to the Enlightenment ideals of his time, he refuses to judge vice and virtue morally but considers them merely as different forms of human relationships. For de Sade, the libertarian ideals emerged from his conception of 'absolute and sovereign liberty' of a self-centred, solitary individual, of an existence 'freed from all limits'. It is a romanticist concept in which the satisfaction of one's own desires excludes any considerations for the pain and suffering such individual (sensual) pleasures may cause others.[3] However, its conception marks out a 'utopian' if not critical dimension, which is missing completely in Ellis' work, where the violence stares blankly into the face of the reader.

That the representation of violence cannot be separated from the violence of representation has been demonstrated vividly by Peter Greenaway in many of his films, as they ponder not only birth, sex and death, but also the connection between aggression and sexuality. Besides *The Cook, The Thief, His Wife and Her Lover* (1988), his film *The Baby of Macon* (1993) is especially pertinent in terms of the discussion of violence,

voyeurism and the ambiguously obscene. There, at the end of the film, the viewer joins the witnessing of the multiple rape of a virgin. The rape itself is not directly visualised. It is 'evidenced' before the eyes of the spectators inside and outside the film by the pretext, the victim's scream of desperation, pain and humiliation, by the shadow play of bodies behind the curtains of the four-poster bed, and the reactions in the faces of the audience in the film. Each violation is announced, counted and symbolised in a twofold way: by piercing a white sheet of paper over a dagger, accumulating one by one, and by the felling of a monumental dildo on what looks like an expanded chessboard. The fusion of defloration and symbolic castration – amongst other significant formal devises – points to the explanatory framework of the symbolic order based on the concepts of psychic drive economy and sexual difference.

Ostensibly the concluding part of a miracle play set in the seventeenth century, illusion and reality converge into a heavily symbolically charged tale that explores contemporary taboos with its culmination in the excessive rape scene. Greenaway demonstrates in a scandalizing yet equally engrossing and affective way how, in a representation of violence that is directed at the senses – the visual sense through the tradition and conventions of painting, which set the scene, direct lighting and camera eye; the audible sense through the eruption of embodied screams, intonated lyrics and artful oration – the senses become complicit in the act of violence. The film revels in the synthesis, in the mounting lack of distinction between reality and representation. In that, this film is truly contemporary. At the same time it marks up an intense tension between religious devotion and ethical communal obligations, between innocence and guilt. It uncovers and contests in its exuberant film aesthetics, literal excessiveness and lucid ideational contention, the double standards of bourgeois society and the role and complicity of art in that.

The representation of violence as a diversion of raw, excessive force in signs and images is by no means a new phenomenon. The cave paintings of prehistoric man in Altamira and Lascaux are evidence of how humans have sought to comprehend the brutality of their existence, to mediate, literally and virtually, sex, death and blood sacrifice.[4] Violence, in its manifold forms, it has been argued, is not just de-structive but also con-structive. To structure, to create and maintain order force is necessary.

The German philosopher Walter Benjamin claims in *Critique of Violence* (1921) that 'underlying the normative order was a legally sanctioned violence.' He detects its origins in myth.'[5] How much violence pervades human experience, and how it has been perceived as intrinsically intertwined with sex and death, becomes already obvious in the construction of the founding myth of European culture. In the antique Greek rendering of this myth, Eros, violence and cultural codings have been intricately interwoven and mutually abraded.[6] Uranos (Sky), the Greek ur-god, descends to Gaea (Earth), his wife, for a sexual embrace. The copulation does not take place because Kronos, ordered by his mother Gaea, takes his sickle and cuts off Uranos's penis. Gaea had initiated this dismembering as a punishment for Uranos's heavy-handed response to the uprising against him by the Titans – some of his and Gaea's children's. Kronos throws the amputated penis away into the world. From

the drops of blood that fall onto the Earth, Erinys, goddesses of revenge, grow, whilst from the foam that is created by the severed penis on the surface of the sea, Aphrodite, the goddess of beauty and love, evolves.[7]

Benjamin distinguishes between 'divine' or 'sovereign' violence and violence that is 'mythical in origin and legislative in form'.[8] He accepts and justifies divine violence as an expiatory, universally transformative and yet totally illegible force, arguing:

> If mythical violence is lawmaking, divine violence is law-destroying; if the former sets boundaries, the latter boundlessly destroys them; if mythical violence brings at once guilt and retribution, divine power only expiates; if the former threatens, the latter strikes, if the former is bloody, the latter is lethal without spilling blood. ... Mythical violence is bloody power over mere life for its own sake; divine violence is pure power over all life for the sake of living. The first demands sacrifice, the second accepts it.[9]

Not only does Benjamin ascertain divine violence as a 'cleansing', a 'liberating' and creative force, he frames it as a foundational part of modern patriarchal society, as a divine power that is directed at a universal progress of and beyond man. This spiritually imbued force resides outside of what can be represented, outside of the symbolic. The tension of this conception, as the American historian Martin Jay contends convincingly, lies between religion and morality. A religiously motivated justification of violence goes necessarily along with a (temporary) 'suspension of the ethical' *Thou shall not kill*, for instance, in the (arguable) religiously motivated service for the greater good. The invasion of Iraq exemplifies this dilemma.

However, violence should perhaps be regarded as a *mixtum compositum* of many causes and influences or, as Friedrich Hacker, the Austrian-American psychiatrist and researcher on aggression, has suggested, as a 'problem that poses as its solution'.[10]

Since the Greek philosopher Aristotle, the channelling of raw energies into socially and culturally accepted representational forms and formats has been considered an effective instrument of spiritual cleansing. Catharsis, the freeing of the mind and soul from latent aggressions and violent desires, Aristotle argues, could be achieved through the (aesthetic) experience of violent, of intensely fierce images. Sigmund Freud, the Austrian founder of psychoanalysis, has developed the view that repression, internalisation and sublimation of drives are part of the civilisation process. Literature, art, film, music and other creative expressions have the capacity to sublimate urges. In Antonin Artaud's *Theatre of Cruelty*, for instance, art becomes valid only as the manifestation of a destructive will.

Communities and societies have created rules, prohibitions and taboos to safeguard the emotional and social equilibrium of vital energies and through them the stability of society. The German sociologist Norbert Elias, taking recourse to Freud's sublimation thesis, beliefs that real violence decreases in the cause of civilisation through its mediated negotiation in cultural manifestations and forms including art.[11]

Two catastrophic world wars and repeated genocides during the last century throw the notion of progressive 'mastery' of human drives through and in culture into doubt. This suggests, that either the civilising 'emotional and social equilibrium' is extremely fragile, or that wo-mankind has left its progressive trajectory. Such conception of human progress is certainly more a projection that underwrites the exclusive premise on which modern western society's identity as a civilised, a refined and advanced or advancing 'organism' has been founded. Such identity includes legally and ethically regulated scopes for discharge of excess energy, sports contests, like body building, or rock concerts and the cinema. Theses regulated outlets are established and maintained in dynamic tensions against the Other, the primitive, 'raw' body social (and individual).

On the other hand, the argument that living out affective impulses and releasing violent energies in the realm of the imagination levels and dispels psychic (and social) tensions in reality has been increasingly opposed during the twentieth century. The growing rejection of this idea has been nourished by a fear that violent images do not sublimate those destructive energies but that they provoke and rekindle forbidden lust, gruesome fantasies and perverse anxieties. It is in this context of moral corruption (set against historical and cultural notions of emotional and social norm/ality) that obscenity as a complex and fluid category is situated, and legally, aesthetically and ethically framed by the respective historically and culturally, socially and politically defined censorship laws.

Georges Bataille has pointed to the fact that prohibition and transgression are of the same order and caught up in a vivid interplay. He has also articulated persuasively his doubts, and was taken up on that by Lacan and others, with regard to the power of the imaginary to 'reflect and tame' destructive urges. Neither images nor signs are able to fully 'suspend' the expenditure of violent energies. Such urges cannot be completely absorbed by the imaginary. A residue of desire is always left that returns 'traumatically or, phantasmagorically or hallucinatory' and creates an emotional predicament that leads to substitute actions. Bataille sees the erotic, war, sacrifice and potlatch, i.e. ceremonial gifting and feasting among certain Native American people, as areas in modern society in which such energies can and are being released.[12]

Jake and Dinos Chapman's work has consistently been concerned with the depiction of violence and with violation. On the surface, it could be contended that the artists continue the shock tactics of the early twentieth-century avant-garde appropriated to a situation of mediatisation through television, film and print media, and an over-saturation of images, which has also been described as a 'war of images'. Such a position implies that an even greater effort has to be made in the production of images to 'stick-out from the crowd'. Images that once were noticeable or even notorious have by now receded to the 'background' of the visual tradition. But it is precisely this background tradition that has conditioned the contemporary ways of seeing in the first place. Both the representation and the simulation of violence have exploded during the past decades. The development of global media, the expansion of the cultural industry and the 'spreading' of the Internet, have not only created new outlets for the discharge of excess energy in, for instance, video

and computer games, in chat rooms or web logs, they have also changed the perceptive and emotional threshold in the experience of such manifestations.

The Chapman brothers deliberately want to offend, distress and scandalize, and have developed a range of effective tactics that have been supported by the mediation network: the system of galleries and collectors, art critics and print and broadcast media. The Chapman's have, so far, remained en vogue with the telematic embrace of sex, violence and death.

Their series *Horrors of War* (1998–1999) draws directly on Francisco Goya's graphic cycle of the same title. In the Chapman version, scenes of horrific violence have been translated into sculptural arrangements in a variety of scales: from tableaux to life size. Slaughtered men, butchered bodies, severed limps and heads hang from torched trees in a desolate surround. Yet even at life size the arrangement fails to impress or move. Rather, the display appears like a construction or toy model kit gone over the top. It looks like 'atrocities in Barbie-land'.

In *Things to Come* (1999–2004) or *Arbeit McFries* (2004) (fig. 9), the London-based duo displays members of the infamous *Waffen SS* – Hitler's heavily armed *Schutzstaffel* (special forces) feared for its brutality – engaged in massacres. Whilst in the former

9. Jake and Dinos Chapman, *Arbeit McFries* (2001).

work the gruesome scene spills out from inside a dilapidated wooden building that vacillates between an old mill and concentration camp vernacular, in the latter, the architectural setting appears as a hybrid between a wrecked mill building from the heydays of industrial capitalism, Greek temple front and contemporary shop premises conversion. This historically and culturally ambiguous fusion of a production premises and site for consumption is further provocatively defined through the McDonald's trademark. Instead of fast food, however, the *mise-en-scène* is littered with dying men, corpses, skeletons – a scene from hell, a hell that has been created from the symbolic convergence of 'insignias' of totalitarianism and global capital(ism), the automated, institutional fast death. Whilst in its graphic details these scenes of carnage may topically move close to what some have termed the 'negative sublime' – the unspeakably terrorising (rather then horrifying) and traumatic – size matters. Their small scale keeps them firmly within the realm of toy (tin) soldiers and entertaining violence. They feel closer to the simulated orgies of violence that occupy part of contemporary popular culture ranging from cartoons to splatter movies, from the standard diet of physical aggression amplified by the required speed of reaction in computer and video games – as in *kill. switch*, (Playstation 2, 2004). Although located outside of the realm of popular culture, the promotion of ideologically motivated bloodshed on the Internet as for instance in the

al-Qaeda recent propaganda videos taps into this paradigm of (lost) sensibility. It is an imagination that is constantly fuelled by media images of carnage, genocide and other unbearable atrocities committed more often than not in the name of freedom and justice – values that are supposed to be the pillars of western democracy.

The 'maggot and bone' scenarios of the Chapman brothers relate to the gory opulent and depictions of the battlefields of civilisation, the martyrdom and doomsday in the history of painting and sculpture as exemplified by the *Laocoon Group* (*c.*50 BC), or the fierce battle between the Gods and the Giants in the *Pergamon Fries* (201–180 BC), by Titian's painting *The Flaying of Marysas* (1771–1776) as much as by the torment of hell in Hieronymus Bosch's earlier triptych *The Garden of Earthly Delights* (1500), the doomed in the *Last Judgement* (1535–1541) by Michelangelo, or the scenes of carnage, specifically the *Massacre of the Innocents* (1621) so vividly imagined by Peter Paul Rubens. Later, Auguste Rodin forms scenes of terror in his *Gates of Hell* (1880–1917). They all draw with different degrees of detail and 'realism 'on literary precedents such as Ovid's depiction of the flaying of Marysas in his *Metamorphoses* or the depictions of inferno and purgatory in Dante Alighieri's *Divine Comedy* (1320).

In 2001, Jake and Dinos Chapman purchased one of the four remaining sets of the *Disasters of War* prints by Francisco Goya, made between 1810 and 1820. This set of eighty black and white print graphics was produced by the Goya Foundation in 1937 from the artist's original plates.[13] On the depiction of the horrors of war, of human suffering and 'the insanity of conflict', the Chapman brothers 'superimposed' coloured cartoon faces. Visages of clowns and puppets appear on figures that allegorise human misery and torment. The artists' provocative in(ter)vention into one of the key works of the high art canon has been met with outrage and incredulity. It was seen as 'meaningless' desecration, as vandalism, as obscene. Not just the act of insertion but what had been added to Goya's emblematic depiction offended.

The ostentatiously 'juvenile' 'embellishing' of Goya's figures of sheer agony and anguish with Mickey Mouse ears, grotesque clown masks, staring alien skulls or gargoyle heads in conjunction with highly charged, controversial political symbols such as the cross and the swastika denotes a deliberate slip in register and style. The obscenity of this 'contamination', its morally corrupt(ing), excessive gesture fires on all 'fronts': at the purely aesthetic boundaries by using a formal language that originates within the (supposedly) lesser arts and the popular imagination, and by marking up those very figures that function as sublimators of violence and aggression; at the ethical frontier through the desecration of a revered masterpiece; at the cultural and economic edge, by the waste(ing) of labour and the destruction of the – though fluctuating – commodity value of the 'original' print suite.

However, against all these charges it could be said, even at the risk of sounding somewhat sanctimonious, that the Chapmans' manipulation, literally and metaphorically, has repositioned Goya's work 'on-scene' – rather then 'off-scene' – of wider contemporary culture supported by the book publication, media reports and art criticism in and beyond

the context of the Turner Prize competition in 2003, at which the work was shown. In order to explain how this 'becoming on-scene' has functioned in this and other cases, it is necessary to return to the initial claim that the Chapman brothers' work (and their artistic personas) gained visibility through its offensiveness. The Russian art theorist Boris Grois has argued that visibility per se, as a fundamental condition of art, has not primarily to do with the issue of novelty as a condition of visibility that allows the image to surface from the masses of (art historical) images, or

> the subject of innovation ... The question that needs to be asked is, how something shows itself as new? Such a question moves the emphasis from a modern(ist) aesthetics in which God, nature, history, life, the subjectivity of the artist, the unconscious, the absolute Other, the desire or language itself – depending on the different aesthetic theories practiced since Kant – reveal themselves as new within the unexpected beyond all familiar images.[14]

In such a constellation, he insists, the 'authentic new' is equated with the real. 'Innovation functions as a transition from the phenomenon to the essence or from the external convention [by which a work is generated] to the inner truth,'[15] which resides in it and is communicated through it. Such operation is based on the production and maintenance of difference, the difference between the 'authentic new' and the conventional(ised) in a work of art, which escapes the conscious control of the artist as much as it is situated beyond the mere visual technology employed or the processes of making. Yet at the same time such authenticity is always threatened by the inauthentic insofar as any innovation is not just revelation but concealment too, a 'concealment of the origins' of the new. Whilst the impossibility of a return to the roots may be thematised by postmodern art, and whilst the conventions that govern the artwork are uncovered (not as a 'truth beyond the conventions' but as the 'truths *of* the conventions at work') – the artwork remains caught within the modernist tradition of authenticity. Authenticity means distinct originality, singularity and exclusivity of the artwork, which in turn provides the foundation for its exceptional commodity value.[16] In considering the Chapmans' work, attention has to be directed at the ways in which their 'innovation' has been made present, that is conceptually and technically visible. As gesture, their inscriptions on the original prints resemble the graffiti in urban centres. Yet the Chapmans' insertions of art-external signs and symbols into Goya's prints suspend the agreed rules that govern the constitution and reception of original artworks. Their gesture violates and destroys the masterpiece and yet for its effect it wholly depends on the recognition and status of the *Disasters of War* series in western history of art and in the cultural marketplace.

It is worth stressing, however, that – unlike the graffiti artists whose sprayed self-affirming gestures decorate and thus symbolically appropriate public and private buildings, means of transport, bridges, hoardings and the like – the Chapman brothers had purchased the body of work in the first place. Therefore, their gesture foregrounds a contestation

between cultural and financial capital, private property and public interest that cuts to the core of the contemporary capitalist commodity circuits and their permeation of all areas of culture. The invalidation of Goya's work is (at least temporarily) superseded by the commodity value that the defaced suite of prints has achieved through the inscription of the 'signature practice' of the Chapman brothers. As notorious representatives of the 1990s young British artists, their work has been promoted intensively by the omnipotent British collector Charles Saatchi and by Jay Joplin's influential White Cube gallery in London. This includes effective mediation through what could be appropriately called 'expectation management'.

Finally, although postmodern art stances have been fostered and endorsed by an understanding of 'anything goes', Chapmans' intervention demonstrates the relativity and limitations of 'anything'. Anything goes in the art world, as long as it allows for the distinction between the 'new' artwork and the background of the art tradition. This relation of difference, the 'visibility' of the novel, lends the transgression of taboos its shocking effect, not the transgression itself. However, the internal area of (high) art has been increasingly pervaded by its external contexts. In other words, the modernist notion of an autonomous, self-referential and auto-telic art – an art whose aims (telos) are defined by itself and from within rather than externally dictated – has been completely eroded by the 'invasion' of the external reality and its objects. Therefore it has become ever more difficult to maintain an effective distinction between the aesthetic and the non-aesthetic, which results in severe consequences for the operations of the obscene as the 'Other' of art.[17]

The British artist Grayson Perry (b. 1960) plays out the idea of 'food for the eye' or 'eye candy' in an almost perverse way in his craft of throwing ceramic vessels. In their restraint forming and yet functional proportioning these vessels approximate the classical ideal of measured beauty. The lustre of the exquisite glazing lures the gaze, holds its attention until eventually the eyes pull away from the decorative opulence, pierce through and 'penetrate' the shiny surface to discover rich drawings of scenes and text fragments that vividly oppose the attractive and delicate. In recent work his subject matter has spanned from paedophilia and child abuse in the home – We've Found the Body of Your Child (2000) – to latent violence, as in I was an Angry Working Class Man (2001), and Dolls at Dungeness (11 September 2001). The themes are often autobiographically informed. His familiarity with regionally accentuated masculine stereotypes in which the iconography of drink culture and the mastery of automotive power and intimidating 'pets' (the English pit bull terrier) plays a crucial part.[18] In Dolls at Dungeness, a direct response to the attacks on the New York Twin Towers and the media frenzy surrounding their immediate aftermath, he shows toys in the role of 'bigots and aggressors', whilst air planes hover over them.[19] The subversion of the ceramic art through the decor, its infiltration into the context of high art not least through the chosen themes and their formal realisation resound in the 2003 Turner Prize winner's earlier work, especially in Cycle of Violence, a series of drawings, published in its first edition in 1992 and republished in a larger format and an increased

print run in 2002 by Atlas Press. In this, Perry takes recourse to his drawing of comic strip adventures, a practice that he first established during puberty, then as a negotiation of burgeoning sexuality, dysfunctional, abusive family relations and (gender, generational and class) identity. According to the artist, faced by fatherhood himself, old wounds opened that led him to re-engage with the graphic genre and with a set of issues similar to those in 1992.[20] The visual and textual language employed is wilfully crude. Strong bodily gestures expressed through firm contours and illustratively-reduced interior lines, and explained and enforced through rudimentary speech bubbles, crystallise the kernel of the human exchange depicted: power relations driven by sexual desire, aggression and abuse. This graphic work could be seen to verge more forcefully towards the invisible boundary of the obscenity argument due to a greater congruence between subject matter, and the register and style in which it is realised.

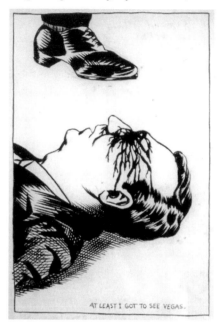

10. Raymond Pettibon, *No Title (At Least I)* (1983).

Raymond Pettibon's prolific practice of drawing moves fluently between the language of the comic strip, the illustration and the caricature. It is resonant of the cacophony of the American vernacular, whether in the spoken word or the visual and material environment: a fluid mixture of different styles and slants married to a widespread desire for easygoing, entertaining communication dominated by the citation, the fragment (*Versatzstück*), the elision, the pun.

Pettibon (b. 1957) has the gift of the (provoking) gab. Literally, this has been demonstrated in the record cover for *Minutemen – Bean Spill* (released in 1982), where, on the B-side of the single, poignantly the anus beneath a graphically displayed male penal erection coincides with the middle hole of the vinyl – wilful and cheap sexual denotations abound. The inscription on the vinyl reads: 'fucking drawing on the label ... is a rank on fucking record companies'.[21] Poignantly, the cover illustrates the punk rock musical piece *If Reagan Plays Disco*: sexual provocation meets a gesture of political resistance.

Pettibon recruits his fluid and heterogeneous array of signs from the rich vocabulary of American urban popular imagination, the literary 'canon' and the omnipresent images of a mediated reality across different cultural hierarchies. His accessible drawings, many of them published in and as part of magazines since 1978, vacillate between a dense

accumulation of text and images that join together into concentrated parodic narratives, and a reduced, laconic form that gets straight to the point. Within the framework of the sensational and spectacular that makes up much of the North American cultural sensibility, Pettibon has distilled those symbolic and at times anecdotal moments in which the trajectories and violence of corrupt(ing) power and its victims unfold along class and gendered lines, and confront the viewer with an intense presence. Although formally and gesturally saturated by sub-cultural currents such as imageries of the Beatniks or the Hippies, his drawings unstitch almost didactically many of their social and cultural ideals and illusions by displacing their signs and symbols in shifted contexts – visually and textually. With politically charged 'nihilism and blasphemy', post-industrial urban normality and human 'transactions' have been reduced in his pictures to their smallest common denominators: sex, violence, and death.[22] And that is the level on which the obscene in his often thought-provoking work operates: the explicit motifs and the 'uninhibited' at times crass representation of excessive, libidinal energies as forms of social and political commentary (fig. 10).

Many of Pettibon's drawings appeal because of their childlike directness, roughness and playfulness, although the latter may turn easily into the sinister. The imageries of Keith Haring (1958–1990) have been nourished by a similar approach. Inspired by his experience of metropolitan life in New York since the late 1970s and his encounter with graffiti, hip hop music and a vibrant dance culture, the American artist developed an idiosyncratic synthesis of disparate languages and registers. Intimately familiar with vibrant clashes and enmeshings of high and low culture, of the ancient and the modern, he employs a strong and flowing illustrative contour line to generate plain, simple and lively imageries. His murals, canvases and prints pose as juvenile exclamations that exuberantly celebrate sexuality – in an entirely literal phallocentric manner – and, at times, release aggressively intense anger and anxiety. For instance, he draws a UFO-cum-giant vagina that hovers over a crowd of men in the Egyptian desert who hold their erect penises in both expectation and fear; or he outlines sperms as devils that leave the missile-penis to forcefully penetrate the female egg in *Untitled* (1988). The potential offensiveness of the explicit and violent themes of his artifices from the 1980s is 'calmed' and partly disarmed through the deliberate puerile and humorous approach to their formal mediation. This is underscored by his stylistic affinities to 1960s American Pop Art à la Andy Warhol and Roy Lichtenstein.

American artists Paul McCarthy (b. 1945) and Mike Kelley (b. 1954) have developed a sustained interest in the depiction of violence in their individual and collaborative visual practice as a complex and layered means to scrutinise and uncover repression mechanisms and how these operate on an individual and collective level.

In McCarthy's work in particular, outbursts of violence are often connected to childhood imaginations, anxieties and icons. His *Contemporary Cure All* (1978), for instance, is a visceral performance to camera and live audience that employs a doll, mask and dildos. It is worth recounting the exemplary performance here in all its details by taking recourse to

a succinct description in a recent catalogue of his video retrospective:

> A rubber mask full of meat is placed on a pillow. Under the pillow is the head of a real man, his naked body is seen lying on a white-draped table ... The artist, in white shorts and black stocking mask, rubs his arms in ketchup ... and imparts instructions to the others [four participating actors]. He fixes a latex penis with adhesive tape into the figure's crotch. He takes ketchup from a big bucket and spreads it on the figure's mask and dildo ... He fixes a piece of black hose to his own right thigh. He moves a black latex penis, first along the supine figure's leg and then over the entire body. Instructed to do so, one of the others follows suit. A long-legged, naked doll is placed into the crook of the figure's arm. ... The artist crouches over the figure on the table, touches his head against the mask and puts a black dildo into an opening in it. He runs his hand over the figure, underneath him and pours ketchup onto the latex penis in the figure's crotch. He cuts up and removes the dildo and stuffs it into the mask. A third artificial penis is cut up, until only one ring remains at the base. Fixed into the figure's crotch and surrounded with black imitation hair, the ring resembles a vagina. The figure's legs are drawn up and stroked with dolls, which are then laid next to the head. The figure's crotch is dusted with flour and rubbed with yet another dildo.
>
> The artist removes the figure's mask and hacks it up at the foot of the couch with an axe. The meat inside spreads over the white sheet.
>
> The artist pummels the couch with his fists and gesticulates with the black latex penis, which reappears when the mask is removed. ... Alternately the artist strikes the mask and the dildo onto the table. He holds the dildo towards the camera, dips it into a bucket of ketchup and hacks it up with the other things at the foot of the couch.
>
> In the sequel, he performs a ritual dance, striking his head repeatedly against the supine figure's thigh. He clasps them and presses them against his head. One of the others present strokes the figure's trunk. Finally, an actor blows into a curved pipe in the direction of the supine figure's crotch.[23]

Against American middle-class illusions of an ideal world, their 'common-sense' and enforced 'countenance', McCarthy sets his eruptions of frantic violence, slapstick-like actions, and unregulated effusions of body fluids: blood, urine, ejaculate, shit, saliva. The latter are often symbolised through ketchup (for blood), mayonnaise (sperm), chocolate sauce (excrements). The links to notion of abjection, Bataille's *informé* and base materialism, in McCarthy's work are by no means arbitrary. 'Dirty sex' and anarchic violent frenzy are

placed in opposition to restraint and discipline as social norms, as guarantors of stabile identities. The latter are shown as corruptions of body and soul. In particular, McCarthy seeks to dismantle the authoritarian myths of the white Anglo-Saxon Protestants, and those of all patriarchal-puritanically contaminated societies, which became particularly pertinent during the 1980s Culture wars in the USA.[24] The palpable connections between the heroic male artist-genius that took centre-stage in American Abstract Expressionism, for instance, and the repetitive and destructive actions of a self-centred, semi-infantile artist in *Painter* (1995), are equally deliberate. Instead of sublimating the raw body and cultivating the senses through art, McCarthy ruptures the polite veil of art's operations towards a refined emotional and social balance in society. He spells out art's complicity in social conditioning and repression. Whilst McCarthy patently demonstrates that the recurrence of repressed desires and anxieties incites feelings of uneasiness, his work does not openly propose a political or social alternative.

In *Fresh Acconci* (1994), Paul McCarthy and Mike Kelley collaboratively 'rework' performances to video camera by Vito Acconci from the early 1970s. In those black and white videos Acconci, having his eyes covered or ears closed and, at times, including other people in the enactment, deals with intense sense perceptions. In McCarthy's and Kelley's coloured video version of Acconci's works *Claim, Contacts, Focal Point* and *Prying* are repeatedly restaged in a representative domestic interior between alternating groupings of four female and two male performers.[25] Here the seductiveness of sensual desire in proximity to psychic fears and physical aggression are played out in uninhibited interactions.

During the 1990s, McCarthy takes on a number of favourite childhood figures such as *Heidi* (1991), *Pinocchio* (1994) and *Santa Claus* – complete with reindeers and elves – (1996–1997). In contrast to Mike Kelley, who looks at gender-specific forms of child play and early childhood repression, Paul McCarthy performances to the camera deconstruct and demythify the ideal and romantic world that was for instance projected in Johanna Spyri's popular *Heidi* tale more than a hundred years ago and handed down to generations of children in a universalised and de-historicised fashion.

Mike Kelley has created a range of strangely morphed polychromatic soft toys and puppets often with multiple interwoven bodies, limps and openings, like *Estral Star* (1989), which he calls 'socialist ready-mades'. Where his figurations serve as 'ideological models, soft and unopposed, the way parents desire their children, even for the price of repression',[26] McCarthy attacks through obsessive activity, violent excess and sexual orgy the symbolic structures and regulatory regimes of hygiene, body and emotional discipline: not per se but in the way they serve as instruments of repression of the drama of human existence and passions, and the belief that such repression is beneficial for the 'human condition', and marks the progress of civilisation.

McCarthy and Kelley's accentuated concentration on the psychical reality summoned up by the specific material ensembles and their vibrant evocation of childhood experiences operates in conscious proximity to the uncanny. In fact, Kelley's intense interest in the un-canny resulted in a personal collection of material, photographs and objects, that invoke

such 'quality of feeling' and led to an exhibition of his private archive enriched by examples of works by, for example, Robert Gober, Kiki Smith, Mark Quinn, and Paul McCarthy that operate on this level.[27] Astonishing in this accumulation of material are the ostensible interconnections between the uncanny and the obscene that warrant a closer look at the relation of both terms to each other. Yet, the collection also demonstrates that not every object that invokes the uncanny has to be necessarily cast as obscene or vice versa.

In his discussion of the uncanny, Sigmund Freud insists that it belongs to the aesthetic sphere, where it describes a 'quality of feeling'. It is related 'to what is frightening – to what arouses dread and horror'.[28] As Freud points out, the German *unheimlich*, of which 'uncanny' has become the most congruent English translation, resides ambivalently in the etymological field of tension between *heimlich* and *heimlig: Unheimlich*, in German, carries with it an ambivalent double connotation where the sinister and frightening also conjures up – albeit in its negated form through 'un' – the cosy, homely and familiar. Moreover, *heimlich* exhibits one meaning 'which is identical with its opposite "*unheimlich*". Inherent in both terms is a notion of the secretive, of something that should have remained hidden and obscure. What is *heimlich* thus comes to be *unheimlich*'.[29] Here, lies a first tentative connection to the obscene: the coming to the surface of something that should have remained screened off. This surfacing is framed by a tension between the unconscious-conscious, and the private-public.

Freud, in his patriarchal mapping of the territory of the uncanny, foregrounds the term's rootedness within the complex libidinal economy and the resulting psychic complexes of the individual. He calls particular attention to two issues here: castration fear, symbolised in literature by the violent severance of vital body parts such as limbs or hands, and the link between the penis and the eye. The castration complex in men is placed by Freud in proximity to another most uncanny idea: the thought of 'being buried alive by mistake'. Whilst castration is terrorising as it threatens men's wholeness and identity by woman as Other, being accidentally buried is linked to 'a certain lasciviousness', that results in the transformation of another fantasy: that of 'intra-uterine existence', i.e. to be in a woman's womb.[30] The latter anxiety builds a telling correlation between penis and eye and connects castration fear with the fear of loosing one's eyesight in childhood. Here a correspondence opens up to Lacan, and the key role of the scopic drive in the formation of subjecthood and the anchoring of 'Self' in sexual difference. Other processes include the return of the repressed and its proximity to traumatic experience in the uncanny; regression, ego-disturbance, narcissism, doubling, death instinct, the omnipresence of thought, and wish-fulfilment.

The uncanny, as Freud has demonstrated, evolves from the work of the imagination that has been triggered off by a certain situation and/or object.[31] The uncanny challenges clear-cut, stable subject-object-relationships, when, at a basic level, for instance it cannot be established with certainty whether a (represented) object is inanimate/dead or animate/alive as Freud's cited examples of the doll Olympia in E. T. A. Hoffmann's *The Sand-Man* shows. The effects of the uncanny are, in Freud's account, primarily achieved through

literary production, but Kelley has shown convincingly that the visual constitutes an at least similarly fertile soil. Paul McCarthy's *The Garden Dead Man* (1992-1994), or Maurizio Cattelan's infamous *Untitled* (2004), where he hung three life-size real-looking dummies of children with ropes around their necks from a tree in a public square in Milan, as well as the sight of corpses, human body casts and waxworks provide fitting examples. In its use the term has been firmly anchored within the traditional domain of the aesthetic. The uncanny leans towards the 'negative' pole of the aesthetic force field, towards the fright, repulsion and distress, rather then beauty, attraction and the sublime.[32] In other words, it is questionable whether something that appears uncanny could also be experienced as sublime. The uncanny and the sublime are linked to different levels of emotional intensity.

However, the uncanny temporarily shakes and corrodes the psychically regulated equilibrium of the experiencing subject. That 'agony of frightened joyfulness', functions as one (amongst others) measurement of psychic movement in the aesthetic experience. Such measurement depends not only on the personal, social and cultural co-ordinates of the viewer. It relates to the context (situatedness) of the experienced object and how the object 'performs' in this situation. In other words, the uncanny and the obscene possess some similar traits particularly in terms of the work of the imagination, the social conditioning, the internalisation of aesthetic standards and the subjectivity of perception and experience. Both definitions are also 'bound up' in complex psychoanalytical processes and related to the economy of human drives. Yet, they differ fundamentally in their cultural situatedness and thus in their 'operative scope': the uncanny describes a 'quality of feeling' within the boundaries of the aesthetic, and the obscene is located as the 'Other' of the aesthetic, as a corrupting force that threatens the humanising function of art. The uncanny and the obscene are marked by different intensities of emotional response: the uncanny is subtle, sneaky, rather latent and ambivalent, while the obscene is framed as a direct onslaught. It issues a full blow, a 'corrupting' shock, it poses unambiguously. Both terms 'afford' different dynamics in the relationship between subject and object. And, finally, the tension between the aesthetic and the psychic are foregrounded in the uncanny, and the latter plays a role in literature and art as a seismographic indicator for the 'existential orientation' of the body social. However, it is the relationship between the aesthetic and the ethic that dominates notions of the obscene in traditional aesthetics, and that has been taken as a gauge for the socially and culturally refracted moral state of society at large.

Horror that evolves from an overlay of the gruesome and the uncanny is made potent in a series of photographs by Ukrainian artist Sergey Bratkov (b. 1960). *Bed Time Stories* (1998) is based on the reported cruelties committed to children by mass murderer Andrej Chikaliko. These atrocities captivated the imagination of the people in his native country and beyond for some time during the late 1990s. Yet in Bratkov's visual version the stories are reversed. The children take the place of the perpetrator. Each of the ten photographed re-enactments is accompanied by a nursery rhyme-like piece of poetry that sketches laconically, and not without humour, the horrifying deed. The carefully constructed

pictures are drastic and grotesque: a blood-splattered row of children on a tram track, an electrocuted woman, a hanged man. Another image shows four young pioneers having afternoon tea. In their midst, the adult pioneer leader is leaning against the back wall with a bullet in his head. The 'blood' splattered on the white wall reverberates the tone of colour of the traditional scarf worn by pioneers, i.e. the members of the communist youth organisation. What horrifies is the banality and triteness of the scenes, even more so when they are displayed in the dimly lit, white-tiled washroom of a former orphanage in the former East Germany.[33] In this institutional(ised) environment, the uncanny and the obscene conjoin, and provoke a roller coaster of feelings in which the familiar becomes utterly destabilised and turns into distress, causes anxiety, revolts. Bratkov's macabre lens-based stagings can be read as double-edged social commentary on a relentlessly brutal and banal everyday reality, and on the inherent voyeurism in a mediated world.

Mat Collishaw's infamous 'Bullet Hole' (1988–1993) (fig. 11) consists of an extremely enlarged photograph of the wound left by a bullet in a person's head. The transparency is spread across fifteen individually framed light boxes. The overall picture centres on the injuring 'insertion' of the projectile into the skull. It does not give sight of anything

11. Mat Collishaw, *Bullet Hole* (1988-1993).

else except for some of the victim's hair around the wound. Looked at from a short distance, it resembles more an abstract pictorial structure with a red centre that carries strong erotic connotations, rather than communicating what it really 'portrays'. The pronounced formal aestheticisation of the illuminated image, based on enlargement, fragmentation and 'grid structure', contradicts the subject that has been brought to bear there: the death of a person, who – in all probability – has been the victim of a violent offence. None of the circumstances of this incident and of those involved are explicated. The formal 'beauty' of the image holds the horror of the occurrence at bay. It shuts out feelings of terror, at least initially.

The images of victims of war, genocide, terrorism and starvation, of fatalities in road, rail and air accidents, of natural and man-made catastrophes, victims of murder, manslaughter and suicide flicker daily over the TV screen or stare at the reader from the grainy title pages of the broadsheets and tabloids. Recent mainstream films such as Oliver Stone's *Alexander* revel in the visual details/fantasies of theatricalised exuberant violence, slaughter and suffering – thanks to the skills and efforts of make-up artists, special effects teams and digital manipulation specialists. In this respect Hollywood mainstream has long converged with the popular genre of the splatter movie (a discussion of this genre lies

beyond the scope of this book). It could be argued that such dramatised graphic depictions of bloodshed, human torment and exitus are by far not as unsettling and effective as those images that operate with an 'absent' death through the power of elision and the effects of suggestion.

Andy Warhol's controversial grainy screen-print of the *Big Electric Chair* (1971) (fig. 12) operates with an 'absent' yet nevertheless intensely charged death. The solemn, under-stated picture, which was based on a pho-tograph of an empty electric chair in the notorious American high-security prison Sing Sing, has been printed in disconcert-ing colours varying between orange, yel-low and pink. It is part of his series 'Death in America', in which he explores the phe-nomenon based on everyday media reports on lethal violence.

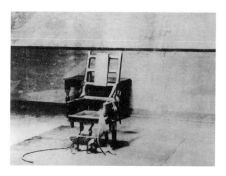

12. Andy Warhol, *Big Electric Chair* (1967).

Hal Foster discusses the *Electric Chair* image as an example par excellence of 'traumatic realism'. He uses the concept of 'traumatic realism' in order to redeem Warhol's work from a mere auto-referential, shallow existence in simulacral readings (the reproduction of reproductions of reproductions of images), where the work becomes totally integrated into the 'political economy of the commodity sign' and loses its subversive aspect. (This is an argument that has been advanced more generally by French philosopher Jean Baudrillard amongst others.)[34] He also opposes an exclusively referential position vis-à-vis Pop Art, with which Warhol's images have become synonymous, that 'tie[s] the work to different themes: the worlds of fashion, celebrity, gay culture, the Warhol Factory, and so on'.[35] Whilst Warhol is seen by some critics as the passive, self-interested art manipulator; other commentators distil an engaged, empathetic subject that points a finger at the sores of American society. With the concept of traumatic realism, Hal Foster proposes a reading that converges the simulacral – the second-handedness of experience – and the referential.[36] He asserts that 'notions of shocked subjectivity and compulsive repetition reposition the role of repetition in the Warholian persona and images'.[37] The compulsion to repeat, to recall after its occurrence the distressing event over and again, as Freud and Lacan have developed, forms a key aspect of trauma. Through repetition, rather than working through it, the traumatic object/event is drained of its significance, and the subject defends itself against the object's/event's effect in an attempt to restore the psychic as well as the symbolic order.[38] That effect of repetition can be observed in the constant replay of horrifying images of carnage and death that enter our living rooms day by day through the media – ceaseless replay of the images of 9/11 comes to mind here. Drawing on Lacan's understanding of trauma as a 'missed encounter with the real', Foster argues that Warhol's *Electric Chair* and other images do not just reproduce but produce traumatic effects:[39]

As missed, the real cannot be represented; it can only be repeated, indeed it must be repeated ... repetition is not production ... repetition in Warhol is not reproduction in the sense of representation (of a referent) or simulation (of a pure image, a detached signifier). Rather, repetition serves to screen the real understood as traumatic. But this very need also points to the real, and at this point the real *ruptures* the screen of repetition. It is a structure less in the world than in the subject – between the perception and the consciousness of a subject *touched* by an image.[40]

Foster locates this rupturing element (the 'punctum') less in the content of Warhol's images than in the changes that occur in the mechanical repetition of them. The 'pops' such as 'a slipping of register or a washing in colour, serve as visual equivalents of our missed encounters with the real'.[41] Echoing Lacan's characterisation of repetition as something that happens 'as if by chance', the variations in Warhol's grainy images of the *Electric Chair* appear accidental, automatic, caused by the variables of the screen-printing process. Ghost-like, the chair seeps gradually to the surface of the colour 'pixels' impressed on the paper through the image screen, like the real punctuating the image screen.

More then twenty years after Warhol's *Death in America* series, American Lucinda Devlin (b. 1947) photographed a variety of modern means of executing the death penalty in the USA. *The Omega Suites* (2001) brings to view gas chamber, injection table, gallows and electric chair. The sterile and highly functional places of institutionalised death are captured in highly aestheticised images: set in the centre of the format, well lit, perfectly composed and attractively 'coloured'.[42] The beauty of the glossy representation belies the horror of the situation. The latter hits home only at second glance. As those empty, 'peaceful' and seemingly banal locations bring to view neither the people who are killed there nor the executioners with their respective individual histories, it is left to the viewer's imagination to fill in this void. This applies to Warhol's screen-prints too. And both works connect death with technology – the killing machines, those automatically finished-off lives. And they permit those who have ordered the killing (as legitimate punishment) a distanced, even indifferent relationship to the event. In that, both their works point insistently to two interrelated aspects: (a) the state-approved execution of people in the name of justice, and the final act of discipline(ing) punishment, and (b) to the lack of a public discourse on this issue. Yet in its seemingly arbitrary and harsh colouring Warhol's *Electric Chair* image appears more obscene and shocking than Devlin's calculated camera shoots.

The ambivalent and highly charged interrelationship between the 'representation of violence and the violence of representation',[43] characterises a number of Jeff Wall's photographic investigations of symbols of modern life, in which he explores violence and death.[44] Inspired by his knowledge of (western) art history, the Canadian artist (b. 1946) devises his large-scale photographic images to the last detail, employing actors and meticulously setting up scenarios. The images are photographically captured, sometimes assembled and undergo digital post-production.

*Insomnia* (1994) shows a man on grey carpet tiles. He lies under a table in a basically furnished and coldly lit domestic kitchen interior. The location parades normality on almost all levels: a disconcerting normality. And yet a latent anxiety creeps in, though its source is difficult to locate at first. The neon tube lighting, with its reflection in the dark kitchen window between two raised kitchen cupboards, sits to the right of the picture's vertical middle axis. It places weight on the diagonally positioned, half shaded body. Is the man dead or asleep? Will he rise any minute or has any life already been drained from him? Why does he appear to be alone and without help, and yet the subject of a photograph? Is the photograph authentic or a fake? Aided by the photograph's title, the scenario oozes ambiguity. Any trace of movement and (e)motion has been removed from the scene through the laborious, calculated photographic process that is typical for most of Wall's work. It supports those undercurrents that conjure up awkwardness and the uncanny.

In the earlier *Dead Troops Talk* (1992), Wall realises 'A Vision After an Ambush of a Red Army Patrol Near Moquor, Afghanistan, Winter 1986', as the subtitle reads. Small groups of soldiers rest in a barren stony ditch. Most of them appear injured with traces of 'blood' and/or caught in distorted body poses. Some of these battle-stricken men face each other and seem to engage in conversation, other look as though they continue fighting for their lives or against others, and three of the fourteen fighters look dead. The work's subject has been inspired by the tradition of documentary photography and in particular war photography while, in compositional terms, the picture invokes the nineteenth-century painting of a Francisco Goya, Edouard Manet and Ilya Repin, heavily inflected by the realist tradition. At first glance, the scene appears utterly unspectacular. The picture's complexity and strangeness only comes to the fore during a more intense encounter. The ambiguity of the work rests on several uncertainties. These include the tension between the temporality that is suggested by the sepia-like colouring of the image versus the date given in the subtitle – the heavy battle gear of the combatants further confuses the photographs' historical belonging. It also oscillates between photographic conventions, which champion the depiction of the factual and particular, and painting, with its generic predilection for the typical and the symbolic. The figures' gestures and facial expressions too, carry forward the title's contradiction between inanimate death and live performance in an unsettling, uncanny way. The set-up of the photograph at first confirms and then profoundly subverts expectations that have been built around war photography.

Wall's works irritate in that the photographic realism, on which the medium's claim to authenticity has rested for too long, is being accentuated in a way that turns it into the thoroughly calculated artificiality of photographic art.[45] The work becomes more real than real, more visible than visible, truer than true. Not violence and death as motifs, but the lingering loss of distance, the loss of illusion, or in other words, the heightened transparency, push Wall's stagings close to the realm of the obscene, in the way Baudrillard has described it (see Chapter 9).

Within the context of heterogeneous photographic approaches in Japan, and of that which is visible through exposure in Europe and North America, the work of Izima Kaoru

(b. 1954) is of interest in terms of his use of artful simulation of violent death in and beyond the fashion and advertisement circuit. Since 1993, the fashion photographer has worked with models to stage violent incidents in what he calls *Landscapes with a Corpse*. In this ongoing photographic series the fashion models pose as fatalities of brutal force. Whether they simulate drowning, being savagely stabbed or dying a wretched death, they are always carefully groomed and perfectly dressed in designer haute couture: Prada, Dior, Chanel... Each meticulously constructed scenario is captured to optimum effect in an overview photograph of the 'murder scene' and a close-up of the supposed cadaver. The initial motivation for the staged photographs has come from the desire to spawn attention for the specific fashion products. It highlights them in the flood of lifestyle and luxury commodity advertisements through emulating media and cinematic images of violent death and by tapping into an exploitative and perpetuated morbid imagination past and present.[46] Scandalous death combined with sex not only makes a good story – its spectacle sells commodities even better. The models in these images are reduced to mere material carrier of the expensive fashion items. This strategy finds its expression in the distinguishing subtitles for each scene: the name of the model and the fashion house are listed as descriptors. Supported by contextual information as to the nature of these stagings, the model vacillates between material body and carrier (of cloth), on the one hand and, on the other, dematerialised corpse that loses its 'referential capacity', that is denied both signification and significance. The theatricality of the scene, which echoes the visual approach by French Vogue photographer Guy Bourdin (1928–1991), emphasises the fashion items and style accessories. The way it is set up and captured screams 'all surface'. The picture does not tune in to the suffering of the victims that may produce empathetic responses in the viewer. In that, Kaoru's images are reminiscent of Bret Easton Ellis novel. Yet whilst Ellis unrepentantly oversteps the mark, Kaoru instrumentalises the play with the thin and fluid dividing line between the aesthetic and the obscene in the knowledge that the beautiful female corpse, with all its implication of gendered power relations and its related functions in art and aesthetics, has been inscribed as a potent 'archetype in the patriarchal canon of representation'.[47] Thus it could be said that Kaoru's photographs are doubly obscene. With Wall, Kaoru shares the deliberate amplification and exploitation of the insight that any representation of violence and death is always already culturally constructed.

# Chapter 5

# 'Playing with the Dead'

## The cadaver as *fascinosum*

The corpse (or cadaver: cadere, to fall), that which has irremediably come a cropper, is cesspool, and death; it upsets even more violently the one who confronts it as fragile and fallacious chance. A wound with blood and pus, or the sickly, acrid smell of sweat, of decay, does not signify death.
*Julia Kristeva[1]*

Little Aster
A drowned drayman was humped on to the slab.
Someone or other had jammed a dark light violet aster
between his teeth.
And as I, working
with a long knife
under the skin from the breast,
cut out a tongue and gums,
I must have knocked it for it slid
into the adjacent brain.
I tucked it into his breast cavity for him
between the cotton wads
as he was sewn up again.
Drink your fill in your vase!
Rest in peace,
Little aster!
*Gottfried Benn[2]*

The German Expressionist writer and physicist Gottfried Benn published his early poem 'Little Aster' on a flyer in 1912. These lines form part of his poetic morgue series. The juxtaposition of the gory business of a human dissection and the beauty of a delicate

flower marks the beginning and end points of life. Whilst the corpse is dismembered and momentarily captured in its inevitable process of decay, the blossoming flower is breathing in life and for an instance unfolds its exquisiteness. In a gesture that deliberately fuses artistry with shock effects typical for the early Expressionists, Benn imposes order and harmony on the chaos of carnage. His gesture is spiced with the distancing cynicism of the pathologist: reason set against the absence of meaning in the face of death, against the void of the decaying body. The mutually amplifying proximity of the ugly, repulsive and normally unutterable, on the one hand, and the pleasing and delightful, on the other, reflects in a broader sense the volatile situation of the immediate First World War period in Germany as seen through the eyes of one of the key figures of the emerging generation of artists.

Benn's vivid morgue scenes identify an aspect of reality that for centuries had, despite a rather brutal reality, lingered at the margins of morale, religious and legal conventions and human dignity. The bloody trade of pathology in search for the causes of death, for any evidence of contagion, illness and bodily decay, was a necessary assignment for the expert few but most certainly not a topic that merited or was even seen fit by the aesthetic tradition for either literary nor visual aesthetic experience and moral instruction. Yet, more than that, Benn's poem calculatingly highlights the transgression of the framework of aesthetic representation through the vivid description of the dissector's undignified rummaging through the corpse, its indifferent reassembly and sewing up. The displacement of the blooming aster in the body's putrefying juices of life exposes it nihilistically to a swift and certain demise. Like many artists of the early modernist avant-garde his work cultivates an 'aesthetics of the ugly'.

The correlation between life and death, which Freud renders in the dichotomy of Eros and Thanatos, lies at the centre of his concept of the human drive economy. Metaphysically, they represent the principal biological energies. Eros, i.e. the sex drive, symbolises life, reproduction, growth, creativity and an 'increase in tension'. Thanatos, i.e. the death drive, stands for destruction, dissolution, negation and death, for a potential elimination of all tensions. Violence is seen as part of both, as a necessary force to create, maintain and dissolve order, as was discussed earlier.

Georges Bataille pursues the relationship between death and violence through the evolution of man in his study on *Eroticism* (1957), amongst others. He argues that man by 'identifying himself with work which reduced everything to order, thus cut himself off from violence which tended in the opposite direction'. The corpse, with its immediate threat of decomposition and putrefaction, not only symbolises order-destroying violence and chaos; it also signifies the 'threat of the contagiousness of violence'. Therefore, 'violence and death signifying violence, have a double meaning. On the one hand the horror of death drives us off, for we prefer life; on the other an element at once solemn and terrifying fascinates us and disturbs us profoundly.'[3] To cope with death, he contends, 'man creates rites and taboos.' The burial of the dead may have fulfilled a number of interrelated functions: to protect the body from 'further violence'; but, more importantly,

to ban the disruptive forces and to reinstate an order on the world for woman's own sake and to protect themselves from the 'contagion' that the corpse both literally and symbolically embodied.

Prominent amongst the inviolable and universal prohibitions that were instituted to protect members of a community was, in Bataille's view, the taboo on murder, which constitutes a 'special aspect of the universal taboo on violence'.[4] Although other cultural conventions in the treatment of the dead – many of them closely aligned to religious beliefs and customs – have been shaped (and changed) in different places and at different times, they all have in common the desire and need to come to terms with the inevitability of carnal mortality. Death continues to carry with it the odour of the obscene, that what (has to) remain(s) unspeakable, tucked away beneath the consciousness, 'off-scene'. Julia Kristeva, in her discussion of abjection, links the corpse to the process of abjection and thus to the establishment and maintenance of 'Self'. This conception draws on Bataille, who contends that 'the horror we feel at the thought of a corpse is akin to the feeling we have of human excreta. What makes this association more compelling is our similar disgust at aspects of sensuality we call obscene.'[5] Death and sex in this aspect are connected by sharing the same body openings: 'The sexual channels are also the body's sewers; we think of them as shameful and connect anal orifice with them.'[6]

Dealing with death and decay in the contemporary situation remains highly problematic, as they are so closely interlinked with the ethical and the legal as well as the aesthetic. Death in the post-war sanitised western world has long disappeared from many people's primary everyday life experience. Dying occurs more often than not in special places: the hospital, the hospice, the nursing home. Nuclear families, low infant mortality and extended life spans have made the immediate brush with death in the West a rare, awkward and denaturalised occurrence, something that has been hidden away, unutterable, traumatic. Dying produces silence(s). At the same time, images of violent death and secondary experiences of dying have crept into life's vernacular owed to the spec(tac)ularisation of postmodern existence, in (pseudo-)documentary and fictional/ised forms, de-contextualised, appearing shallow and banal in many instances and respects. Newspapers but more importantly television, film and the Internet, video and computer games, make second-hand experiences of violent death: murder, carnage and human mortality omnipresent – available 24/7.

Sue Fox (b. 1963) is one of a number of artists to have done intense visual research in the morgue. The British artist almost obsessively looks with her 'vivid scopic armature', the photographic camera, at the remainders of human existence through the realities of autopsy and cremation. In her morgue series (fig. 13), her interest concentrates on the materiality and messiness of the human body, on its vulnerability and violability. Her close-up photographs of insights into the morgue since 1993 show, for example, the pathologist's hand at the moment when s/he prises open the rib cage to gut the male corpse, or the disconcerting hollowness of a 'cleaned-out' male cadaver. The latter stands synonymously for the void, the meaninglessness of death. Her images demonstrate almost too vividly that

death is an abhorrent, messy and distressing business. The rituals and ceremonies for the dead, which are to the present day predominantly religious or at least spiritually inflected procedures, can only thinly veil the natural facts of dying: the excretions that occur at

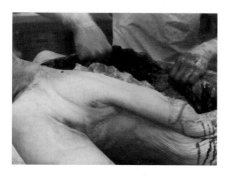

the point of total muscle relaxation, the cumbersomeness of handling a body in rigor mortis, the sensation of touching cold and lifeless flesh, the sight of a an organism violated by accident or post-mortem, the stench of rotting flesh or open wounds. What makes up a human body, what constitutes humanity? What remains of a life once the corpse is handed over to the flames of the crematory or the funeral pile or buried in the soil? Fox's photographs do not readily supply answers. By visualising the deconstruction and decomposition of

13. Sue Fox, *Open Body* (1996).

a cadaver and the process of its 'incineration', she forces the viewers themselves to look for answers to these existential questions. It equally shocks and captivates how the human corpse disappears in the greedy flames: first goes the skin, then the other soft tissue and organs until the skeletal structure lays bare and sinks together into a pile of hot ashes.

Sue Fox conducts the camera and edits the series of colour photographs to crystallise significant moments that project the emotionally detached position of the image-maker, similar to the objectifying gaze of the pathologist, of science more generally. The invisible photographer (conflated with the viewer's standpoint) is a distanced observer surveying and rationally controlling the situation. The pictures seek to cut out emotive subjectivity in favour of a material(ist) perspective that satisfies the rational urge to grasp the irrational at the level of the phenomenon.

Fox's documents seem to have derived from the same morbid curiosity that has driven Midas Dekkas, a Dutch biologist, to dedicate a whole book to the description of processes, stages and time scales of decay and putrefaction, human and other. Whilst Dekkas' *The Way of All Flesh: A Celebration of Decay* (2000) draws compelling pictures through the use of garish examples and gripping comparisons, Fox employs the camera to comprehend the incomprehensible of the impermanence of life. Her carefully conceived images meander between moments of the sublime, that carry with them a cathartic impulse, and a screening off of the real by delving into the domain of aestheticised representation. Her dealing with the scatological may be taken as obscene only in the directness in which the topic is being tackled. By looking closely at the violation of the body after death, her work touches on important ethical questions. What is a human life worth after it has perished? How does an evidence- and knowledge-driven society respect the dignity of human life, and what remains of it in death? What is at stake in dealing with the deceased in medical, secular and religious procedures? What are the rights of the dead? Much of the effect

of Fox's work results from the repression of the scatological and the sealing off of the related discourse and sphere of knowledge production from public access. In that, her work vacillates between transgressing and confirming cultural taboos.

Andres Serrano's earlier morgue series of 1992 has evolved from a different set of formal principles. His large cibachromes zoom in on those details of the human cadavers that best reveal the specific cause of death. Those range from drowning to asphyxiation, from meningitis to pneumonia. A matter-of-fact caption supplied with each picture affirms the interpretation of the visual signs of the fatality. An exception to the rule has been made in *Child Abuse*: the image shows only the infant's closed eyes, which are surrounded by a pristine – and symbolically highly charged – white cloth gently wrapped around the head (and presumably the body). Either, the traces of the deed seem to be too horrifying to be shown or this gesture is intended to signify the silent killer behind closed doors of (dys-)functional family life. Like Fox's dead, Serrano's corpses remain anonymous. Yet, whilst Fox's deceased figures have been reduced to mere material facts, objects of study devoid of any dignity or personality, Serrano 'reinvests' them with some sort of identity through the traces of their 'case histories'.[7] By photographing and publicly exhibiting those bodies, Serrano raises complex ethical issues that concern the rights of the dead over their own body and lived lives.

Serrano's photographic approach to the representation of death is marked by an extreme realism: straight shot on colour film married to a decidedly aestheticised formal composition of the image. The extreme cropping of the images until the right detail is captured takes place through the camera lens. Serrano's approach oscillates suggestively between revealing and concealing, between the forensic and the empathetic, between the uncanny and the familiar to lay bare the unspeakable horror of our mortality, of sickness, violence and death. Yet in these staged tableaux, moments of solemn and sublime beauty, and dignity within the perished lives are equally accentuated through the classically balanced composition of the images, the application of a defining, dramatising light and dark contrast, and not least through the high image resolution. As artworks, the glossy photographs rely on and exploit art's claim to truth. Simultaneously, they unashamedly 'flaunt their own artificiality' as much as their existence as expensive art commodities. Their iconic character marks them as belonging to a symbolic order and signifying practice that can be equally circumscribed by popular culture or art history. That aside, in the depiction of the subject, a high degree of voyeurism is implicated as the camera seizes dead people who cannot (any longer) refuse intimacy with its intrusive and objectifying lens.

A fascination with death can also be observed amongst the young British artists of the late 1980s and 1990s. It could be argued that their handle on existential issues is driven by a good deal of sensationalism fuelled by their own experiences of what the French writer and philosopher Guy Debord has called *Society of the Spectacle* (1967). This is a society where 'life presents itself as an immense accumulation of spectacles. Everything that was directly lived has moved away into a representation.'[8] Against the suffocating anaesthesia of a spectacularised, media-oversaturated and immensely commodified society, and yet as

part of it, these artists have reverted to the shock tactics of their avant-garde forefathers but without necessarily adopting their anti-bourgeois stance/ideology.

Between 1991 and 1996, Damien Hirst (b. 1965) produced a whole series of *Natural History* sculptures in which dead animal specimens are 'suspended in death' in large glass tanks: fish in *Isolated Elements Swimming in the Same Direction for the Purposes of Understanding* (1991); a tiger shark in *The Physical Impossibility of Death in the Mind of Someone Living* (1991); a sheep in *Away from the Flock* (1994); two pigs in *This Little Piggy Went to Market, This Little Piggy Stayed at Home* (1996). Most spectacular and controversial perhaps of them all is *Mother and Child Divided* (1993) (fig. 14). Four rectangular glass tanks,

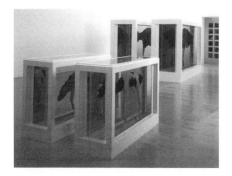

14. Damian Hirst, *Mother and Child Divided* (1993).

which – like the ones in the other sculptures of this series – seem to come straight out of the minimalist formal repertoire, hold one part each of a cow and a calf. They are neatly sliced along their body axes, and preserved in formaldehyde. The belonging parts are juxtaposed and leave space for the viewer to move between the tanks and to take in the body interior that has been exposed through the act of dissection. Here, modernist art meets science. The matter-of-fact display is situated ambiguously at their intersection. Hirst's 'use of animal cadavers' and the application of standard scientific preservation methods do not seem to fulfil any particular purpose that inherently necessitates and justifies such an undertaking other than to stun and provoke the audience. The grossness of such a gesture is exaggerated in the works' captions – sentiments that vacillate between child's play and grand philosophical motion. They amplify the gravity and yet banality, the incomprehensible and uncanny yet commonness and familiarity of death. In that they may allude to man's killing of animals in the service of existential and/ or economic demands (farming of animals and food industry, the hunt for zeal pups or whales), or of knowledge gain and human wellbeing (animal experiments and vivisections in the laboratories of the cosmetic and pharmaceutical industry, etc.).

In order to realise the artist's intention to scandalise, the works have to be firmly placed and mediated within a (post)modernist art context. Hirst, the *enfant terrible* of the UK art scene during the 1990s and perhaps most prominent representative of the yBas, has successfully generated attention through controversy that catapulted his objects into the art circuit, print media and television broadcasts, all with the support of art's mediation network. Temporarily, at least, they have impressed themselves on to the collective consciousness. From within the confines of art, Hirst may have managed to send a pertinent reminder of the perversity involved in our life practices, in which millions of animals are experimented on in the name of science, human wellbeing and sustenance by placing the

excessive, unimaginable and particular incidence of death in proximity to a seemingly universal rational order and objectivity taht is inscribed in the chosen display format.

Controversy and ambiguity, sometimes vociferously expressed, have also surrounded the public display of Gunther von Hagens' *Anatomy Art*, wherever it has been shown since 1995, whether in Japan, Germany, Austria, the USA or the UK. The exposition consists of a substantial number of exceedingly skilfully prepared human (and animal) corpses and specimens – each one devoted to a specific function or aspect of the bodily system, or to symptoms of disease and 'abnormality'. A Heidelberg-based pathologist and anatomist, Hagens has invented the process of 'plastination', which allows him and his team to achieve an extremely intricate and precise analytic visualisation of the complex human (and animal) anatomy.[9] The German title of the show, *Körperwelten* (which, in its literal translation as 'Body Worlds', was also chosen as the exhibition's name by its organisers in the USA), calls to mind a proximity of the objects to the physical, to the sciences as much as to the spectacle. The title for the UK show stakes out von Hagens' claim on the tradition of art. Flaunting a proximity to Joseph Beuys in his personal appearance, not least by sporting a similar hat and mannerisms, he clearly sees himself as a representative of the anatomist-artist tradition.

Von Hagen's projection of his craft of dissection and anatomical display in (proximity to) the domain of art is founded on a two-fold, interconnected, historically defined understanding of art both as a craft- and skill-based endeavour and as a gift bestowed on the talented creator. Such understanding is reinforced by the commentary in the accompanying catalogue, *Anatomy Art*, with, for example, the strategic citing of the nineteenth-century anatomist Joseph Hyrtl:

> Dismemberment is the heart and soul of anatomy. It is a craft, however,
> that requires skill if it is to be successful. The art of dismemberment must
> be learned. Beyond that, it also requires an innate talent for technical work.
> Anyone not possessing this talent will not make much progress towards
> solving the mystery of the grave.[10]

In this regard, it should be noted, that the term 'art' is still marked by more than just residual denotations of craft, skill and quality of execution. Von Hagens contends that 'anatomy falls within the tradition of the Renaissance when art was a product of ability,'[11] however, he moves beyond the mere craft aspect stressing:

> Whole-body plastination is an intellectual achievement requiring the ability
> to see the finished specimen in the mind's eye just as a sculptor envisions the
> completed statue while he is carving. If the specimen has soft, flexible tissue
> such as muscles when it leaves the silicone rubber bath, it will need to be
> positioned, a process guided by both aesthetic and educational considerations.

This statement is reminiscent of the argument that, historically, led to a separation between crafts and the 'liberal' arts during the Renaissance period, in the wake of which the latter moved into the *quadrivium*, i.e. in medieval learning the higher division of the seven liberal arts, consisting of arithmetic, geometry, astronomy and music. With the shifting conceptual position of art, the artist began to emerge and establish as an intellectually empowered creator, rather than a craftsman or artisan, from the fifteenth century onwards. Clearly, von Hagens stresses his intellectual abilities and educational intentions in relation to his work, yet he rejects any responsibility for the reception of it in the context of art, insisting:

> Experience at exhibitions has shown that the aesthetic aspect of posed specimens make such an impression that visitors consider a number of these to be works of art. There is no dispelling of that conclusion either, because 'art is in the eye of the beholder'. No anatomical works of art have been created; they become works of art through the judgement of the visitor to the exhibitions.[12]

The nature of his display suggests otherwise, given that von Hagens works with and on real corpses. In order to demonstrate the functioning of the body, he has to divide it into its micro-structures and then reconstruct it.

The very choice of the preferred motifs for the body display is indicative in this context of the intended location of the work. *The Swordsman* (fig. 15), for example, is one of numerous figures arranged in striking poses that display the anatomy or, better, certain aspects of the anatomy – be they muscle, bones, sinews or the intricate arterial system – to optimum effect, and thus make it very suitable for instructive purposes. The figure is split in three ways, so that every muscle involved in the swordplay is seen. His posing, as with the formal vocabulary applied to all of his dissected bodies, including the *Chess Player* or *Horse and Rider*, draw on, and re-enact iconic images of heroic bodies that originate in the classicistic tradition, which has significantly shaped the canon of high art, and still does. Despite their 'materiality', these well-proportioned bodies – all form and intact surface – seek to stay well away from the boundaries of the ugly and revolting. They emulate visual symbols of power (of reason) that have been deeply engrained in the collective cultural memory of the West

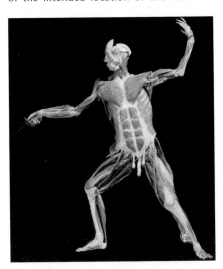

15. Gunther von Hagens, *The Swordsman*.

from Greek antiquity, via the Renaissance and Classicism, to Modernism through frequent exposure and referencing. The preference for tested artistic means of staging a figure powerfully and impressively, such as the *contraposto* or the *figura serpentinata*, underpins the palpable ties to the domain of art. However, the selected 'milieus' for the display, a (multi-purpose) exhibition hall or a museum of science, may slightly complicate such interpretation, although, in the current climate, they could be and have been construed as dialogue between art and science.

Take, for instance, von Hagens' televised (hence public) dissection of a human corpse that took place in a gallery in Brick Lane, London, on 20 November 2002. It was intentionally situated within the immediate context of the *Anatomy Art* show. The event was viewed live by a randomly selected but paying audience in the gallery space. The terrestrial television station Channel 4 broadcast the autopsy later that same night in an edited version. Whilst the live audience followed von Hagens' performance directly, the TV audience was fed a mediated version, in which camera sequences following the dissection were interwoven with shots of the reactions of members of the live audience and accompanied by a continuous commentary provided by two established British medical professionals. The act of broadcasting supported the notion of spectacle, that had already emerged in connection to the live event and its scandalising media promotion: *spectaculum*: a *Schauspiel*, a performance for the eyes. The corpse is being comprehended from the distance of the camera/television screen. Touching is not possible (and was not permitted at the live event) – and the noises and smells connected to the 'deconstructive' procedure, which could be experienced by the live audience, lost their gripping effect in the broadcast version. Therefore, transmitting the emotive audience responses took on a greater urgency then documenting the process of taking a corpse apart. This editorial strategy underlines the role of the audiences as witnesses, who attest the authenticity of the event, its staging 'on-scene' in the context of an art setting, and not 'off-scene' somewhere else. Therefore, the event and the show are clearly placed within what the German philosopher Jürgen Habermas has called the 'public sphere'. Habermas locates the eighteenth-century emergence and twentieth-century degeneration of the 'bourgeois public sphere' in a shift in the understanding of reason: from being a tool for knowledge to 'acting' as a public medium of communication.[13] In the case of von Hagens' public dissection, the relationship between knowledge production, communication and entertainment appears highly ambiguous. By placing the 'anatomy lesson' awkwardly as both art event and TV show, it has been moved closer to a medieval public dissection (of those who had died on the margins of society such as criminals and prostitutes), than satisfying the urge to 'know thyself', that is, the quest for enlightenment and knowledge that motivated the often illegal business of autopsy from the Renaissance onwards.

Tensions between art and anatomy reach back into history when the anatomist Vesalius performed public dissections within the spec(tac)ularised framework of the 'anatomical Theatre', or to Leonardo da Vinci's explorations of the human body on the basis of 'undercover' dissections, meticulously documented in numerous anatomical drawings. In the

eighteenth century, the French anatomist was amongst the leading figures to discover the interior and the functioning of the human body spurred on by the Enlightenment's emphasis on ratio and knowledge.[14]

Clearly, by situating *Anatomy Art* and the accompanying dissection at the interface of art and science, and so drawing on two established and privileged domains of public discourse and knowledge production, the organisers installed a legitimising safeguard with the aim of insuring against any 'slippage' of the objects into a mundane spectacle, and any accusations by the audience of obscenity. When Channel 4 decided to televise the first public autopsy in the UK since the 1830s, it could be almost certain – it seems with hindsight – not only that this event would be perceived as educational *and* entertaining, but also that it would register as an onslaught on a largely sanitised society generating a great deal of public interest and controversial debate.

The intense media promotion of that autopsy and the *Anatomy Art* show have raised suspicions that self-stylisation through spectacularisation has been a potent driving force behind the public exposure of von Hagens' work, rather than mere teaching and 'illumination'. Such an impression is enforced by von Hagens' showmanship and his stylish autograph card, for example, which shows the 'maestro' with his trademark Beuysian felt hat. While the legality of the autopsy procedure was itself in question (since von Hagens did not have a UK licence for this kind of work), moral issues also evolved from both the public and the performative nature of the event as much as from the format of the exhibition of the precise and painstakingly prepared plastinated specimens in and beyond the UK. They concerned the dignity of human life (and death) and the supposed exploitation of human remains in a situation where dying and death is predominantly present as media(ted) or simulated event, yet almost invisible, removed from direct experience in everyday life. The claim for exploitation was made on the grounds of allegations of the illegal acquisition of corpses from Siberia and the purchasing of bodies of executed prisoners from China. In contrast to voluntary donations of bodies certified by people during their lifetimes, illegal acquisitions violate a right that is fundamental, especially in contemporary western culture. That right has two intertwined bases: the intense focus on the individual; and the need for a final place where the body as the 'house of the soul' (and thus, by inference, the soul itself) can be laid to rest and the survivors' grief can get to work. Von Hagens' display does not allow for that, and Church leaders in Germany have attacked him for 'playing with the dead'.

Of particular concern to a considerable section of the audience was von Hagens' display of foetal abnormalities and deformations in newborns. Bowing to public pressure, when the show was held in Berlin in 2001, warning notices were placed at the entrance to a small room off the main exhibition hall in which the jars with those formaldehyde-filled specimen where housed. Here in particular, it was felt that von Hagens' exhibition mutates into a freak show, which is – except for the dramatic props – not dissimilar to Joel Peter-Witkin's 'play with corpses'. Witkin has presented opulent and compelling photographic tableaux with bodies and body parts, skulls and skeletons reminiscent of the *vanitas* motif

that featured prominently especially in seventeenth-century Dutch and Flemish painting, and served as a pertinent reminder of the transient nature of human life, against undue vanity and idleness – *carpe diem*.

Witkin's photographic staging of corpses from the early 1980s came into being in a morgue in New Mexico. His 'models' are selected from amongst those who have died an anonymous death on the streets of New Mexico. *The Kiss* (1982) consists of two halves of a dead man's head embraced in a kiss. The dishevelled exterior of the elderly man, the closed eyes and toothless sunken mouth suggest peacefulness until the eyes wander to the tumultuous array of arteries, sinews, flayed skin and muscles that surround the neck vertebrae. Witkin operates with a clash of two conventions of the aesthetic representation of violent death: the classicistic one of the sublime, suffering body, and the anticlassicist, mannerist tradition of the grotesque, tortured, ruptured body and its creatural dimensions. The irrational excess of violence, symbolised in the splitting of the head and the flaying of its neck, is counteracted with the centred positioning of the motif, the symmetrical fusion of the heads in the kiss and the pronounced black and white contrast of the photographic image. Through the gesture of the kiss, Witkin not only fuses the heads, he also closes up the mouth opening. He inverts the anti-classicist grotesque gesture of the mouth ajar (think of Edvard Munch's image *The Scream* for instance), which is a symbol for the pain of the violated, suffering body (necessarily removed from its acoustic signal), the usually red opening through which the interior of the body cannot only be entered but through which the body interior, the creatural is released, cried out. (Besides, in the visual still media of photography and painting, the difference between scream and laughter cannot be clearly established without further contextual information.) In *St Sebastian* (1982), another photograph from this early series, the post-autopsy corpse of a younger man, roughly sawn up along the middle of his entire upper body, is propped up on a chair, held in position by what looks like metal straps or brackets. The violation of the body is thus twofold. The title of the work places the cadaver in proximity to Christian iconography and depictions (of the martyrdom) of Saint Sebastian by Renaissance artists such as Albrecht Altdorfer, Matthias Grünewald and Hans Memling.

However, Witkin's formal means amplify not so much the surreal quality of the central scene and the theatricality of its setting, but integrate the unimaginable into an aesthetic order and its sublimating and distancing operations.

Death, as much as the deformations, disfigurations and abnormalities of the human body, has not ceased to interest Witkin, as his work *Corpus Medicus* (2000) testifies. The lower body of a slim man is 'draped' on a dissection table. Where it has been cut off with precision from the remainder of the body (any excess of blood has been removed from the 'wound'), a sumptuous curtain falls down to the very left hand side of the image. In another work, the severed head of an older man is placed in full profile on an antiquated book that serves as a pedestal in acknowledgement of the tradition of the portrait bust. On top of his head, the man carries a plate of fruit, one of which has dropped down to the plinth, resting against the neck. To make matters even more dramatic, the eyes of the

'sitter' are covered with a black scarf. These mannerist and grotesque scenarios call into presence the phantasmagorical imageries of Hieronymus Bosch or William Blake. Though their formal vocabulary is more analogous to the excesses of the Baroque, the overarching theme of Witkin's work can be located in the tradition of the grotesque: its notion of hyperbole, extravagance and audacity, and its inversion of beauty and rationality. The grotesque tradition is firmly rooted within popular art forms, folk art and carnival as Mikhail Bakhtin has shown.[15] Those boisterous forms of expressions have been closely connected to a range of themes widely excluded from the aesthetic norm, which in today's terms could perhaps be characterised as sex, drugs and rock 'n' roll. With its emphasis on physicality, on the 'corrupted flesh', on the untamed and excessive, on the exaggerated and monstrous, the grotesque traditionally aimed at tearing down established boundaries and hierarchies from the perspective of the disempowered. Yet, to return to Witkin, he takes away the last ounce of power from the powerless by manipulating anonymous dead without seeking permission. Operating not unlike the infamous early nineteenth-century Edinburgh body-snatchers, William Burke and William Hare, he deprives his 'models' of their fundamental human right to own their bodies and to determine what happens with them after death. He takes away the last inch of dignity through the macabre stagings of their bodies. A cynic might argue that he gives visibility and attention at last to those who have lived a mostly invisible and unnoticed existence at the margins of society. Yet, even if this is true, it remains highly doubtful if they would have wished to gain it through these forms of exposure.

Like von Hagens' work, Witkin's operations magnify the whole contested area of body and organ donations and the pressures that come to bear on it from ethical, legal and religious perspectives. Furthermore, Witkin seems to accept the horrendous shock friends or relatives must get when they unwittingly come across the face or body of a person they once knew, and which now confronts them in what is literally a freaky scenario.

However, through its proximity to the grotesque and association with the lesser arts such as caricature, Witkin's work sits rather uneasily within the aesthetic domain. Yet, its slippage towards the side of the non-aesthetic is partly alleviated through an ostensible, extensive referencing of art historical precedents in terms of tropes and imageries, of composition principles and style conventions. This also makes the gory sight more bearable, at least for the unconnected, distanced viewer. The ineffable becomes more acceptable. Moreover, the integration of the individual images into a series, that is into an (aesthetic) order, as is also the case in the work of Serrano, Fox and von Hagens, provides an additional means that allows for the potential rationalisation of the representations.

Impulses of excess and the abject underscore a number of the British artist John Isaacs' works. In the grotesque series *A Necessary Change of Heart* (1999–2000), Isaacs (b. 1968) stages a series of hyper-realistic wax models of unsettlingly disintegrated human cadavers and body parts on a dissection table swimming in a puddle of what looks likes blood and water. In *The Matrix of Amnesia* (1997), a monstrously obese, naked 'primordial body', seemingly overwhelmed by and suffocated in the enormous body flab, is placed in

'different locations' and photographed. Those locations include, for example, a deserted side street in front of an anonymous shop façade. Each of them induces a different meaning. This and other scenes share the mocking scientific methods of evidencing and knowledge production.

The simulated butchered and decomposed body and body parts of *A Necessary Change of Heart* stand in stark contrast to what little can be discerned of a rather anonymous, sanitised clinical surround in which they are displayed. Whilst the *mise-en-scène* deliberately evokes associations of a post-mortem or a 'surgical study', the visceral nature of the objects on display contravenes all traditions for the representation of the body/body fragments in such a context. In the history of anatomical studies which Isaacs' 'models' reference, the visualisation of the body and its functions as much in three-dimensional as in two-dimensional media was strictly guided by an aesthetics that emphasised the (divine) beauty and wherever possible integrity of the body and its constituents. The creation of anatomical models was informed by the – historically changing – ideal of the human body. Traces of blood or any other bodily secretions or any naturally occurring flaws (outside the specific scientific interest) where carefully 'edited-out', and the organs and body parts arranged in a pristine surround and in ways that closely followed usual artistic conventions for the exhibition of (art) objects. When a part of the body, a body interior or an invasive procedure had to be displayed, this was done with aesthetics in mind too. Any severing or opening-up was crafted in a measured way, with a clear incision or a precise clean 'severing' of the required component, and always with sympathetic attention to the functional structure and the proportion of the corpse.[16]

Isaacs, on the other hand, indulges in the gory details of bodily destruction and 'excess', of an 'out-of-control' body whose sight is revolting, and yet mesmerizing at the same time. More than the vulnerability and transience of human life (and the anxieties these produces) are at stake here: there is also a satisfying pleasure in transgressing the disciplining and sanitising regimes and frameworks of representation. As Bataille observes, 'The transgression does not deny the taboo but transcends it and completes it.'[17] Isaacs' gory displays plunder the arsenal of our suppressed anxieties and hidden fantasies. They play to the desire to look and see in order to recognise and, through their 'life-like' appearance, may permit the Real to momentarily pierce the screen. However, this punctuation remains incomplete and restrained, as the object plays to the visual sense alone (as it does not capture the overwhelming stench of the decomposing body or the hushing noise of the maggots that feast on it).

The American photographer Nan Goldin (b. 1953) has approached the dead from an entirely different perspective. Since the 1970s, her photography has captured her life-world, in particular her circle of friends and acquaintances, from a very personal and intimate point of view. The authenticity of the work, intentional and externally projected on to it, is anchored in the emulation of the snapshot, the supposedly spontaneous and unedited (sometimes even unfocused and jagged) take of the camera. Parts of these 'documents' of life experience are made up of images of dying friends during the first public phase

of the AIDS pandemic. The latter is represented through capturing of the dignifiedly laid out body, as for instance in *Cookie in her Casket* (1989), through looking at the rituals of bidding farewell. Here, life and death, gain and loss belong inextricably together. Those photographs touch. In their proximity and restraint they communicate the traumatic experience for the surviving. Catching a final glimpse of the dead: could it help to preserve their image and nourish the memory of them? Does it give away anymore about the *raison d'être* of the person's life, the beliefs and values by which it was lived? Fox considers death 'outside of ritual' and thus, it could be said, alludes to the 'crisis of death' in modern society, which from an anthropological point may have given rise to photography in the nineteenth century, as Roland Barthes has so persuasively argued.[18] Goldin, on the other hand, seeks to fight the 'horror and excess of death' and its platitudes, to return it into the symbolic order, to make it a meaningful event – however futile this might be.

> The horror is this: nothing to say about the death of whom I love most, nothing to say about her photograph, which I contemplate without ever being able to get to the heart of it to transform it. The 'only thought' I can have is that at the end of this first death my own death is inscribed; between the two, nothing more than waiting; I have no other resource than this irony: to speak of the 'nothing to say'.[19]

Goldin's photographs conjure up Ferdinand Hodler's drawn and painted images (1914–1915), in which he documents the dreadful wasting away of his cancer-stricken lover Valentine Godé-Darel. The record of this premature death was handed over to the sublimating force of art. The final image of Hodler's mistress was painted by the Swiss artist half a year later, 'cleansed from all traces of illness and dying, as if resurrected as an immaculate image' in his memory.[20] Through the image she has been virtually reconstructed and re-materialised. The significant order of life has been restored through the power of the image and the imagination against the chaos, against the absolute meaninglessness of death.

# Chapter 6

# Anti-Normative Acts

## Radical liberation?

One day they agreed between them that they were very near the state of perfect happiness. 'I guess it's alright' Adele said with a fond laugh "and when it's alright it certainly is very good. Am I not a surprising pupil?' she asked. 'Not as nearly so good a pupil as so excellent a teacher as I am deserves' Helen replied. 'Oh, oh!' cried Adele, 'I never realised it before but compared with you I am a model of humility. There is nothing like meeting with real arrogance. It makes one recognise a hitherto hidden virtue," and then they once more lost themselves in happiness.

It was a very real oblivion. Adele was aroused from it by a kiss that seemed to scale the very walls of chastity. She flung away on the instant filled with battle and revulsion.

*Gertrude Stein[1]*

I started to move and to make some kind of joke but Joey mumbled something and I put my head down to hear. Joey raised his head as I lowered mine and we kissed, as it were, by accident. Then, for the first time in my life, I was really aware of another person's body, of another person's smell. We had our arms around each other. It was like I was holding in my hand some rare, exhausted, nearly doomed bird which I had miraculously happened to find. I was very frightened; I am sure he was frightened too, and we shut our eyes. I feel in myself now a faint, a dreadful stirring of what so overwhelmingly stirred in me then, great thirsty heat, and trembling, and tenderness so painful I thought my heart would burst. But out of this astounding, intolerable pain came joy; we gave each other joy that night. It seemed, then, that a lifetime would not be long enough for me to act with Joey the act of love.

*James Baldwin[2]*

Gay and lesbian artists have employed the portrayal of the (other) body, the representation of intimate same-sex relationships and their sexual consummation in various ways in their negotiation of identity or identities. Some of these aesthetic strategies draw on and have incorporated what the dominant heterosexual culture has rendered obscene and therefore confined to its margins – ghettoised and subjected to more or less vigorous policing. Provocations that challenge conventional notions of sexual difference and binary gender distinctions have formed part of gay, lesbian and transsexual liberation politics, driven by the aim to emerge from the fringes of society, to gain visibility and a voice that enables them to actively advocate their human and social rights. In the wake of the liberation movements of the 1970s, being visible and heard was equated with political empowerment. It was translated into the ability to transform or leave behind spaces of discrimination, exclusion and ignorance.

Since the 1990s, however, visibility and audibility have ceased to be plain indications of a successful transit from the margins to the centre, thanks to the interplay of a growing cacophony of voices recouped by the media and global capitalism, and the promiscuous use of images and voices across different cultural domains and hierarchies. For instance, black artists such as Chris Ofili, Steve McQueen or Mona Hatum found inclusion into international mainstream art and its critical discourses. Authors like Hanif Kuraishi and Salman Rushdi gained critical acclaim and celebrity status. Films such as *Bend it like Beckham* enjoy popularity, as do ethnic fashion models, actors, comedians, jazz musicians or rappers. In fact, the margin-centre opposition, like the high and low bifurcation of art, no longer fits the bill in a context where, according to the British cultural critic Kobena Mercer, the 'expanding circuit of [art] biennales' has moved 'beyond the Euro-American axis to include geopolitical spaces in Australia, Latin America, South Africa, Korea and Turkey'. Thus, Mercer contends that 'the outward face of globalisation' has

> installed an ideology of corporate internationalism, whose cumulative effect
> was to *sublate* the discourse of multiculturalism. Cultural difference was
> acknowledged and made highly visible as a sign of a 'progressive' disposition,
> but racial difference was gradually detached from the political or moral claims
> once made in its name, such as the demand for recognition at stake in the
> Eighties debates on 'black representation.[3]

Drawing on racial identities, Mercer has coined the term 'multicultural normalisation' to denote the divorce of visibility from political agency. Multicultural normalisation marks the difference between the representation of 'blackness' and black people's potential to artic-ulate their protest and critical resistance in the context of racial difference and continued 'white western dominance'. The visibility of black artists no longer necessarily functions to address and rectify racial discrimination and social injustice in society at large. In more erudite ways, it often operates as a cover-up of class-based, gendered and generational polarising rifts within (black) ethnic minority groups in the West.[4] In this context, Mercer

draws attention to the need to develop refined instruments of resistance and analysis. Those methods and tools also have to concern the dynamics between the aesthetic and the obscene and its defining contexts of circulation and discursive framing. This perspective is equally applicable to issues of diverse sexual identities and their visibility in society.

The following discussion moves from works of the previous two decades that explored 'compounded' otherness at the intersection of racial difference and 'transgressive' sexual identity or identities in provocatively explicit ways. By moving beyond single-issue liberation politics and one-dimensional 'off-scene' stances it seeks to highlight what is at stake when considering visual strategies that calculatingly challenge conventionalised boundaries of art, decorum and the law in the present complex mediated situation, where, at least in the space of cultural production, almost everything seems to go and not much is left to shock people out of their preconceptions, ignorance and complacency.

In 1989, two openly gay photographers had their creative lives cut short due to AIDS-related diseases: Robert Mapplethorpe (b. 1947) and Rotimi Fani-Kayode (b. 1955). By that time, the American photographer Mapplethorpe had established himself internationally as one of the most controversial and important artists of his generation. In Britain, Fani-Kayode, a photographer of Nigerian origin, had played a foundational role in the broadening of the conceptual and formal scope and the infrastructure for black photography.

Mapplethorpe has, in and beyond his lifetime, ruffled quite a few feathers in the art establishment by introducing outright pornographic content into the territory of aesthetic refinement and high art. Not that the pornographic display is a novelty in itself in the visual arts – one only needs to think of Picasso's *Minotaur* series for instance or Rodin's explicit drawings, which achieved approval under the umbrella of erotic sublimation. What is new is the pronounced homoerotic focus of Mapplethorpe's work interlaced with fetishism and sado-masochist practices in its confluence with the chosen medium of representation: studio photography, as for instance in his series of *Altars* from the 1970s. Where a painting or drawing is immediately recognisable as an artistic translation into a symbolic language and can thus be 'positioned' in terms of its dominant aesthetic experience and intellectual pleasure rather than being seen as the foregrounding of carnal desire and sexual (self-)indulgence, photography is considered to amplify the immediacy and literalness of the pornographic, as will be explored later. On the other hand, photographs exploiting homoerotic desire in a classical formal language were widely exhibited and sold during the nineteenth century.[5] However, their exposure and circulation, as with other (more hetero-)sexually candid material, was located mainly within the popular cultural arena closely aligned to the development of means of mechanical reproduction, i.e. lithography, screen-print and photographic processes. Mapplethorpe, as a connoisseur and collector of nineteenth-century photography, was familiar with the formal repertoire of classical beauty. He combined his sense for symmetry, balanced tension, crisp and clear tonal contrast in a highly controlled and stylised, and thus quite cerebral and formally sanitised language. Such a style of expression speaks of the power of reason and artistic will of the male creator that runs contrary to the libidinal excess of many of the pictures contents.

In *Christopher Holly* (1981) (fig. 16), Mapplethorpe concentrates on the flawless and pronounced physique of a black man. Reduced to his main 'corpus', i.e. without the head and hands as hallmarks of individuality, the body is both stereotypified along racial genealogy and transformed into a dense material landscape in juxtaposition to the infinite white 'horizon'. Such corporeal condensation is not usually at work in his portraits of white men. This opposition between black/matter and white/mind echoes the bifurcation of form and content that is heightened as well as scrutinised intensely in Mapplethorpe's work. The photograph belongs to a range of images that break a significant taboo in western mainstream culture: the display of the penis, and especially the erect penis. The male nude with its visible genitalia has not permeated the strata of advertising or the music video, although they are nowadays saturated with erotic innuendo aimed at the sex drive particularly of heterosexual young people. To the present day it is mostly the female nude, with its naturally 'veiled' sex, that has become a staple diet in the public market place. It serves as a key instrument for the persuasive equation of (hetero)sexual gratification with the pleasure of material consumption and social status/power. The bared male body 'has neither celebrated' prominent appearances in mainstream feature films nor in television or print media. If it is made fully visible at all, then man poses in his non-aroused status or turning his back to the viewer. Lacan has argued for a distinction between the penis as organ and the phallus as a sign.[6] The phallus signifies the hegemonic patriarchal symbolic order. Rather then the physical ownership of a penis or the lack of it, it is the presence or absence of the phallus as a linguistic signifier that organises symbolically sexual difference and 'otherness'. And because of this function, the phallus has remained excluded from direct (re-)presentation in western culture. Like the cuttle fish in Holbein's *The Ambassadors*, it appears symbolically transformed or as inversion inference through the visualisation of its lack in the female Other. In the context of existing power relations in the early 1980s, the display of the erect penis in *Christopher Holly* issues an ideologically ambivalent statement as the sign for signifying power belongs to a racially othered body. It speaks of empowerments as much as it inserts notions of exoticised sexuality. Thus it hovers between hopes for overcoming the racial segregation and dominance through the power of Eros – in a conjugation of Bataille's 'extremely heterosexist' concept of eroticism and its resistance to (dominant) discipline and control[7] – and traditions of orientalism. Eroticism is understood to 'bridge the gap between self and world'; it is 'a siren that leads one to the brink of a transformation that requires the very loss of the body'.[8] Orientalism, on the other hand, relies on the reification of the non-white, the other body.

16. Robert Mapplethorpe, *Christopher Holly* (1981).

The suggestion and exploration in Mapplethorpe's staged images of other forms of expression of sexuality among men – anal or oral – clearly proposes 'certain kinds of bodily permeabilities', which remain 'unsanctioned by the hegemonic order'. As Judith Butler argues in the context of abjection, 'Male homosexuality would, within such hegemonic point of view, constitute a site of danger and pollution, prior to and regardless of the cultural presence of AIDS.'[9] Yet the hysteria surrounding AIDS and its erroneous yet convenient exclusive association with deviant sexual bodily exchanges, particularly in the 1980s, has heightened the perception of homosexuality, not only as not being 'outside' the hegemonic, 'homophobic signifying economy', but also, in contrast to lesbian practices, as 'both uncivilised and unnatural'.[10] By this account, the obscenity of Mapplethorpe's images can be said to work in at least a two-fold way.

Heated debates were stirred in the USA in relation to Mapplethorpe and other artists' work, when Republican Senator Jesse Helms sought an amendment to the law in 1990, by incorporating a clause that prohibited the public funding for art that was 'obscene' or 'indecent' and thus limiting the operations of the National Endowment for the Arts in support of artists' work. Although an Independent Commission, instigated by Congress to investigate the legality of such clause, came to the conclusion that it was not safe to operate and that the NEA was not the forum to apply such tests, the obscenity criterion continued to contaminate judgements on the aesthetic quality of artworks and the value of their experience, which provided the basis for public funding decision in the USA. Where the modernist art doctrine – underpinning the ethos of funding decisions purely on the basis of aesthetic quality – insisted on the autonomy and autotelic nature of the aesthetic, reality demonstrated that this value category cannot easily be kept apart from immediate political concerns, nor from societal contexts. In other words, the definition of what is 'aesthetic' and what is not has always been interwoven with considerations of (dominant) morality (i.e. what is deemed to be good), as well as regards for the ruling law (i.e. what is permitted). And as ethics and legislative are complicit in the operations of the aesthetic/ obscene boundaries, so are the ideological and political.[11]

The court case against Dennis Barrie, the Director of the Cincinnati gallery where *Perfect Moment*, a posthumous retrospective of Mapplethorpe's work, was staged in 1990 is noteworthy in this context. The argument used against Barrie juxtaposed obscene content and aesthetic form, and the Court acquitted him of propagating obscenity, because the artist's classical composition and his 'mastery' of the formal properties of the work were judged to outshine its indecent subject matter, its outright operations with the lexicon of pornography. The Court's decision suggests that it is not what one says but the way one says it that is of importance for the distinction between the obscene and the aesthetic. It affirms the paradigmatic and performative dimension, that is, the contextual, the political and social framing of the aesthetic and thus of obscenity at work. The American art historian Rebecca Schneider observes aptly:

Any image framed in an art museum or an art history text book is 'decided' art, historically buttressed by the language of form *over* content, while at the same image appearing as a fold-out in Bazoombas or Hot Pussy is, by virtue of the content-oriented venue, porn. Thus it is not the contents within the frames but the decided nature of the frames themselves that 'artify' or 'pornographize.' The apparent transgression of venue relative to content was precisely what caused the general Mapplethorpe uproar in the first place. In Western cultural tradition ascendancy of form over content was reinscribed in a decision which, ironically, both instituted and eclipsed porn content within an art frame.[12]

Such situated decision between formal powers and content-seduction maps fairly congruently on and reaffirms the distinction between high and low culture. Mapplethorpe's work interrogates the formal terms of such binary differentiation and the underwriting of the 'appropriate and inappropriate' by class, race, gender, generations and geography.

Where the discussion of Mapplethorpe's work has been shaped by the knowledge of his own white gay identity (and the desires and perceptions aligned to it), Rotimi Fani-Kayode's work has often been connected to Mapplethorpe's practice because of a shared homosexuality and preoccupation with the representation of the (black) male body as the object of homoerotic desire. However, Fani-Kayode's biography complicates such a reading. Born in Nigeria into a well-respected family, he spent his formative years between Africa, the UK and the USA before he established himself as an artist in Britain. Fani-Kayode's creative agenda has therefore received vital impulses from his diasporic existence. His symbolically charged photographs of the black male body are marked by influences of his native Yoruba culture as much as western modernism and contemporary art. The racially determined corporeality is interspersed with artefacts and objects that recall ambivalent perceptions of Africa, a projection of concrete memories of lived experience and a generalised, homogeneous and exoticised cultural stereotype. Thus the black body constitutes a 'focal site for an exploration of the relation between self-projection, erotic fantasy (sex) and ancestral memory (death)'.[13]

The white, beaked mask in *Golden Phallus* (1989) (fig. 17) and the covered erect penis transform the 'symbolically overdetermined' black body. It is positioned in a field of tension between western anthropology, fetishised object and political proclamation with a signifying distance to all of those aspects. The phallus in this work formally echoes the beak and vice versa. Compositionally they form a dynamic layer with the symbolic strings suspending and formatting the penis into a phallus that cuts across the black body and pushes it further into the dark background. Ambiguity takes hold founded on the white, highly charged markers. It emphasises and repels the carnal homoerotic desire that is produced by the perfect(ed.) black body. The signifying agency of the black body suggested by the phallus is thus rendered suspicious/artificial by its suspension mechanism. It literally becomes a puppet on a string in and for the dominant white culture.

*Golden Phallus* belongs to the series *Communion*, a suite of loosely connected images made in collaboration with Fani-Kayode's partner, photographer Alex Hirst, in the face of the artist's premature death. The theatricalised gesturing of the nude body, often fragmented and condensed to its 'universal' appearance, alludes, in conjunction with the inserted ritual objects and fetishes, to the shamanist practices of a priest and the role of trance in African culture. Spirituality through ecstasy is temporarily achieved through excess, through losing control of one's self in rhythmic and repetitive movement, in a temporarily sustained expenditure of physical energy that trusts in the transforming and transcending libidinal powers of the body. Those objects and fetishes also contrast with the stringent formal discipline that governs Fani-Kayode black and white photographs.

17. Rotimi Fani-Kayode, *The Golden Phallus* (1989).

The public 'exhibition' of desire that transgresses normalised sexual and racial stereotypes openly at a time when the dominant value system demanded that such anti-normative acts – although they occurred – remain tucked away in the closet: invisible and unspeakable, produces notions of obscenity around Fani-Kayode's images. His symbolic displays mark a departure from the documentary tradition with its sociological and critical intention as the main field of practice for black photographers in the UK and beyond. In his work, Fani-Kayode speaks from the position of a black gay photographer, not for it. His bodies reside in a diasporic gap between the past and the present in which the hope for an innocent return to the origins and the completion of the fragmented body to an organic whole has been forfeit for a more explicit politicised scrutiny of the body-mind dichotomy. Fani-Kayode's photographs project ways in which ambiguous, situated identity/identities and memories can be (de)constructed and negotiated.

There is an affinity between his mature photographic work and the aesthetic strategies developed by British director Isaac Julien (b. 1960). Julien's film *Looking for Langston* (1989) is a lyrical excavation and exploration of the life of the gay Afro-American poet Langston Hughes, who surfaced during the Harlem Renaissance in New York of the 1920s. The movement of documentary scenes is 'intercut' with poetic insertions and the photographs of Robert Mapplethorpe. Bound together by an atmospheric jazz soundscape, the multimedia collage generates a 'kaleidoscopic synthesis', through which the past is recovered and invoked in the present politics of race and politics of art. The social context in which Afro-

American culture thrived in and around the Cotton Club opens up a trajectory to the Black Art movements of the 1980s London and the negotiation of alternative sexual identities as part of it.[14] This combination of aesthetic strategies in the film has been deliberately employed by the black artist and film-maker to unsettle formalistic aesthetic exploration. However, the collage approach does not rupture the formal framework, so much as permit the homoerotic enactments to conquer the film and dominate it. The inclusion of open same-sex exchanges illuminates the complex life experience of the Afro-American poet in a climate in which not only whiteness but also heterosexuality officially asserted their hegemonic powers across all areas of cultural production, and thus doubly marginalised the sexually and racially other. Homosexuality within the context of whiteness may have been regarded as deviant but tolerated at least in the artistic bohemian circles at the fringes of bourgeois society (as well as within the ruling class in the UK for instance); its surfacing in the context of the oppressed black other, however, complicated matters further and was subjected to discrimination by and exclusion from one's own racial group, and severe prosecution by the dominant white legislation.

The frank representation of homosexuality – which in the late 1980s, framed by Mapplethorpe's iconic images, would have been deemed risqué and shocking not only by the 'mainstream' white audience, but also by the black community – remains firmly embedded in the narrative flow across historical periods. The critical discourse that has spun around this film assures its position within the parameters of art and its locations and distribution circuits, whilst at the same time it has come to play an instrumental role for the (black) gay community and its heterogeneous politics. Julien himself considers his film practice:

> as that of a transnational subject, a practice committed to making
> interventions in what has been named in other contexts as circum-Atlantic
> diasporic cultures. In my own practice, cinema can be a critical tool and can
> be used as an effective means to recirculating memory.[15]

Julien, like Mapplethorpe and Fani-Kayode, plays with and challenges the viewer's own projections and prejudices in an area of sexual and racial relations that has, at least until recently in the West, existed only at the margins of society. And those deeply held beliefs ultimately influence the intensity of response to all of their imageries. As such, their subject matters – and the moral challenges these may hold – rather then their formal appearance per se, have pushed that work into the limelight of public debate at different times in recent history.

It appears that black female and/or lesbian artists have to date been less inclined to explore issues of identity and gendered subjectivity by taking recourse to the forthright display of sexual(ised) nudity and corporeality. Reasons for that may lie in the amplified otherness and marginalisation of ethnic women and attendant gender and sexual stereotypes of colonial heritage as well as of community-intern makings. The latter is

compounded by a sexual over-determination of men particularly within Black African and Caribbean communities. In other words, the transgression of sexual conventions even for purposes of political resistance and social agency may have been too close for comfort for homosexual and/or racially othered women artists.

Sutapa Biswas, a UK based artist of Indian decent, provides a rare example in the staging of her naked body in *Synapse* (1992), a series of twelve photographs. In these images, she performs herself in front of large photographic projections onto paper screens of details from the facade of a famous temple from central India.[16] The private studio was turned public in the exhibition mode of the photographs documenting her exposed smooth and voluptuous body emerging into an imaginary space, that within the western cultural context, like the body itself, appears exotic, displaced. The viewer is looking into the image, remaining unacknowledged by the model's gaze, being left in the powerful position of watching, scrutinising and appraising the scene.

The British photographer Ingrid Pollard had in the early 1990s produced a range of photographs in which she draws on the fragmented black female body. Its fragmentation emphasises the impossibility of being a whole subject. The fracturedness and multiplicity of the black subject's identity, although symptomatic for postmodern identity constructs in general, is magnified by the accompanying pieces of a narrative. Descriptors in *Deny: Image: Attack* like 'dyke', 'bent' and 'queer' pronounce the lesbian identity of the black 'sitter'. 'Manhater', 'bulldagger' and 'lesbian castrator' linguistically invoke strong references to homophobic sexual fantasies interwoven with visual stereotypes.[17]

From a position of whiteness, the transgender visual artist Della Grace, also now known as Del LaGrace Volcano, has for more than twenty years occupied a prominent position amongst photographers concerned with women's same-sex relationships. Employing visual codes of pornographic representation, s/he sought to seize 'heterosexual sites and customs' and to challenge presumptions about same-sex desire and lesbian lifestyles.[18] Recently, notions of intersexuality, i.e. being both male and female and neither male and female, have taken centre stage in his/her digital image manipulations on the theme of sexual interaction. The interlacing of ornately inscribed – tattooed, pierced and wearing (body) jewellery – and visually disjointed body parts in overt sexual performances makes visible an in-betweenness in a defiant and discomforting way. The unashamedly candid display of sex and desire in his/her digital photographs serves as calculated means for provocative self-assertion and activist consciousness-raising.

During the 1990s, white South African artist Marlene Dumas (b. 1953) created a range of paintings and drawings that 'delight' in the exploration of the pleasures of flesh. Their subject matter comprises bodies, predominantly of women, that expose their genitalia lustfully to the viewer, for which they draw on the pornographic while, formally, they are firmly anchored in the class-defined and gendered tradition of painting and drawing, and recall consciously art historical precedents as for instance in *Velvet and Lace (Schnabel meets Baselitz)*. Where Mapplethorpe and Fani-Kayode have nurtured their formal repertoire through the exploration of refined studio-photography, i.e. high-end

imaging technologies, Dumas employs, throughout her practice, everyday Polaroids as an auxiliary means. The instant photographs serve the imaginative transformation of the captured gestures into pictorial principles and means of painting. For the series *M D-light*, the images were shot by the artist 'at the strip club Casa Rosso in Amsterdam's red-light district' as well as taken from sex magazines.[19]

The painted models emerge from cursory body contours, and the loose shapes are often generated by bland blotches of run-in ink or paint that vacillates between 'object'-definition and symbolic value. The lack of a personalising face and/or a designating title for the work does not allow for any identification with the 'sitter', on which its sexual allure conventionally depends. Also, Dumas' articulate figurations, such as *Dorothy D-Lite* (1998) (fig. 18), ambiguously occupy a pictorial space that is either scantly sketched or left wholly undefined/infinite by harsh figure-ground contrasts. It is a surround, which refuses to situate and thus to clarify the reference in terms of the object's positioning. Such wilful lack of definition incites an ambivalent sexually motivated and (indicated by the tone of the figure's skin colour) racially under-noted address that swings back and forth between homoerotic allusions and heterosexual titillation. The vagueness of orientation in turn eschews any hasty attempt to (re-)turn to the referential in order to assume a clear-cut position and moral stance. Dumas' paintings and drawings magnify their qualities as informed representation and signs (and all the conventions that come with it) rather then literal and immediate displays. They throw into question how painting has been taken either to reflect a pre-given reality or to produce a reality of its own. They articulate how, in the light of the latter, painting as a sign then dominates, mediates and constitutes that to which it refers.[20] Dumas' work affects the viewer as it ruptures the comfortable (or comforting) object-subject positioning between suggestive female nude and contemplative (male) viewer. The physical and seductive reality of the image, its existence as a tangible media surface foregrounds the implicated voyeuristic position in a paradoxical manner. It demonstrates

18. Marlene Dumas, *Dorothy D-Lite* (1998).

the mechanisms and somatic dimension of the gaze. In that her pictures not only produce enlightening interferences with the pleasure a painting communicates as idea and as sensual appearance. But they allude to their powerful mediation in public discourse that informs the perception of the work as aesthetic configuration vis-à-vis its Other, the obscene display, and its subsequent reading and interpretation.

# Chapter 7

# Obscenity and the Documentary Tradition

I am convinced we have a degree of delight, and that no small one, in the real misfortunes and pains of others. There is no spectacle we so eagerly pursue, as that of the uncommon and grievous calamity.
*Edmund Burke*[1]

The cunt fuckin well yelps n huds ehs neck n the blood's spurtin oot aw ower the bar. Must have goat a vein or an artery. Thing is, ah didnae even fuckin well mean tae dae that tae the cunt, it wis jist a fuckin lucky bonus. Lucky fir him, cause ah wanted it tae be slower. Wanted tae hear um fuckin squeal, n pled n beg, like they bairns eh beasted probably did. But the only screamin ah hear comes fae that daft cunt. Second Prize as the beast's blood pumps oot, n one ay the auld cunts goes: – Jesus Christ.
*Irvine Welsh*[2]

This chapter interrogates the relationship between the documentary tradition and notions of obscenity that derive from the on-scene, that is from placing into public view what should have remained hidden from it. It takes a closer look at *Case History* (1998) by Ukrainian photographer Boris Mikhailov (b. 1938), and *Ray's a Laugh* (1996) by British artist Richard Billingham (b. 1970). Mikhailov's *Case History* was published by Scalo, an art publisher situated in Zurich, Berlin and New York, in 1999. It contains about 450 photographs on the 'condition humaine' of Kharkov, the artist's home town. Most of the pictures are close-up portraits of *bomzhes* (homeless and dispossessed people) and their existence at the deprived and devastated margins of the city. Billingham's book consists of photographs of his immediate working-class family, alcoholic father Ray, mother and housewife Liz, and troublesome brother Jason. He captures the 'home-bound life' of his

parents and, in some instances, his brother in a small council flat in Birmingham during the early 1990s. These photographs where intended as reference material for paintings, a discipline in which Billingham had received formal training, until they were discovered and published by the art dealer Anthony Reynolds.

Both photographic bodies of work have received considerable and often controversial attention for related reasons. The photographic images, though quite different in their origins and intended use, reference the documentary tradition in an attempt to record aspects of the daily lives of 'ordinary' people and take the value of human dignity as a primary theme.

It is crucial to note that the photographs are documents rather then records. Documenting means that the material has been actively composed and edited through, for instance, the selection and change of the camera angle, the focus, the exposure, etc., and through the post-production selection of the images for dissemination. The material is informed by the decisions of the image-producer at all stages. Recording denotes a relative absence of those authorial interventions.

The specific conduct of the photographic camera amplifies issues of voyeurism, notions of spectatorship and empowerment. Mikhailov's and Billingham's photographs have been produced and brought into the public domain from within the confines of high art. Thus both artists could be seen as exploiting their privileged and creatively empowered position as recognised 'signature artists', and as affirming the victimisation and marginalisation of their (in Mikhailov's case nameless) photographic models. Yet, at the same time, their work seeks to move beyond the binary opposition of neutral observation and partisan identification. Through reflection they attempt to adopt a critical and emphathetic stance to observe and document life reality and individual circumstance. They point the camera at situations where those particularities push towards some degree of shattering generalisation.

Whilst praise has prevailed for Billingham's work, accusations of exploitation and indulgence in the catastrophic, deplorable and obscene have been levelled at Mikhailov's. Moreover, it has been argued that the shock that Mikhailov's images, in particular, provoke actually prevents the viewer from scrutinising the images, from looking closer and closer at what is being shown and at how these images are being carefully orchestrated by the artist. The focus on the referential distracts or perhaps even diminishes their artistic merit.

In a contemporary situation in which reality is incessantly mediated – and where fly-on-the-wall television programmes, web 'blogs' and instant imaging snapshots reign – what is the function of photographic realism, produced and circulated within the expanded domain of art? Does it record phenomena of everyday life or symbolise a general(ised) idea? Does it act as a social and cultural consciousness, as a repository of memory, as a catalyst of revolutionary social change? In a situation where the boundaries between the aesthetic and the obscene are increasingly dissolved under the perennial avalanche of explicit and horrid media images, can pictures still reach and touch viewers out of their habitual patterns of thought and behaviour, out of their contentment? Should they? And

if so, how far can images go to do so? What is the relationship between the aesthetic and the ethic responsibility of the image-maker? And how does the social and cultural situatedness and circulation of an image influence its effects?

There have been numerous examples in recent history where drastically realistic visual documents have been strategically employed with the intention to advocate, to educate and to activate: in the prevention of AIDS infection; in Benetton's advertising campaign from the 1990s; in recent UK Department of Health advertisements against driving whilst under the influence of drink and drugs; in mobilising support against the famine in parts of Africa, or in reports from the battlefields of Iraq, Afghanistan, the Sudanese Darfur region; from the genocides in Rwanda, and the former Yugoslavia and their aftermaths, and accounts from the terrorist hostage-taking in a school in Beslan, Russia.

Such image production and dissemination is charged, culturally, often ideologically. Pragmatically, its task is to inform and influence, to affect and thus to produce a partisan public. It is founded on the premise that visual images are the best means of communication in society with the capacity to 'comment' critically about collective and personal values, about the human condition. Such images are deemed to reach beyond their own reality. The documentary approach has occupied a prominent position in the production of knowledge and critical discourse since photography became established as accessible visual technology in the nineteenth century, based on a resilient trust in its objectivity, in its immediacy and thus authenticity.

Historical precedents for such practice range from early press and advocacy photography to sociologically and anthropologically motivated visual studies, from the drama of everyday life to the banality of war. It can be found in the positivist work of German photographer August Sander, especially his typology of *People of the 20th Century*, in Henri Cartier-Bresson's captures of the 'decisive moment', and also in Nan Goldin's visual records of her circle of friends, and Sally Mann's *Immediate Family* (1991). Sebastião Salgado's black and white images of human suffering across the globe, the war photography of Robert Capa and more recently of Luc Delahaye are particularly pertinent in the context of the discussion here. Applied to the latter group of works in particular, we must ask, to take up Susan Sontag's question, 'What to do with such knowledge as photographs bring of faraway suffering?'[3] It should be noted that 'faraway' does not just denote geographical distance; it can equally imply social, cultural and psychological remoteness.

It is the 'political economy' of the documentary photograph that is at stake in the discussion here insofar as it is intertwined with the complex relationship between contemporary art and obscenity. Discursively, documentary photography exists ambivalently and fluidly across and between different cultural domains and circuits of knowledge production including journalism, art, sociology, history, anthropology, ethnology, archaeology, etc. The relationship between the intended target audience, the distribution 'channels' and the actual circulation of documentary photographs in the public domain – as with any other cultural products – has of course a determining influence on what is expected of those images, how they are read and interpreted.

To expand and deepen this discussion, it is necessary to return to and engage with Mikhailov's and Billingham's work in more concrete terms. Mikhailov's *Case History* opens with twenty photographs in which his camera zooms in on nine men and women. They present their pale and ailing bodies unashamedly to the camera outside, framed by bushes or neglected arable land, or in front of a high brick wall with its plaster crumbling down. They have lost everything; there is nothing else to lose. Several photographs are taken of the same person or group of people: full-figure portraits and close-ups of the face or the diseased bodies. Throughout the book, images are untitled. The *bomzhes* remain anonymous. The first section sets the tone for the whole book. Its nameless protagonists feature repeatedly in other pictures that give distressing insights into the life on the streets and in the homeless shelters of Kharkov. The reappearance of the people in the images suggests the construction of a narrative that is underscored by the title of the project.

*Case History* means literally 'anamnesis'. It signifies the medical past of a patient: the development of illnesses and injuries that make up the life history of a person. Like a palimpsest, these events are inscribed in (and on) the body as a network of overlays. They make up the formative body memory. It can also mean a report of (life) experience that resounds in the English expression 'to compare notes'. Importantly, case history also suggests an evidence-based, objective (and objectified) narrative, a container for a certain aspect of a person's life.[4] Mikhailov's patients are the underdogs, the 'losers' of society, people across all generations who are exposed to homelessness, abject poverty, illness, alcohol and drug abuse, physical and mental demise. These are people who appear bereft of any hope, who seem beyond any help, who face a premature and in some instance an imminent death. With a pitiless camera-eye, Mikhailov captures the anonymous victims of society,

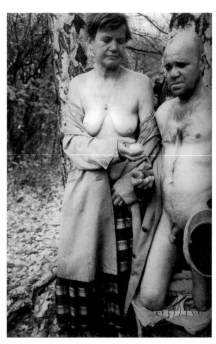

19. Boris Mikhailov, *Untitled*, from *Case Study* (1999).

of a transformed economy that moved radically and rapidly from the Soviet command system into a national and global capitalist market economy. His subjects are the people who have become ostracised and invisible or, more accurately, the people who are shut out and overlooked by those who are more privileged, who have found their place in the new social, economic and political situation.

In this respect, a parallel between the process of abjection for the establishment and maintenance of subjectivity at individual level could be drawn towards society. If so, what Mikhailov photographs is then not the process of abjection but its result, the abject, those who are of and yet not quite of a societal organism, the body social that Mikhailov documents. It is the surplus on which the wealth of capitalist society is founded.

In the introduction to his visual work, Mikhailov speaks of the motivation for his work:

> Since the beginning of the century, Russia has constantly attracted attention because of social cataclysms. Of course, it's not entirely so. Let's admit that it is not the Russian situation itself, but the fact that a 'world' experiment took place there ... the building of socialism. Now the experiment seems to be finished and we are probably witnessing its completion. And we'll consider that as a photographer I 'documented' periods of that experiment. This book belongs to one of the latest periods of that 'great' experiment.[5]

Mikhailov's photographic perspective echoes what W. J. T. Mitchell observes in respect of an earlier Marxist regard of the medium of photography, in particular that articulated by Walter Benjamin:

> The camera is, on the one hand, the epitome of the destructive, consumptive political economy of capitalism; it dispels the 'aura' of things by reproducing them in a levelling, automatic, statistically rationalized form ... Benjamin also echoes Marx's faith in the dialectical inversion and redemption of these evils by the cunning historical development: capitalism must run its course, unveil its contradictions, and produce a new class that will be so nakedly dispossessed that a complete social revolution will be inevitable. In a similar fashion, Benjamin hails the invention of photography as 'the first truly revolutionary means of production' ... Benjamin regarded the camera as both the material incarnation of ideology and as a symbol of the 'historical life-process' that would bring an end to ideology.[6]

Mikhailov also explains the nature of the exchange the portrayed persons entered into. They receive 'a little money' from the artist (more than the Kharkov art institute pays them) for undressing and revealing their bodies to 'sit for' the artist's camera: 'They agreed to pose for the so-called historical theme. They agreed that their photos would be published in magazines for others to learn about their lives.'[7] The contract the two parties enter into echoes Marx's doubly free worker who has nothing else to sell than their labour, and in this case their body. The encounter between photographer and his 'models' takes place on the territory of the *bomzhes*, the photographer is both intruder and guest. The relationship between the photographer and his 'hosts' is complex – dominated by power relations that

are built on differences in economic and cultural capital and class. It is forged by different needs, and dependent on mutual trust and on hospitality. The photographer includes himself in the documentation. He can be seen whilst photographing a young woman's pudenda, or kneeling in front of a man's bared penis with genital warts. In another image he is soaking in a bathtub – naked, caged in a claustrophobic setting. Or he shows his own and his wife's body, only partially uncovered. Possessing a clearly identified voice in the book in word and image, being seen in charge of his 'models' and the photographic work, Mikhailov visibly remains the social and cultural 'Other', whose identity is founded on the exclusion of the 'nakedly dispossessed'.

The photographs thematise the 'coincidence of death, violence and desire' that caused their critics to speak of a 'revulsion-death-life-art'.[8] The most disconcerting aspect of Mikhailov's images is his preoccupation with sexuality and sexual transactions. These are highlighted in conjunction with broken and diseased people and amplified through his models' state of incomplete undress or in the juxtaposition between (semi-)naked and clothed people. Sex belongs to the basic human impulses. It is the moment of a person's deepest vulnerability and, at the same time, an instant of intense pleasure and hope. Sex, violence and death are never far away from each other.

Mikhailov's images are infused with Christian iconography. The first part, designated as a requiem, cites, amongst others the motif of the *pietà*. Mikhailov explains:

> When I was first working on the book, I suddenly felt that many people were going to die at that place. And the *bomzhes* had to die in the first rank, like heroes – as if their lives protected others' lives.[9]

Christian iconography, recurrent throughout the book, is tightly interwoven with the motif of the victim analogous to Christ's sacrifice and the compassion it commands. In fact, much of the tragic in the photographic documents derives from the insight that the observed were once amongst the heroes of society. The photographs infer the Soviet tradition of Socialist Realism that centres on the depiction of the heroes of that social project, the workers, farmers and soldiers. From there, 'impulses for renewal for a new community are being desired and projected.'[10] However, Mikhailov's photographs 'negate a central moment of a culture of remembrance': the cult of sacrifice that lies at the heart of Soviet society. It is expressed in the reverence for its heroes who gave their life for society. Mikhailov does not stop at the negation of the myth of sacrifice and heroism; he reinstates the myths in its negation. The *bohmzes* are both: the victims and the heroes and, as such, they constitute the social coherence. 'His recourse to religious motifs and matters of faith of European culture,' his insights into the decline of society, the end of a 'rhetoric of expectation', the confluence of documentation and staged performance, and the depiction of his own body and that of his wife aim at the visualisation of the unity of the ostracised and the desired.[11] Whilst the social coherence is fractured it can still be thought in the mechanism of sacrifice. It is the broken body that is loathed and yet

desired. It embodies the negation and at the same time confirms the functioning of the social organism.

The argument that Mikhailov's photographs, which evolve from his 'negative interest', verge on or are obscene is driven by two things. On the one hand, the images put on display, on-scene, what has been squeezed out of sight in contemporary Ukrainian society (and beyond). This is invigorated by the images' power stemming from the confluence of their wilfully frank and blunt appearance and (assumed) authenticity. Thus the pictures perforate the screen of conventions of photographic representation that are governed by their belonging to the art discourse. Mikhailov's phenomenological approach removes the mask of a polite bourgeois society and the dignified distance as aesthetic convention to point the finger to the repressive and exploitative power of new capitalist society in his native country. On the other hand, this argument builds on the circulation of Mikhailov's photographs from within the art sphere, and their ambivalence of de-aestheticisation by focusing on the ugly and repulsive, and yet simultaneous aestheticisation through the adopted conventions of representation and reception.

Billingham's photographs of his family operate in a similar way but at a less extreme level, both in terms of the theme and its formal resolution. The close-up pictures of his father and mother are not snapshots but carefully composed photographs guided by a

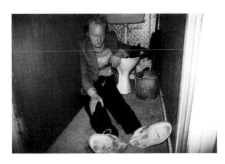

trained pictorial aesthetics. They capture gestures, fleeting moments and details, for example the very point when his father tumbles off his chair clumsily and helpless, or when he is slumped in front of the toilet bowl. A series of images is concerned with his prematurely aged face. From a frog perspective, the camera focuses on the narrow and at times hollow-looking mouth, the nose and eyes, the features of an old man. Then again he changes from the same perspective to the wrinkled neck, the lifted chin or the gaunt chest area. In

20. Richard Billingham, *Untitled* (1994).

the portraits of his mother, smoking or resting on the living room sofa, visual influences from the image bank of western culture can be traced: Breughel's burlesque ensemble of figures, Goya's *Maya*, perhaps or – in the profile views of his mother smoking – the classic advertisements for Westerns or cigarettes. All those family images feel somewhat claustrophobic. The proximity of the background and the lack of any vistas compress the situation. The space is tied up, and it elevates its protagonists. In a way, the photographs reverse celebrity photography by championing the social underdogs and its cultural values which surface in the interior decor and accessories especially in the living room.

The critical potential of the images unfolds in pronounced reference to experiences of external everyday life in ways that take issue as much with working-class self-stylisation

as with anti-heroes, marginalised victims, which is communicated by the uninhibited, confident posing of the family members. By implication, this stance also points towards middle-class self-righteousness and ignorance, assisted by the images' calculated public circulation, through which they cut ambivalently through and reaffirm political rhetoric and value hierarchies.

Yet such a reading has to take into consideration that Billingham took pictures of his family building on (and exploiting) mutual familiarity, intimacy and trust between him and the portrayed. It can be assumed, that the way the images are seen within the circle of family, relatives and friends is different to how they are looked at by the completely unconnected viewers. For those familiar with the models, their relatives always remain people, even when they appear embarrassing, ugly or grotesque looking in a photograph. An outsider, detached from those connecting personal insights, necessarily perceives the photographs differently. The publication and sale of the photographic images, which were made with a different intention, has exposed the portrayed rather than the image-maker to intense public scrutiny and to some extent violated their dignity and integrity. This is to say that the fact of their distribution, not the images in themselves, moves them towards the obscene.

Billingham's photographs have recourse to the tradition of nineteenth- and twentieth-century Critical Realism and its prominent subject matter: the working classes. The insights into the particularities of a life are situated at a distance and are less visible from the vantage point of the social strata of the art book buyers and the reaches of the white box, the gallery space. However, at the time the images were published, the yBas (young British artists) had come to dominate the UK art scene and were in the process of confirming their international reputation (supported and instrumentalised for its own political goals by the Labour Party when they entered government in 1997). The yBas had cultivated a materialist, loutish and often-shallow engagement with selected aspects of working-class culture – in all its constructedness and its projections across the social spectrum of the UK – ranging from the macabre jokes by Damien Hirst and the Chapman brothers to the outright provocation of Tracey Emin, and the decidedly laddish attitude fashioned by Sarah Lucas.

Mikhailov and Billingham set their work within the field of tension between bourgeois culture, with its power and didactic stance, and folk tradition with its sentimentalism. Their photographic approaches receive broader interest and affirmation through the blurring between the private and the public propelled by the still-growing presence of reality TV as well as commercial television broadcasting. Yet the effects of their images are reduced by the same inflation of fly-on-the-wall and *Big-Brother*-style programmes. In other words, the media consumers become increasingly accustomed to the exploitation, the physical violence of the camera and accept (and expect) voyeurism as a standard spectatorial position. This complex and dynamic net of cultural overlays and convergences too informs the negotiation between the aesthetic and the obscene in the reception of Mikhailov's and Billingham's work.

# Chapter 8

# Recycled Fantasies

## Obscenity between kitsch, convention and innovation

He kissed her until she was no longer herself but his, and it was so wonderful that it was impossible to think of anything except that she loved him and he filled her whole world, and she was no longer afraid.
*Barbara Cartland*[1]

'Don't loiter girl! Do you think I shall lose appetite for the meal if you are so long about serving it? No; I shall grow hungrier, more ravenous with each moment, more cruel ... Run to me, run! I have a place prepared for your exquisite corpse in my display of flesh!'
*Angela Carter*[2]

*Le petit jardinier* (1993) (fig. 21) is a one-off, hand-painted photograph by the French duo Pierre et Gilles – Pierre Commoy (b. 1949), the photographer, and Gilles Blanchard (b. 1953), the painter. It 'sports' a man in the prime of his youth, standing in a field of poppies and marguerites and urinating. His body's perfectly pronounced physique is enhanced in two ways: cosmetically, through waxing of the chest and abdomen, and technically, through hand colouration (digital manipulation). Apart from a pair of blue jeans, which are artfully arrested just below the crotch, giving full exposure to a carefully trimmed crop of dark pubic hair and the excreting penis, Didier (the named model) is wearing a straw hat and a red-and-white-checked scarf knotted around his neck, off-centre. The round straw hat and dainty scarf are wilfully reminiscent of a feminine code of rustic fashion, underscored by the fabricated setting of the *mise-en-scène*: under a blue sky with cumulus clouds, which fills two-thirds of the format, in the midst of a gently rolling countryside lies an open meadow with a farmer's house in the right background and grazing cattle towards the left middle ground. A stone wall guides the eye from the figure in the foreground to the traditional detached building in the right background. Whilst the landscape appears

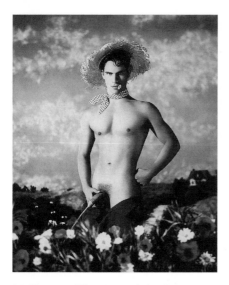

21. Pierre et Gilles, *Le petit jardinier* (1993).

to be a kind of stage backdrop, the out-of-focus red-and-white flower, set in lush greens, produces a colourful low shower-screen, a visual barrier between the carefully illuminated model in the centre foreground of the picture, as he pisses towards the literally confronted viewer. To maximise the exposure of the 'male pride', the model, placed on the vertical symmetry axis of the picture, has his body slightly turned away from the front-on capture of the lens.

The picture is composed in portrait format, oozing stability and calm. Its setting can be read in art-historical terms as hovering between Arcadian and burlesque references, a kind of home-grown nostalgic exotics in/for the post-industrial city dweller. It equally scores with glossy lifestyle advertisements for healthy food and relaxation in the countryside away from the pressures of contemporary urban existence. The unspoilt, luscious countryside underscores the health, freshness and physical prowess of the model on display. It connotes his potential stamina and extrovert sex appeal. These, in turn, re-emphasise the seductive intent of this highly aestheticised, slick staging. The picture's intention is crystallised in the clichéd gesture of the man holding a daisy in the angle of his mouth accompanied by a persistent 'bedroom gaze' at the viewer. The obscene creeps into the sickly sweetish and alluring scene through the act of urination with its ambiguous connotations of potency, sexual orientation and availability. Pissing here alludes to the risqué of sexually deviant practices ('natural champagne' and the like) in a cultural situation – as described previously – where (post-)industrial society has keenly sought to erase, not only from its public and semi-public interfaces, all remaining traces that point to the messiness of the human body. Through a whole range of interconnected channels, the sanitising impetus has established its firm grip on the private sphere(s) too, including, of course, sex. The acknowledgment and display of all bodily fluids has been pushed 'off-scene', it has become an avowed taboo. In that, the French photographers' in many ways banal image violates a strict prohibition, yet its effect and appeal depends precisely on the upholding of the forbidden. Rather than aiming to be transgressive in its gesture and political in its intention – as can be said for much body performance of the 1970s and the Abject Art of a decade later – this image foregrounds a wilful slippage along the spectrum of cultural production between high art and kitsch. It 'camps up' some skilfully made-up eye-candy predominantly for a diverse

homosexual clientele, as much as it translates the poster format into the uniqueness of art photography that oscillates between the gallery space, a mediated global digital presence in the World Wide Web (from where it can be downloaded legally on a pay-as-you-print basis) and the printed page of the glossy art book.

What is the relationship between art, kitsch, and the obscene now? The term 'kitsch' evolved in the later nineteenth century and came to signify artistic or literary material that was considered to be of low quality, often produced to appeal to popular taste and marked especially by familiar sentiment, accessible sensation and formulaic slickness. The term is wholly anchored in and inextricably linked to the modernist division between elitist and autonomous, 'autotelic' art and mass popular culture. Where art emphasises the original, innovative work, kitsch is aligned to the prescribed aesthetics of mass-produced 'artefacts', and the hierarchies of values that comes with it.[4] Kitsch is used as such from the perspective of those who consider themselves above and beyond it, who feel au fait with the intellectually and aesthetically demanding 'serious', authentic work of art and its emotive and intellectual challenges. But rather then being fundamentally dissimilar from art, kitsch 'embodies' a different kind of intensity. It offers a kind of 'life-affirming' 'ersatz-beauty' or enjoyable ersatz-sublime that smoothes over or blends out the complexity of reality, its tensions, conflicts and ugliness.[5] Where art, from an elitist perspective, is there to humanise, to challenge and stretch the horizon of the masses, kitsch is seen to seek to appeal to their apparent tastes and desires. As such it is marked by strong escapist currents from the alienation and isolation produced by everyday life in capitalist society. The boundaries between art and kitsch are therefore fluid rather then fixed (or fixable) and closely linked to corresponding distribution and consumption circuits.

Pierre et Gilles operate successfully with a growing suspicion and uncertainty of the category of the autonomous, authentic, multidimensional art which has also affected heteronymous, 'simulated', one-dimensional kitsch as its twin. Kitsch as the twin rather then the Other of art transmutes the radical 'Other' of art, that is the obscene, the dirty and excessive, into the more palatable and digestible risqué.

The effectiveness of the operation of much Pierre et Gilles imagery is deeply embedded in the visual reconstruction and appropriation of popular myth. Firstly, a substantial part of the mythifying tendencies of the work stems from the more or less explicit exploitation of references to class. The title *Little Gardener*, for example, plays innocently with the equation between passing water (like a child) and watering (and thus nurturing) the flowers in bloom, though the adjective 'little' obviously conflicts with the 'hunk qualities' of the model, including his sexual organ. The labelling of the model as a gardener deliberately places the display within a working-class framework of references and power relations. This positioning as someone who would usually work in the service of well-healed clients is calculatingly accompanied by clichéd sexual associations with the 'rough and ready' and the 'beefcake': an extremely handsome and physically perfect young man vacillating in an exaggerated way between savageness and cultivation, provocation and promise for the discerning consumer – a gay analogue perhaps to Lady Chatterley's lover.

The stereotyped eroticism in Pierre et Gilles has resonances with the accomplished drawings by Tom of Finland from the later 1950s onwards. The commercial Finish artist put on display 'flawless images of male sex objects who, however unbelievably handsome are still sufficiently human to be acceptable'. The drawings 'combined an element of humour and enjoyment even in the most uninhibited situations', as the British author and broadcaster Emmanuel Cooper suggests, and thus achieved a quality (through their creative mediation and exaggeration) that photography can rarely rival.[6] During the 1980s, the American stereotype of the eroticised butch cowboy, lumberjack or sailor, which was popularised through magazines such as the 1950s *Physique Pictorial* by Bob Mizer, found their way as a more urbanised and politically correct yet equally suggestive and mythicised 'cross-section' through American society into the fabrication of pop music groups in the 1980s in the form of Village People.[7]

Secondly, and interconnected with the notion of class and sexual identity, Pierre et Gilles camp up their 'portrayals'. Shiny or sumptuous fabric and luscious textures, make-up and false eyelashes, the claw-like fake polished nails, the wigs and high heels are key ingredients of their work. The emphasis lies on appearance, surface and artifice engaged in a play with and contest of naturalised conventions of style, quality and cultivation in the space of postmodern consumerism and identity politics. Those style elements and shapes of popular and high culture are bricolaged, recontextualised and filtered through a specific sensibility that comes out of 'probing of cultural production' in a gluttonous, bloated society of wealth and leisure.[8] Susan Sontag, in her 1961 essay 'Notes on Camp', insists:

> Camp does not engage in oppositional polemics against these other
> sensibilities (that would be an avant-garde stance) inasmuch as it offers an
> alternative of divine indifference to them: ignoring 'both the harmonies of
> traditional seriousness, and the risks of fully identifying with extreme states of
> feeling' in favour of style and aestheticization.[9]

Camp has been considered to epitomise a 'feminized relation to shopping, tasting, sampling and consumption'.[10] It is marked by tangible resonances of travesty, the careful over-the-top styling so favoured by drag queens, exhibited in carnivalesque displays and parades and associated with role play, cult of extravagance and personality. Pierre et Gilles' visual gambits with class-defined gay stereotypes as much as with the figure of the saint and the sinner buy into existing presumptions only to twist them with a wink (rather then a wank).

Pierre et Gilles' staged photography also bears obvious connections to Pop Art of the first and second generation exemplified by the king (or should one say queen) of camp, Andy Warhol, and his understudy Jeff Koons. In the context of obscenity, kitsch and camp beyond its association with gay culture, Koons' screen-print series *Made in Heaven* (1991) and even more so the naturalistic translation of one of the images into a life-size, sculptural ensemble demonstrate the ambivalence of the operations of the obscene. The sculpture,

which represents Koons' copulation with Cicciolina in missionary position on a flowery, ornate 'bed', was realised by Bavarian wood carvers who have become famous across the world for their traditional Christmas decoration craft. Whilst formally the pornographic is rendered with all the material qualities of camp and the emotive intensity of kitsch, including its over-keenly hyper-real and sweet colouring, the exposition of the work and its discursive mediation installs and embeds it 'assuredly' in the temple of highbrow art.

Jan Saudek (b. 1935) has devoted his photographic skills to the depiction of the desiring body in relation to historical and cultural sexual stereotypes across the spectrum of heterosexuality in all its nuances. Since the 1950s, the Czech photographer has experimented with staged live tableaux; starting off with black and white, colouration

22. Jan Saudek, *The Holy Matrimony* (1987).

has been gradually introduced in his rather earthy and licentious imageries. The territory of heterosexuality in its fullness and deviations against the background and as a resistant to its social and discursive constraints unfolds on the stage of a relatively constant environment: the crumbling walls of his basement studio in Prague. This environment for his theatre of libido and transgression sometimes reflects projected imaginative/alternative reality or opens out to lustful encounters. Yet the ailing location, in conjunction with the historicist props and costumes as well as a colouration that tends towards the luscious and treacly, lends the images a morbid bohemian charm and agony. They invoke the rotting decadence of a bygone past that never was by interlacing bourgeois junketing, the eroticisation and promiscuity of the social underdogs like the prostitute and the sailor, and the sentimental representation of the saint and the sinner. Motifs and figures that have emerged within popular entertainment and mass reproduced photography since the mid nineteenth century as well as in salon painting of that period have nourished Saudek's visual pathos but also lend an impetus to Pierre et Gilles' thematic repertoire. In both of their works, elements of the burlesque, though realised in different styles, can be traced. The burlesque, deriving from the Italian word *burla*, denotes mockery, a joke or ridicule. Its connection to popular entertainment evolved in seventeenth-century England, where the burlesque emerged in dramatic form as a parody of social events. In the mid nineteenth century, burlesque appeared as comedy with musical performance in which the sexual display of the female body peppered with 'ribald humour' became the main attraction. Immodestly dressed women transgressing any notions of bourgeois respectability entertained the lower and middle classes, 'making fun of (or burlesquing) the operas, plays and social habits of the upper classes'.[11] In the USA, the burlesque gained notoriety in the period after the Second World War as male entertainment through a

'bawdy variety performance' with grotesque elements, mainly by women. Whilst its demise is closely linked to the commercially successful establishment of strip clubs in America it lived on for some time in porn and *Carry On* films.[12]

The contexts in which creative work is located and which it addresses are significant for its readings. Saudek's hedonistic proponents stand in stark contrast to the official heroes of the art of Czechoslovakian Socialist Realism – the working classes, the soldiers and the political elite – and its adopted cultural heritage and accepted themes. The images' morbid formal style contravened the optimistic pathos that underscored State art; and the excessive libidinal energies that are represented in his work have highlighted and challenged the dominant sexually repressed morale and imposed body-discipline until the fall of the Iron Curtain. Yet this specific ideological condition(ing) and the political and practical constraints for his image production that have most certainly confined his photography to the studio environment and underwritten its proximity to the 'clandestine' amateur approach have hardly been noted when the work begun to be exposed and achieved acclaim in the West.

The burlesque, interwoven with grotesque elements, permeates the portrayals of physi-cally handicapped people and 'incomplete' bodies that constitute a considerable part of Joel-Peter Witkin's photographic practice. His motifs derive from the 'reworking' of the western canon of painting as well as from early photography. But instead of putting on display the beautiful, idealised body that perfects nature, his theatricalised exposures of anti-normative bodies, accessorised with masques and/or elements of historicist attires, reside in an ambiguous territory between fable, miracle chamber, carnivalesque parody and plain freak show. The associative, montaged surrounds in which the models pose, and which contravene assumptions of photography's transparency, transport the individual from any real-life coherence into the realm of fantasy and kitsch. They thus stress the distance between them and the viewer in ways that affirm the organic and functional wholeness (and by implication of the very term) supremacy of the viewer. These derided and marginalised models are by no means rehabilitated, they are moved from off-scene to on-screen, objectified as Other and outsider, rather 'looking back' at the viewer as em-powered subjects. If parody of dominant values was intended, that parody backfires, as it is built on acknowledging the authority and power of the parodied element (original text or artwork), which in this case is the power of the complete and able body. Thus, Witkin's work appears utterly and thoroughly exploitative rather then enlightening or redemptive.

Peter Greenaway comments insightfully on Witkin's work:

> I came across Witkin in the late seventies and eighties and was disturbed.
> The images – and they are heavily prefabricated images – not acts or events
> – were undoubtedly of the pornographic however you twist the definition
> of the word to legitimize de Sade or Bataille or, indeed, Balthus. But these
> images also mock our outrage and show up our hypocritical disgust, which
> never stands up to much logic or sense anyway, when we condone so much

real obscenity around us without so much blinking an eye. Extravagant sexual behaviour, gratuitous posing, the exhibition of the freak, but not Diane Arbus exploitation, nor the double standard of that meretricious movie Freaks, or that bourgeois, bogus, tidied-up titillation of *The Elephant Man*, or the contemporary standard interest on English television for the sexually savaged dead female from *Brighteyes* to *Twin Peaks* to *Prime Suspects*.[13]

In his own films, Peter Greenaway, as has already been suggested, has not shied away from tackling provocative issues, above all the double moral of bourgeois society and the exceptional status of art since the Renaissance that feasts on the assumptions of its sublimating and humanising powers and its elevated status in society. This is particularly powerful in his 1989 feature film *The Cook, The Thief, His Wife and Her Lover*, in which Greenaway creates intensely earthy and opulent scenes of erupting desire and bodily consumption which take their inspiration from the Baroque tradition of painting and its iconography; in particularly from the still-life tradition. The van of chilled meat, for

instance (fig. 23), is potently resonant of Rembrandt's painting *Le boeuf écorché* (1655), and its propinquity to the Christian crucifixion motif. In the unfolding luscious and lascivious and equally violent scenes, the eyes of the viewer are 'allowed forbidden pleasures'. Collapsing the position of the voyeur and the viewer into one, the film – as do others by Greenaway – 'shows the voyeur what he fears to be caught observing'.[14] He juxtaposes the

23. Film still from *The Cook, the Thief, His Wife and Her Lover* (dir. Peter Greenaway, 1991).

imaginative and symbolically loaded visual and spatial scenario with the unfettered violent obscenities uttered and enacted relentlessly by the Thief. Within this paradoxical bricolaged situatedness, the contradictory registers of style confront both the sublimating powers of art, the symbolic order and its underlying sexual difference and drive economy. An external urban setting recalls the urban backdrop for Hollywood gangster films of the prohibition period. It opens into a kitchen and its servants that bring to life a pre-modern time. These locations are interwoven with a dining interior that evokes an early twentieth-century aristocratic setting, which is linked to a swish modernist restroom. The extensive library in the Lover's spacious apartment is intercut as a place of intellectual and physical delight that, towards the end of the film, turns into a site of brutal murder. The Lover's cultivated speech and conduct is pitched against the derogatory and lewd colloquial and – for polite society's standard – riotously violent and abusive behaviour of the Thief and his companions.

The Thief's behaviour culminates in the slow, painful and exceedingly cruel stuffing and suffocation of the Lover with the pages of his beloved books. The film reaches its

cannibalistic climax when the Thief is forced by his Wife to tuck into the masterly cooked and presented 'roast' of her Lover, and to have as starters, so to speak, his penis and testicles. When the Thief refuses to do so, he is shot dead by his long-suffering Wife, Georgina. This is a symbolic death that demarcates in its extremes the boundaries of western civilisation and symbolic order, its problematic ethical and legal underpinning. It points to the price for both the violations and the maintenance of values and order.

A similar stance can be detected in the interventions of Gilbert and George, who, throughout their sustained collaborative practice, have embraced, mocked and challenged the notion of bourgeois respectability, homophobia and moral double standards. These have been set in tension to bohemian transgression of social norms that was commonly associated with the marginal(ised) modernist artist of the late nineteenth to mid twentieth century. Homoerotic desire and class(ified) charm have marked their aesthetic engagement throughout their career as art collaborators. Blood, sweat, seamen, urine and shit have been employed as potent markers of bodily realities, visceral desire and symbolic hierarchies in the high art domain so coveted by the bourgeoisie. However, where base materialism and pronounced derogative textual vernacular muscle into the artists' stagings of externalised selves and their parody of the quintessential white, middle-class (homophobic) English stereotype, its cultural repository and sentiment, their predilection for symmetry and balanced pictorial tensions, for the structuring modernist grid and bold colour contrasts, as much as their use of screen/digital prints keep in their sublimating grip the abject/ obscene subject matter. Declaring their lives as artworks, performing as 'living sculptures', their self-representations have weathered as evergreens the 'storms' at the centre of the British cultural establishment, not least, because Gilbert and George (b. 1943 and 1942 respectively), especially in their carefully choreographed video work and public stagings, have successfully emulated the popular cultural iconography and media formats as much as a burgeoning celebrity cult that emerged in the wake of pop culture and took hold. These phenomena were fostered by the growing television and media network. As the openly gay and subversive arty version of Flanders and Swann, and, later, as it could be argued, Morecambe and Wise, they straddle the gap between the ruling upper-class and the working-class value-horizons in an increasingly multicultural, pluralist context.[15] Where the comedy duos spiced the accepted with the outrageous and comfortable hints at the risqué, Gilbert and George counteracted valued aesthetic formulas with sometimes witty and at other times blunt homoerotic and sexually explicit representations.

The early work of French photographer Bettina Reims (b. 1954) developed from asking female amateur stripers to pose and bear it all in front of her camera eye. *Chambre Close* (1992) – made in collaboration with philosopher and writer Serge Bramley, who is also her partner – reiterates expertly an aesthetics that reminds of Mapplethorpe's mature approach. It makes an investment in principles of classic composition and beauty; principles that sanction the revelation of flesh beyond and beneath seductive undergarments or suspenders, with exaggerated red lips or a bare mount of Venus. The eye is seduced by the smooth and flawless surface of the glossy images, their colours and measured

construction. Only gradually the tensions between this restraint aesthetic measures in the construction of the images and the calculated slippage from erotic suggestion into the realm of excess and savage/uncontrolled and uncontrollable at the level of the pictured trope surface. The initial visual allure as much as the increasingly sedating sameness of Reims's imagery stems from a sustained insistence on idealised beauty: all her models cut perfect figures. They are in their prime, fit, and have perfect bodies with unblemished skin. Their physical beauty and by inversion exquisite minds even transform the *heilsgeschichte* (the history that stresses God's saving grace) into a delectable, pleasurable spectacle in *I.N.R.I.* (2000). Narratively situated and framed by Serge Bramley's accompanying text, the suite of highly theatricalised large-scale photographs seeks to offer a contemporary take on Christian iconography. Working with actors, fashion models and lay performers, Jesus appears in a range of divergent contemporary guises, as woman or a black man for instance or a hunk in jeans. The scenes of his mission, suffering and sacrifice alternate between elaborate stage sets, a derelict hospital in Paris or the sun-baked surrounds of Mallorca. Whilst the mildly risqué, titillating *Chambre Close* coffee-table book achieved considerable success, the more than eighty large-format colour pictures of *I.N.R.I* grabbed public attention through controversy. Church representatives in particular accused the work of heresy, blasphemy and obscenity, and called for its banning from public display. Her recent work *X'Mas* showing teenage girls, posing nude for the first time, has also aroused some controversy as it was considered immoral and licentious particularly in the context of a contemporary preoccupation with paedophilia.

Reims's slick aesthetics is consciously complicit in and reiterates the continued fixation on youth as predominant cultural value of global capitalism forged by the fashion and cosmetic industry in conjunction with the omnipresent media machine. She secures a fluid exposure of her images across the area of established art as well as in the realm of mass produced images by bringing together a calculated aestheticism of form – emulating advertising and fashion/lifestyle imaging, the shopping mall and the merchandising of luxury goods – and a proclivity for popular iconography infused with the representation of elevated style codes that elide material consumption with the pleasure of the flesh. Her work fully endorses the comprehensive sexualisation and commodification of culture. It is invested with considerable trusts in the collusion of the viewer to be enticed and enveloped by the highly manipulative image constructions.

On the surface, particularly in terms of the visually slick, commodity cult and cool 'trendiness' and intention, there is a lot of rapport between Reims's photography and David LaChapelle's pictorial imagination. Yet, the American photographer and graphic designer (b. 1970), who early in his career worked with Andy Warhol, is more daring in his visual tactics in response to the cultural market segments and audiences he seeks to reach. Working at the intersection of advertising, product branding and styling, he has adopted the old tactics of Surrealism: the combination of objects from disparate spheres of reality on a formally unifying and re-contextualising third level: not an umbrella and a sewing machine on Mont Blanc in this case, but a beautiful young woman with half

a cow cadaver placed closely together on an immaculately white bed, ready for embrace and copulation. The visual shock effect that relies on pushing against or overstepping the admittedly fluid and socially and culturally mobile markers of 'good taste' at the level of content and register seems to become a necessary ingredient to attract the interest of the MTV generation and younger viewers who have grown up with the negotiation of an incessant flood of multimedia information anywhere and any time. It is a generation whose relatively short attention span has been increasingly formatted by the short video clip, the fast filmic sequencing, the (political) sound-bite and catchphrase in the tabloids, and whose visual imagination has become accustomed to a diet of explicit violence and sex, shock and horror.

The *Cremaster Cycle* draws on similar mediated sensibilities. For almost a decade, the American artist Matthew Barney (b. 1967) has produced, this 'self-enclosed aesthetic system' that consists of five standalone yet interrelated parts. Through the medium of film a range of creative expressions are bound together including drawing, sculpture and installation, dance, (musical) theatre and photography into a 'polymorphous' and 'out of sequence' *Gesamtkunstwerk* (a total work of art). It is intertwined with fragmented references to haute couture, (horror) movies, pop culture, science fiction, opera and more. With multiple beginnings and uncertain endings, the cycle unfolds as a dynamic multi-layered process of trans-formation and hybridity that grows out of the confluence and divergence of its multimedia and polyvalent components.

Trained as an athlete and schooled in processual art practice, Barney's work has focused in the cycle on the exploration of the 'internal matrix' of the/his body and its 'psychic, libidinal and physical energies.' With shared affinities to Marcel Duchamp's *Bride Stripped Bare by Her Bachelors, Even*, and Vito Acconci's *Seedbed*, Barney has propagated a self-enclosed, onanistic organism, that is 'marked by a relentless erotic pulse' and serves as an 'instrument of narcissistic gratification'.[16] As the title and structure of the *magnum opus* proposes metaphorically, it evolves and envelops temporal and special loops that defy any rationalist linearity. 'Cremaster' means 'to hang' (with a rope) and denotes 'a thin muscle consisting of loops of fibres derived from the internal oblique muscle and descending upon the spermatic cord to surround and support the testicle.'[17] On the macro level, the hermetic narrative meanders in a field of tension between a temporality that stretches across centuries and an individual lifespan, whilst at a micro level it concentrates on the earliest stage of embryonic development, when the sexuality of the foetus is not yet decided. 'The *Cremaster* cycle imagines the prospect of suspending this [six-week] phase indefinitely, resisting the inexorable impetus towards division' into male and female difference.[18] Within this conceptual framework, Barney explores the range of psychoanalytic concepts – such as the castration complex – and eroto-physical formations – like body orifice and membrane – that are associated with sexual differentiation and corporeal/psychic identity employing intense visceral stagings and elaborate allegories. The temporal confusion that marks Barney's monumental work is echoed in the deliberate 'disregard for generational differences', that serves as a key characteristic of the 'perverse imagination'.[19]

The overwhelming continuum of artificiality of the formal/ideational composition shelters, though at times rather flimsily, from the obscene openly rupturing and governing the sublimating screen of art. Whilst the intensity of the visceral translated into a complex 'patchwork' of layered symbolism in Barney's work may remind in some ways of the art of Peter Greenaway's films, its formal rendering, even where elements of the grotesque and phantasmagorical are concerned, is far more surgical, cerebral and above all narcissist. Barney's journey is a highly individual and arti-fictional one that feasts considerably on the iconography of contemporary globalising media culture and its increasing sexualisation.

# Chapter 9

# 'Know Thyself'?

My awareness of being a naturally sexual person was also an awareness that I could be something other than a porn star ... I am accustomed to showing my sexuality openly; it is important for people to see the power of female sexuality ... My work talks about me, about my sexuality, and it is work that becomes political because sex is political.
*Annie Sprinkle[1]*

Pornography and obscenity. What they are depends, as usual, entirely on the individual. What is pornography to one man is the laughter of genius to another.
*D. H. Lawrence[2]*

In 2000, the art publisher Taschen launched *Digital Diaries* by Natacha Merritt (b. 1978), as both a glossy book and a dedicated website. The diaries consist of series of digital images which, according to the publisher's claims, provide an account of the 'very private sexual journey of a twenty-first century girl', the then twenty-one year old North American photographer. They depict situations in which Natacha Merritt and others exhibiting their nude bodies to the camera and to each other, posing lustfully, masturbating and copulating. The visual 'travelogue' is spiced up with some moderate elements of bondage and s/m.

Eric Kroll the 'father-figure' of American fetish photography has written the foreword. In it he sets the scene for the sexually candid images describing them as 'self-representation' of the, of course, young, fit and beautiful female photographer as 'urban nomad with chance encounters'.[3] These tête-à-têtes are said to mark moments of intimacy in anonymous places – nondescript hotel rooms in one city or another – with strangers, beauties in their prime and handsome hunks, during 'anonymous nights'. It is an invitation for voyeurs, proudly issued on the back book cover, to look at pudenda and phalli, to

savour with one's eyes fellatio and other sexual activities. Yet, Kroll does his best to place Merritt within a credible context of recent art history, citing Bunny Jaeger, Diane Arbus and Cindy Sherman, in an attempt to move these clearly pornographic images by a female photographer into the domain of erotic art: 'erotic self-portraits' and 'powerfully erotic images of other young women. They were guttural and unselfconscious.'[4] But how unselfconscious can they be when they are supposed to function as 'self-exploration, self-realisation', a 'form of masturbation, [l]oving one's self, by means of a digital camera'?[5]

The emphasis on digital imaging technology fulfils a crucial function. It strengthens claims to immediacy and authenticity made by the diaristic format – the digital camera as 'eyewitness', suggesting that the images captured are immediately downloaded onto the computer desktop and from there – with a minimum of editorial interventions and/or concerns for the mercantile and stylistic calculations of the publisher – 'transferred' to the printing press or broadcast on the Internet, the latter containing a sample of the book's still photographs and texts for a limited period. The style and layout of the book supports this pretence: the 'printouts' of the digital images appear in various sizes – from double-spread to full-page and less than quarter-page visuals – and in different resolutions. They alter between portrait and landscape format with the effect that the book has to be turned frequently to view them comfortably. The visuals are accompanied by cryptic titles in ten-point Courier, one of the standard computer typefaces. The image titles either point laconically to the obvious (the main subject of the images: *red lips, erotica,* etc.) or sketchily indicate a place or name a co-actor. They appear in the form of a file name completed by the file format (tiff, jpeg, etc.). Interspersed are one-page written accounts allegedly by the photographer, in which she reflects in a first-person voice on personal circumstance, contemplates her sexual persona and 'lustful' encounters, and mulls over formal strategies for a photography that aims to spec(tac)ularise sex. The titles of the texts seem arbitrary too; they list male names as markers of new (sexual) 'transactions' rather then as an introduction of new individualised players; names of places as 'location' of the encounters; or trademarks of film media for analogue photography, like Agfa, the global manufacturer of analogue and digital material for the re-production of images, to flag up her reflection on genre-specific strategies of visualisation. The texts punctuate the unfolding of the visual 'her-story' by introducing new series of images with slightly altered motives, scenery and 'casts'. At the same time, they assist to construct a rather loose and shallow narrative nexus that 'supplies' a much-needed degree of 'plausibility for the licentious pictures of ever-renewed and continually satisfied desire,'[6] of always pleasant and pleasurable experience – as is typical for a pornographic display.

The photographs are shot from the position of the 'unobserved observer', feigning intimacy, innocence and naturalness. The moments captured, in terms of the location of the scene and the style codes of its players, mobilise the 'convention of realism', as an event that happens in the real world.[7] Yet the sexual motives reveal themselves as thoroughly composed and highly artificial. They are interlinked with the codes of language for this genre, and aim for what Linda Williams terms 'maximum visibility' of organs and their

'interactions', or 'maximum visual access' in the words of American art historian Abigail Solomon-Godeau.[8] The preferred angle of the camera is therefore the 'testifying close-up' of erogenous zones in total or half-shot, to make fully visible what is going on 'or in'. Privileged are those sexual positions and 'insights' that reveal the most of the genitalia, that give most satisfaction to the scopic drive. The central perspective remains crucial to achieve maximum visibility as is the fragmented body, reduced to its sexual organs and the actions played out on them: licking, massaging, sucking, penetrating, coming.[9] In some of her photographs, Merritt has condensed the body to such degree of their sexual details that an inference to the bodily whole becomes absolutely impossible, and the genitalia mutate into an abstract sign, a mere ornament.

The stress lies on the spec(tac)ularisation of the sex organs and the sex act. These generic conventions do not lend themselves easily to any narrative flow or character building. They disrupt: from one 'meat shot' to the next. The emphasis on the visualisation of sexuality is underpinned by the shaving off of most if not all female and male pubic hair. In this way, Merritt's 'visual confession' is occupied with the 'dramaturgy of numbers',[10] which is a hallmark of the iconography of desire rather than giving a record of the unfolding of events or of her personal observations and reflections, as the literary genre of the diary would suggest. Merritt's diaries have quite obviously appropriated the 'narrative' strategies of the porn film. When intimate

24. Natacha Merritt, *Digital Diaries* (2000).

observation and reflection are taken literally, as Kroll does in his introduction, they happen through the photographer's body vis-à-vis a mirror and/or camera objective.

The mirror takes a prominent place in Merritt's images. It is at work, not so much as a means of self-exploration and narcissism, but foremost as a technical device that allows the photographer to pose and shoot images at the same time. Having adopted a rhetorical strategy that shifts from looking through the camera lens to being in the image herself may suggest an interpretation of 'embeddedness'. Instead of self-knowledge, however, it is self-surveillance that these images foreground: control and discipline. The key question for Merritt seems to be: How am I being seen by others? Or, more appropriately: How am I being seen by men as object of desire, in the state of arousal, as sexual performer and sexual Other? What does the sexual arousal and act look like when staged in front of the camera? Such a stance implicates the voyeuristic position, and the desire to see and know for certain. It identifies with the forensic, the objectifying gaze, a gaze that is underpinned by a position of signifying power in the symbolic system, with the dichotomy of man as subject, and woman as object. Embeddedness occupies a different position in terms of

the knowledge and power it produces compared to embodiment, although in its visual reading it relies on the latter. Embodiment of experience and its display, it can be argued, empowers the subject as it builds on understanding.

A good example of the power of embodiment in the context of porn can be found in Pipilotti Rist's *Pickelporno* (1992). There, the Swiss video artist (b. 1962) fixes a small surveillance camera on a stick; the camera takes the position of the sexual partner when the artist moves it closely across her own body. The viewer becomes enveloped

by a 'kaleidoscope of mesmerizing bodily images', which the camera captures from a hyper-real nearness: 'breasts, eyes, toes, and pubic hair, swell to oversized and uncustomary dimensions.'[11] The dynamic of the camera gliding across the ignited/ igniting bodyscape, the bulging of its 'mounts' under the microscopic caresses of the surfing lens, emulates the rhythms of shifting attention to one's own body in the

25. Piplotti Rist, *Pickelporno <Pimple Porno>* (1992).

unfolding carnal embrace. It is an attempt to visualize sexual feelings, to show what wo-man sees, feels and thinks when s/he kisses, licks, touches, immerses in the sensual act. Rist seeks to overcome the distance from real experience, the unattainable, that is part of the staple diet of porn. The 'Pimple Porn' is far removed from the knowledge system produced by (self-)surveillance, its informational and evidential, objectifying and ultimately disciplining character.

It is worth noting that the term 'embeddedness' is a recent and popular media coinage that entered into public consciousness during the Second Gulf War when select, state-approved, reporters directly broadcast on TV, radio and the Internet from among the fighting forces and on the battlefields – reporting 'when and as it happens', to use the BBC News 24 slogan. The notion of embeddedness in this context has arguably been employed to suggest an immediate and therefore inherently authentic and objective viewpoint that quite deliberately underplays the correspondent's situatedness within the limits of political, military and security interests, state propaganda and the strict censorship rules that go hand in hand with it. Embeddedness produces information first and foremost, rather than knowledge and understanding. For it to become knowledge it requires critical analysis, interpretation and ownership.

The embeddedness of Natacha Merritt as a female photographer in the pornographic display amplifies, as Linda Williams contends, that much of the 'frenzy' of heterosexual pornography is rooted in its aspiration to make visible what remains invisible: the female climax of sexual pleasure.[12] Bill Nichols and his co-authors observe that photography like any other 'silent' medium has more problems in testifying the authenticity of the sexual performance compared to video or film. Whilst ejaculation verifies man's successful

engagement as sexual agent and is therefore often displayed outside of the partner's body, there is no equivalent visual indicator of female satisfaction. In film, the viewer's carnal knowledge and sexual experience is being relied on, when a woman's groaning in excitement is employed as proof (however unreliable it is in reality) for her orgasm. In still photography, the phallus signifies sexual agency, its ejaculation functions as a substitute for the demonstration of woman's fulfilment, read in conjunction with the bodily interaction and her facial expressions.

> Mainstream pornography represents a phallocentric order symbolised by male desire and a universal masculinist order, naturalized as a given. The phallus stands for sexuality and power. All men desire the same thing as signified by their penises. The socially constructed activities [sex practices] raise the organ to the level of signifier, the phallus. The phallus provides an index or standard of power and authority.[13]

Merritt's 'diaries for the twenty-first century' display a standard diet of heterosexual porn in which the female body functions as projection screen for what is commonly regarded as male fantasies and desires. Beneath Taschen's marketing ploy of sexual self-finding, self-expression and self-education lurk images that have no other aim than to sexually arouse the (male) viewer through the exhibitionist posing of the female body, through warm-ups for the actual heterosexual act of penetration in the form of self-manipulation, onanism, female-to-female and female-to-male foreplay. Crucially, the visuals show men (or women for that matter) neither engrossed in exciting female libido nor 'lubricating' women's viewing pleasure. Whether it is the image-maker's self-display in front of the mirror and/or the phallic camera lens, her self-experimentation with soap, dildo, enema and the like, or the sucking of cocks and other ways of predominantly 'servicing' male sensuality; the dominant gesture carried forth by Merritt's imagery is one of compliance and submission rather than female sexual (self-)confidence, equity and control. The digital diaries buy neatly into the stereotypical role of women as sexual Others rather than 'zooming in' on embodiment of 'feminine experience', on sexual complexity and difference.

Merritt's diaries are by no means the first time that a 'pornocopia' has been constructed in a predominantly visual diary format. An earlier prominent example is Nobuyoshi Araki's *Pseudo Diary*, published in 1980 by Byakuya-shobo. The photographer (b. 1940) was by then on course to becoming one of the best-known Japanese eroto-pornographic image-makers at home and in the West in recent years, not least thanks to the exposure he received through numerous exhibitions in leading art galleries and museums and Taschen's voluminous book project *Araki: Tokyo Lucky Hole* (1997). It has been claimed that the pornographic is his main motif, but that it forms an integral part of his autobiographical approach, part of a 'personal reality.'[14]

For some time, uninhibited sexuality was considered (and flourished) as one of the few areas of freedom for men in the urban centres of Japan's enormously repressive and highly

disciplined society. Nobuyoshi's ascent as a photographer of this metier is closely connected to the boom of the sex industry particularly in Tokyo at the turn of the 1970s and 1980s, on the back of a relatively permissive legal framework that lasted until 1985.[15]

> A compulsive shutterbug who never goes anywhere without snapping it all on 35 mm film … Araki is fond of depicting everything and anything, though sex is substantially higher on his agenda. The sex magazines used to feature Araki's photographic sex diaries, documenting his encounters with students, housewives and prostitutes in Love Hotels and massage parlours.[16]

The 'coarse' side of his photographic output seems to have been fuelled by his and other artists' rebellion against the peculiar Japanese censorship laws that amongst others measured in percentage the permitted amount of pubic hair visible in photographs, manually inking out the exceeding proportion. 'Many magazines made a point of playing a game of brinkmanship with the law.'[17] Amongst them was *Photo Age*, founded by Byakuya-shobo in 1981, which mainly featured Araki's work.[18] And it seems to have been a gesture of dissent that went hand in hand with the sex that has propelled such magazines – and sexually explicit art in general – to popularity in Japan.

However, the strategy employed by Araki in his *Pseudo Diary* and other similar 'spoof' personal records is based on the visual introduction of an event with all the necessary ingredients to make the viewer believe it had actually occurred and the photographer came across it by a lucky chance. Yet, in the process of recounting the incident, it becomes obvious that the event was contrived, a fiction carefully composed by the photographer. Araki's attitude to photographing sex, his penchant for working as an 'embedded reporter' on the expanding and highly profitable sex business was coloured by the same kind of hedonistic indulgence that developed alongside consumerist wealth and disposable leisure time in Japan (and beyond).[19] Whilst taking issue with the underlying argument that the documentary and objective, and its truth claims, are inherent in photography, he exploited the same argument as a condition of pornography. Attempts have been made to reinterpret his entrenched phallocentric take on exploring carnality:

> Araki sometimes likens photography to the sex act, and his camera to a penis, but he never looks or gestures at the women, his subjects, in a phallocentric manner, to project his own lust, and to extract the hidden truth, then Araki becomes a woman when he takes photographs. He absorbs the incomprehensible scenes he witnesses as well as the superficial relationships formed there without altering them. He 'copies' with a refined eye. One might refer to Araki's camera as a device that resembles a vagina pretending to be a penis. In Araki's own eloquent words, 'There is a camera between a man and a woman.'[20]

Such justifications are doomed to fail, because, as Freud has argued, their theoretical foundation, i.e. the equation between penis and eye, is part of the same procreative, signifying (and exploitative) power position of man. As the images demonstrate, camera and photographer fuse into one to literally excavate and lay bare sexual difference, the hidden sexuality of the Other. Araki, first and foremost, sexually reifies womanhood. As for the often praised dissent that motivates his work and has pushed it beyond accepted boundaries, his 'daring' exposures do not venture from the relatively safe realm of hegemonic heterosexuality interlinked with a naturalisation of patriarchal power. Nor do they articulate a different angle on sexual relations other then that sex sells and can be bought like any other commodity.

Rather than putting forward an alternative departure from such a pornographic tradition, for instance looking for heterosexual equality, Merritt's *Diaries*, which in their formal gesture supply 'soft core images for a hard core age',[21] offers a convenient, marketable continuation of the approach fashioned by photographers like Araki.

As book projects by one of the foremost global art publishers, both 'diaries' manage to turn the conventional(ised) obscene into an accepted/acceptable art practice.[22] The Taschen publishing 'emporium', which actually evolved from a comic book shop in Cologne in the 1980s, has fully grasped the continuous and increasing blurring and erosion of the boundaries between high art and popular culture, and has actively contributed to it through its expansive publishing strategy. By situating those diaries (amongst many other sexually explicit volumes) in close proximity to the continuum of erotic (high) art, the publishing house encourages the convergence of ambivalent contexts of sexual arousal (pornography – the 'underbelly' of popular culture) and aesthetic contemplation (art), (e)motions of (different) sorts.

The focus of the two diaries on heterosexual pleasures in conjunction with the ostentatious embrace of the artful no doubt proved beneficial in successfully circumnavigating existing censorship; or perhaps they expose the partiality of current legal, moral and aesthetic framings of the obscene. Moreover, in the face of technological advances in the area of visualisation, a shift of the boundaries between the legal and illegal, between what is considered obscene and corrupting and what aesthetic and moral, may be observed. The American theoreticians of new media Jay David Bolter and Richard Grusin discuss this in regard to the situation in the USA. They show how, under the pressure of immediacy, the media hierarchy captured by anti-obscenity laws has been redefined. This hierarchy and the assumptions in which it is rooted have, they argue, been particularly revealed by 'erotic representation':

Written or printed pornography without illustrations is regarded as the least immediate. Graphic pornography, such as comic books and illustrated sex manuals, comes next. The major cultural line is clearly crossed with photography. Erotic photographs as subject to censorship or possible criminal charges in ways that graphic art and books no longer are. This cultural

reaction stems from a belief in the immediacy of photography ... Film and video are even more threatening because they are regarded as photographs in motion. The place of digital technology in this hierarchy has been shifting over the past decades.[23]

Their position in the order of censorship depended on the traditional representation model that is re-mediated and the cultural status it had/has attained, whether it is the literary book, the 'erotic picture book or photographs', or the video that is becoming interactive and even more 'erotically' immediate through computer animation.[24] It is important to stress that the boundaries between the lawful and the unlawful, between the acceptable and the censorable are not only dynamic, but also highly culturally, politically, socially and morally charged. The parameters of what is considered obscene differ from country to country, with parts of Northern, Central and Western Europe entertaining a more liberal and non-interventionist approach, for instance the Netherlands, Germany, the Scandinavian countries.

With regard to the constitutive role of institutional frameworks in the exploration of sexuality at the intersection of creative imagination and scientific knowledge production, between what Foucault has described as *ars erotica* and *scientia sexualis*, there have been truly challenging, provocative approaches in recent times. Among them ranges Zoe Leonard's 'matter-of-act', black-and-white photographic close-ups of vaginas of all sorts and sizes. It was not her motif as such that contained the radical gesture, as this had found its way into the realm of serious art through Gustave Courbet's notorious painting

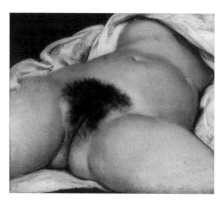

26. Gustave Courbet, *L'Origine du monde* (1866).

*L'Origine du Monde* (1866) (fig. 26). It has also been intensively explored in the images of French photographer Henri Maccheroni, (b. 1932). The latter captures the female vulva and clitoris in extreme close-ups that completely disconnect them from their bodily contexts, metamorphosing them into organoid forms such as a flower in his series of *100 Photos Érotiques* of 1969 for instance. Neither was the scandal of Leonard's images caused by the fact that a woman had dared to take them. The transgression and offensiveness of Leonard's 'low-tech' and rather clinical photographs was generated through both the location and the fashion of their public display. In the Documenta IX in Kassel, Germany, in 1992, she chose to place them as equal works of art and in a sober fashion in the Neue Galerie in-between opulently framed canvases by salon painters of the eighteenth and nineteenth centuries. By disrupting the

conventional order of the positivist museum's display, which is normally taken for granted, she asked pertinent questions concerning the nature of painterly representations of such kinds, and the implications of such an order of display: 'enclosure or exclusion'. Thus the American artist (b. 1961) points to wider issues regarding women's place in the system of visual depiction and in the history of art as indicator for their position(s) in society at large, both past and the present.

A decade earlier, the American Annie Sprinkle (b. 1954) made the transition from 'hooker', porn actress and pin-up model to sexual activist and performance artist. Along with some fellow porn actresses, she was invited by Carnival Knowledge, a feminist performance group, to participate in *The Second Coming*, a series of performances developed for an 'avant-garde art space', Franklin Furnace in New York, in 1984. The series intended to

> explore a new definition of pornography, one that is not demeaning to women, men and children. Set in a replica of Annie Sprinkle's living room, the piece focused on the difference between the women's image and their 'real' selves. While the women 'gather for the meeting,' they inconspicuously remove their porn costumes, exchanging them for street clothing. [As] Bell remarks. 'The stripping, subtle as it is, connects the audience visually to burlesque theatre, reminding the spectator that most of the women worked and work stripping in these theatres.' In violation of this pornographic context, Sprinkle serves tea and cookies to each woman as she arrives.[25]

This performance very much echoed Sprinkle's inauguration as whore, as Sheila Marie Thomas and Linda Williams suggest; the performance of sex in a reversal of conventional conditions – indirectly: as she was lured by the potential of making money not from the actual massage business but from what the massage parlour stood for: commercial sex.[26] Sprinkle suggests that her move into prostitution was spurred on by her own hedonistic sexual curiosity. Resisting society's prejudices, she actively accepted, developed and increasingly projected publicly her role as whore through the means of performance with and of her body and in multiple forms of (stage) acts and discourses. She consciously constructs her life story not as a reflection on experience of prostitution but as a postmodern performance that is being put on with fervent irony and deconstructing masquerade.

It could be argued that her attitude is one of refusal when it comes to accepted sexual subservience or the anti-porn feminists' mono-dimensional perspective of victim(isation) that underscores the positions of American activists Angela Dworkin and Catherine MacKinnoch. Though 'politically ambiguous' and provocatively politically-incorrect in many instances, her radical sex activism and staged performances celebrate woman's powerful sexuality and her own dynamic, multifaceted identity/ies. They speak of her incessant becoming and transformation. Sprinkle's camp flaunting of her sexuality and her collapsing of prostitution, porn, art and sex education cannot be considered independently of the social and cultural circumstances and institutional frameworks in

which they were situated and on the back of which they actually turned not only political, activist and, above all, aesthetic, but through which they achieved wider exposure, valorisation and recognition.

Blurring the boundaries between autobiography and actualisation, cliché and myth, and wholeheartedly embracing the media – print and broadcast – Sprinkle sought to fully place her story in the public domain. She gained creative and economic autonomy and earned professional respect through taking her unashamed experimental sex work and the radical examination of her sexual identity into an increasingly media-saturated and mediated world. Her attitude received vital impulses, encouragement and amplification through both the second wave of feminism and gay activism. It was formed in the context of an emerging diverse range of aesthetic practices concerned with the exploration of identity in terms of sexuality, gender, race/ethnicity and class. Her growing public success was aided by the post-Kinsey, contraceptive pill and pre-AIDS climate of blossoming sexual freedom that went hand in hand with a more candid public discourse on sexuality, that was nourished by and nourishing in this climate, within and beyond the norm of heterosexuality.

Arguing from the perspective of George Dickie's institutional approach to the question of how art can be defined, it could be said that it is the positioning of a work in a 'multi-placed network' of social practices rather than a singular function or an essence that makes an object, a process or a performance an artwork. In other words, the creative activity and its outcome has to be intentionally situated within a complex set of relations, factors and practices that define the social system of art.[27] The gallery, museums and art schools and the discursive network of art critic and historians, art educators and mediators, as well as the respective publication, media and distribution structures play a crucial part to locate and/or move the experience of radically transgressive work into the realm of the aesthetic – though this of course is not a process free from contradictions. In many ways, Sprinkle acquired insight into the workings of both the art and the (mass) media systems.

Her acquaintance and collaboration with Willem de Ridder, a founding member of the European Fluxus movement, as well as with the heterogeneous aesthetic strategies that were brought together under the umbrella of Fluxus more generally, produced vital impulses for her journey from society's underbelly of prostitution, porn film and sex image to politicised activist performer addressing broader and diverse audiences with shows such as *Nurse Sprinkle's Education Class* (1985) and, later, *Post-Porn Modernist* (1990–1995) and *Hardcore from the Heart* (1996–1997), amongst others.[28] During this transformation process, she increasingly sought advice from and exchange with other artists and cultural activists and studied for a BA in Fine Arts at the School of Visual Arts in Manhattan.

> Sprinkle's infamous 'Public Cervix Announcement' [where she placed herself on stage, legs akimbo and invited the audience to look into her cervix with the help of a hand-held flashlight] is in direct lineage with both Yoko Ono's 1964 performance entitled 'Cut Piece,' "in which [Ono] sat motionless on

the stage after inviting the audience to come up and cut away her clothing ...” and Shigeko Kubota's 1965 Vagina Painting’ performance, in which she applied paint to paper using a brush inserted into her vagina.[29]

Insights into the workings of the publishing industry were not only accumulated through her modelling experience as a pin-up for *Stag, Cheri, Hustler* and other magazines. She also founded magazines, and documented the 1980s sex scene as a writer on sexual pleasures and as a journalist for magazines including *Newsweek*.[30] Some of Sprinkle's performances have also been shown on TV and received reviews in art journals. She has been the subject of documentaries and interviews during the past two decades, and was also more recently included in the video *Afflictions*, a compilation of 'young cutting-edge performance artists' released in 1998.[31]

Annie Sprinkle as a sex labour activist, prostitute, pin-up girl and porn star turned performance artist 'embodies' a dialectical image that maps out an undecided, uncertain space between sex business, art establishment and media industry, between the obscene and the aesthetic, the excessive and the regulated, the intimate and the public, between 'agency and objectification'. Sprinkle's shrewd awareness of her 'fluid' position and role in a postmodernist situation is clearly articulated in the title of her autobiography: *Annie Sprinkle, Post-Porn Modernist: My Twenty Years as a Multimedia Whore* (1998). She appeared in about 150 porn movies during the 1970s. They included pieces with revealing and by today's taste fairly naff titles such as *Wet Christmas, Kneel Before Me, The Devil Inside*. She also featured on posters and (self-published) postcards, in magazine ads and on flyers. Her career as porn star coincided with the heyday of the porn film industry in the USA, in the wake of the (mainstream) cinema success of *Deep Throat* – in the mid 1970s, North America boasted around 900 porn movie houses. With *Deep Inside Annie Sprinkle* (1981),

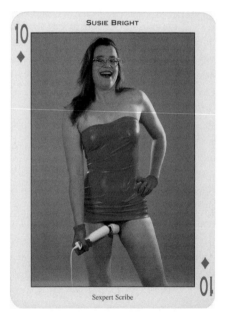

27. Annie Sprinkle, *Sexpert Scribe* (1995).

she made her debut as writer and director of her own hardcore films; subsequently, some of them were also produced and distributed by her. Embracing trial and diversification before mastery and perfection, she has also been involved in a cottage-industry-style production of sex mementos such as 'porno prayer candles, cervix buttons, postcards,

porn videos, books or Tit-Prints',[32] that went along her burlesque style performances, and further magnified her parodic stance. Sprinkle is not only represented in many a private collection of porn movies, pictures and pleasure objects; she is also on display in New York's Museum of Sex as one of the main figures of the city's sex scene in the later 1970s. However, as a multimedia performance artist, she has adopted, adapted and appropriated a carnivalist attitude in which truth is revealed through laughter. She is also documented in one of the main 'temples' of western art: New York's Museum of Modern Art. Its library and archive owns a set of her *Pleasure Activist Playing Cards* (1995) (fig. 27), on which she and her female collaborators exaggeratedly pose in many clichéd pin-up fantasies and as 'sex-education' dummies, and other print material.

Finally, the meaning and effect of Sprinkle's pleasure-driven performative work and feminist engagement cannot be fully grasped without acknowledging the role that an understanding of pornography as a 'will to knowledge' has played in her creative evolution and activist transformation, and the context in which such a notion came gradually to the fore of public discourse during the 1960s and 1970s. The comprehensive scientific study of heterosexuality across a broad spectrum of practices and proclivities was pioneered by Alfred Kinsey and his staff in *Sexual Behaviour in the Human Male*, published in 1948, and *Sexual Behaviour in the Human Female*, published in 1953. The discipline of sexology, which Kinsey helped to establish, promoted a discursive framework in which female sexuality and women's 'entitlement to sexual pleasure, at least within marriage, was being recognized' and scientifically explored.[33] This and other work on heterosexuality, in turn, motivated the production of sex manuals, sex advice videos and adult sex education programmes for television (Oswald Kolle's sex education programmes in West Germany of the 1960s for instance). They set out to familiarize the users/viewers with accepted forms of heterosexual pleasure, with fe/male erogenous zones and with handy tips to stimulate both sexes. Moreover, they helped to find a language with which to openly speak about sex and break through prudish silence or metaphors. 'Permissive' attitudes to sex, particularly with the availability of the contraceptive pill from the late 1960s onwards, supported their distribution and popularity. However, much of the scientific discourse during the 1960s and 1970s helped to 'reaffirm that sexuality was principally a matter of physical performance and athletic technique'.[34] Though these educational materials helped shed light on what was still widely considered women's hidden sexuality, they did not necessarily establish new ways of knowing and experiencing that could allow women a sexual experience defined by themselves rather than driven by male desire.[35] The latter was addressed (from heterogonous positions) with the strengthening of feminist positions during the later 1970s and1980s driven by works such as the *Hite Report* (1977).

Producers of pornography in the 1970s sought to capitalize on the authoritative discourse on human sexuality. They promoted pornography as an accessible and widely available instrument for the exploration and understanding of sexuality in its manifold expressions through the curiosity of the gaze. They built on the belief that by seeing one knows. The optical organisation of the world, as Foucault has argued, includes its

possession. The wave of porn films during the 1970s started off in the 'guise' of mass enlightenment and education.

Sprinkle's sex performances in videos and live events commenting on her earlier sex video work like *Herstory of Porn–from Reel to Real* (1997–2001), however, diverge from the classifying approach, sociological impetus and report character. For more then two decades, she has experimented with and expressed her sexuality in multiple forms in front of the video camera and, in doing so, she did not shy away from the inclusion of female masturbation, homosexuality and what have normally been considered transgressive sex rituals. By 're-enacting' those earlier 'hardcore flicks' and disrupting them through equally ironic and analytic live comments and interactions with her projected on-screen images, she not only dismantles the visual and narrative codes of pornography, she also reveals the constructedness of both her sexual persona and her sex activist/artist/educationalist existence. From the conventional privileging of the eye in her porn productions, she has been moving towards a deconstruction of the spec(tac)ularisation and the knowledge it produces by potentially activating all senses and embodied sensuality through a shift from drawing on the observer to invite audience participation in some of her life 'actualisations'. In any case, Sprinkle has contributed to the articulation of female sexual desire and pleasure from a woman's point of view. And she has done so provocatively and controversially, but equally successfully, by speaking through a range of voices, performing and displaying her work in a range of locations: from theatre to gallery, from club to the lecture theatre of the university, from museum to television and the Internet; and by reaching out to and bringing together different constituencies

Sprinkle's (post-)post-porn modernism 'is a way of grappling with the meaning of the live female body in this techno-cultural moment, the era of simulation and virtual gratification, and of dismantling old paradigms and hierarchies of pleasure'.[35] Her effectiveness in contesting dominant patriarchal concepts of female pleasure and sexual power relations is rooted in the astute insight, clear understanding and tactical utilisation/ appropriation of the discursive, representational, institutional, and power frameworks which she addresses, in and across which she operates, and in and across which her multifarious and ambivalent practice is being exposed and discussed.

# Chapter 10

# Digital (Counter-)Currents

In a sense, pornography is the most political form of fiction, dealing with how we use and exploit each other, in the most urgent and ruthless way.

*J. G. Ballard*

A woman – half sitting, half kneeling on what looks to be an upholstered stool – is captured in a closed-off interior situation, literally and metaphorically. She inhabits and slightly exceeds the life-size portrait format of the photograph. Whilst her head is facing the viewer directly, her body is turned slightly to the left. In the somehow blurred colour image the viewer can make out that her legs, which are awkwardly spread apart, give some limited sight of her sex. She is dressed in black stockings held up by suspenders. The outfit is completed with a tight and skimpy black corset that finishes beneath the breasts, buttressing them, as well as extreme knee-high and high-heeled boots in white. They are the kind of boots that are a standard requisite in the sex business and loom large in male sexual fantasies. The hazily veiled picture still allows the viewer to recognise that the woman's head is subject to some kind of gagging. Her eye, nose and neck regions are covered up with black material. Closer inspection shows her arms are tied to the sides of her body and her slim legs held in a rather strenuous position by straps that are fastened around her waist and ankles. The totality of this performative arrangement makes up a display in which the woman features as an object of pronounced fetishist obsession and tamed s/m desire. Spread legs and bondage – the woman's body all receptacle – her configuration signals to the (male) viewer that she is ready to be '(ab)used'. The gesture talks of female passivity and subservience, her – voluntary or forced – compliance with male desire.

This untitled photographic picture forms part of Thomas Ruff's series of *Nudes* produced in 1999–2000. The German artist (b. 1958) came to the fore during the later part of the 1980s as a younger representative of the school of 'objective photography', having studied under the highly influential photographer Bernhard Becher at the Art Academy Düsseldorf.

Bernhard and Hilla Becher's 'objective photography' situated deliberately within an art context was instrumental in the development of aesthetic strategies of descriptive, documentary photography in Germany following on from the work of August Sander and others earlier in the twentieth century. This

conceptual approach sought to reduce the influence of the subjectivity of the image-maker through the accumulation of objects of a specific type, be it water towers, timber frame-domestic buildings or individual portraits. As Benjamin reasoned in the mid 1930s, the camera lens restructures the optical activity of the sense of sight in that the technical eye of the camera makes accessible what the natural eye is not able to see or is not paying attention to. It brings to the fore what he terms the 'optical-unconscious'. Those classified objects are captured and displayed as series that are formally held together by unifying picture format, scale and framing. Ruff's specific approach to photography has been marked by a content-related use of different photographic technologies and forms of representation driven by a

28. Thomas Ruff, *Nudes c02* (2000).

heightened awareness of the fact that the photographic image 'is always constructed by the person who is behind the camera'.[1] In this respect, he magnifies considerations for the relations between the technical aspects, that is, the picture-defining factor and the applicative function of photography.[2]

For his series of nudes, Ruff has selected and downloaded the raw material from the vast number of Internet sites that circulate sexually explicit photographic material. The images were taken from the economy of online pornography that can be accessed by credit card wherever and whenever a connection to the World Wide Web can be facilitated: at home, clandestinely in the workplace, in an Internet café. The low price and general availability of stationary PCs, the growing number of powerful laptops, new generation mobile phones with Internet access and video function, Wi-Fi zones and online terminals mean that these items continue to increase in number and are becoming ubiquitous in urban locations such as hotels, airports, libraries, shopping malls, on street corners, making access to pornographic material child's play.[3]

Numerous claims have been made for the 'impact' of digital information and communication technologies on cultural assumptions, consumer attitudes and behaviour, on the ways knowledge is produced, distributed and accessed, and on the ways reality is

symbolically represented. They have been closely linked to the argument that one thing driving the development of means of mass communication and information is the quest for higher degrees of immediacy. Each new text, imaging and sound-recording technology, from the early photographic camera to the digital video camera, from the mechanical music box to the home entertainment system, from the book to the computer, all of those inventions have sought to reduce the media interface of representation. Technology has aimed to transcend the book page, the television screen or computer display. The desired and attempted eradication of these mediation interfaces between the actual event or real object and the viewer holds the promise of achieving a more 'direct encounter' with reality, a greater 'transparent' immediacy and authenticity.

> Immediacy is our name for a family of beliefs and practices that express
> themselves differently at various times among various groups ... The
> common feature of all these forms is the belief in some necessary contact
> point between the medium and what it represents. For those who believe
> in the immediacy of photography ... the contact point is the light that is
> reflected from the objects on to the film. The light establishes an immediate
> relationship between the photograph and the object.[4]

The logic of immediacy is closely interrelated with the logic of hypermediacy, as Jay David Bolter and Richard Grusin, amongst others, have persuasively argued. Hypermediacy means the combination of multiple media (like in a web page, a video game or a music DVD), that takes its 'raw ingredients' from 'images, sound, text, animation and video in any combination'.[5] The interplay between the logic of transparent immediacy and hypermediacy constitute and (trans)form practices of remediation that is the 'representation of one medium in another'.[6] 'Remediation always operates under the current cultural assumptions about immediacy and hypermediacy.' Hypermedia applications such as a web page or a video game are 'always explicit acts of remediation' as

> they import earlier media into a digital space in order to critique and fashion
> them'. However, digital media that strive for transparency and immediacy (such
> as immersive virtual reality and virtual games) also remediate. Hypermedia and
> transparent media are opposite manifestations of the same desire: the desire
> to get past the limits of representation and to achieve the real ... The real is
> defined in terms of the viewer's experience; it is that which would evoke an
> immediate (and therefore authentic) emotional response.[7]

The concept as well as the social and cultural function of obscenity, it can and has been argued, is intimately linked with a desired sense of presence, of 'transparent representation of the real and the enjoyment of the opacity of media themselves'.[8] What can be a greater confirmation of a medium's capacity for immediacy then the witnessing of actual sex.

This experience is hardly spoilt by the knowledge of the capacity of digital imaging technologies to manipulate and fake images that has completely eroded photography's claim to authenticity and intensified the long-apparent crisis of representation.

The digital 'pleasure bites' that Ruff has recycled and appropriated, have first appeared as low-resolution, relatively small web images. Before Ruff blows them up to almost life size, their file size is just large enough to present them clearly enough on the average computer screen. Such monumentalisation would have produced individual pixels of two square centimetres each and thus destroyed the representational quality of the image. Instead, each of the seventy-two pixels per inch was multiplied by thirty-six. This operation generates the impression of a semi-transparent veil that blurs the whole *mise-en-scène*, denaturalises and depersonalises it.[9] Based on the principles of control and chance, order and disorder, some further image manipulations out of the digital bag of tricks have been employed to soften, haze, obscure and conceal the spread, bound and copulating bodies. Movements and actions become adumbrations. This manoeuvre accentuates the performative element of the display, the staging of the body, but it does not make it more striking and distinctive. Rather, it reiterates and stresses the repetitive nature of pornographic photography, its clichéd poses, positions and props in a way that the individual picture can be hardly recalled, yet it cannot be forgotten either. There is a level of communication at work in them that operates in an almost 'subcutaneous way' that remains difficult to fully elicit.

The visual material Ruff has selected for *Nudes* comprises references to the pin-up tradition, in this context with more or less unobstructed views of the female genitalia, and with a certain amount of phallic display. They also include exaggerated French kisses, 'lesbian numbers', full-blown intercourse of heterosexual as well as homosexual variations, and soft forms of sado-masochistic 'configurations'. Most of the images would normally function as 'warm-ups for the decidedly phallic activity' that constitute the core of Internet pornography, which has been modelled on both the peep show and the stag film. The activities put on display by Ruff are in their majority an 'emblem for the erotics of the heterosexual, male viewing observer'.[10]

The digital photographs subscribe to the pragmatics of arousing sexual desire. This becomes glaringly obvious in their direct references to the conventional formats and dominant economy of the voyeuristic male gaze. Whilst any online display can potentially draw on the multimediality of the digital realm in which image, sound, text and animation join forces to titillate their 'vuser' (viewer+user),[11] Ruff has deliberately restricted those staged bodies in action to visual still reproductions and reduced the potential of their intended seduction in favour of an investment into the cultural codes of their construction not least through a strategic emphasis on the exhibitionist performative character of the posing and exhibit of sexually motivated (en)act(ment)s.

As the surrounding environment becomes blurred and homogenised, other scene-setting and 'marketing' elements which might have been involved in the initial online exhibition disappear. These could have included an 'erotically charged' soundscape, a

'luring' or extolling oral and/or verbal commentary. In Ruff's mono-sensual reproductions these elements are 'shut out'. Instead, the corporeal gestures and optical signals that have become conventionalised in the advertisement and selling of sex are 'placed' centre-stage. The reworked still images bring to the fore the 'crude baiting for visual creed' of this kind of exhibition of bodies.[12] They underscore the visual dimension of the production of obscene material in its calculated address to the voyeuristic gaze: the embodied one, and that of the 'eye of imagination' – if such a separation is possible at all. They conform to and affirm the dominance of the sense of vision in western culture, which is engrained in (philosophical) language itself from 'idea' to 'theoria', from the 'eye of the mind' to reflection and speculation. In this sense then, Ruff's series implies that the importance of erotic and pornographic images lies in their relationship to acute bodily sensations mediated through the sense of sight. Pornographic images are not looked at by neutral, immaterial eyes, rather, their effects are generated by the 'carnal density of the observer', by an embodied vision. In that, collective, conventionalised practices of looking and specific individual dispositions, intentions and applications intersect on the shifty grounds of the ob-scene. The 'thickness of the body' in the construction of visibility – what becomes visible, how, where and when – may have been of a more central concern in modern vision and in the critical debate about the construction of the viewing subject than has been generally acknowledged, as Jonathan Crary and Linda Williams have vigorously argued.[13]

Pornographic images are made to appeal to the voyeuristic gaze. Voyeurism depends on a separation between a visual partaking in the sexual act and a physical non-participation. The distinction between implicated eye and detached body stimulates an imagined bodily involvement as a continuous monologue daydream, as the German art historian Matthias Winzen has argued. One stands outside oneself, that is, one cannot live out through and in one's body what is being suggested in a narcissistic way by one's own body-oriented imagination. The eye-body disparity in which voyeurism is rooted might be considered as an analogy for the relationship between computer and body, between a relatively uninvolved yet visually alert onlooker and the actions of the pixels on the screen.[14]

Ruff's concentration on manipulated and monumentalised still photography in an act of retroactive remediation re-invokes the old rivalry between photography and painting. In this body of work it is connected to a recourse to the re-construction of the traditional separation between spectator and spectacle. Not least through their muted and flattened expressivity, their local fixity and stationary character, for their sheer scale and the requirements for presentation that goes with it, *Nudes* widens the gap between onlooker and the picture. What the digital online material sought to greatly lessen if not to make transparent in the consciousness of the 'vuser', who has become increasingly accustomed to the moving image, has been strategically stressed so that the images spell out their mediated nature. Rather than representing reality they represent images of images of reality: simulation instead of immanence.[15]

The usual small-scale photograph is a tactile, tangible and highly mobile (transportable, collectable and exchangeable) object that is able to produce a degree of intimacy with

the viewer by being 'on site' of the immediate experiential space of his or her body. Therefore, the objects displayed on them can almost 'move into' the viewer. Ruff's large-scale photographs however impose an insurmountable distance to the viewer and thus support a dematerialised form of seeing. Despite their enveloping measurements, they produce an alienating effect. In conjunction with the generated visual barrier, the veil, they scale down the intensity and 'erotic power of persuasion'. In short, the attraction of the Nudes is ambivalent: the hazy images lure the gaze, yet keep it at arm's length. In this way, the images stimulate a complex, multi-layered and selective process of perception, an act that seeks to remove or circumvent those visual barriers to uncover all the pictures' details, to strip them bare in order to get from its surface values to their supposedly deeper meaning. However, in the end the viewer is left disappointed and unsatisfied as the impossibility of visual penetration becomes glaringly apparent.

Ruff's sexually explicit 'depictions' have – in size and format – been customised for display in a representative public or semi-public situation: a gallery, reception area or 'drawing' room. They were produced as chromogenic colour prints and laminated/concealed with Diasec Face. Ruff has mounted his images with a white border and placed them in contemporary wooden frames in a print run of five, and two artist's proofs. The untitled but numbered pictures have also been made available as coffee-table book accompanied by a fictional text specifically created by French writer Michel Houellebecq.[16] This 'double-barrel' dissemination strategy secures Nudes wider exposure to a broader audience and lends them an enhanced degree of longevity beyond any attention to the work that the exhibition circuit even with an extensive critical discourse and media coverage would have managed to achieve on its own.[17] The glossy book format with its pronounced durability, representative character and continued availability (or at least accessibility through public libraries and second hand book shops) enhances the cultural currency of both the publication's subject and the art's producer. It thus inscribes it more firmly into the collective cultural memory. The book format differentiates the work from the economics of the Internet with its predominant existence for the now-time (Jetztzeit) and instant accessibility, its accelerated wear and tear.

The double exposure of Ruff's pornographic material produces potentially very different real effects for the beholder. In the public space of the gallery the images are fixed to the wall and their large scale commands a distance between them and the viewer, which supports the work's elevation into the aesthetic sphere and a 'standard' contemplative encounter. The comparably compact coffee-table book is portable and can be manually handled with ease. As such the latter potentially connects tactility and visual pleasure within an intimate setting. It thus can potentially operate as a physical template for autoeroticism and other practices of sexual gratification.

The case has been made that Ruff's series of Nudes has evolved from the artist's continuous efforts to examine the potential of both traditional and digital photography particularly in terms of their indexical function(ality). Indexicality signifies the dimension of a sign (and photographs, as much as other cultural images, are signs) in which the

signifier is not arbitrary, but is directly connected in some way to the signified. This link can be either observed or inferred.[18] In some ways, photography as light-writing functions similar to the footprint in the sand, as Susan Sontag observes: in the first instance, the camera can only capture what has appeared in front of its objective and is relayed to it through light. Yet, the outcome is already informed by the programme of the optical apparatus and its user's playful choice(s) actually made from the multitude of virtual combinations constituted by the programme of the apparatus. The 'seized' information can then be potentially manipulated – in traditional photography through analogue processes, and within digital media in much more radical ways, which undermine any notion of authenticity.[19] However, as photography was considered special in its indexical relationship to the world, which forms the foundation of its system of representation, it was thought that therefore photography has the capacity to document reality in a factual and objective way – hence the (German) name for the lens: *Objektiv*. It is seen to get closer to the real world than painting (the realm of imagination, fiction and heightened symbolism) would have ever been capable of. Painting always reveals itself as an aesthetically elevated and 'refracted' mediation of the world.

The intervention of photography was closely connected to the production of pornography. In a similar way, amongst the first civil and commercial applications of digital photography and the Internet were the production and distribution of sexually explicit material. Internet user statistics give credence to such claims: In September 2003 there were 260 million porn websites – compared to 14 million in 1998 – which generate well over US$1 billion annually. Of the total number of websites globally more than 50 per cent are 'sexual in nature'. Statistics indicate that the usership of pornographic Internet sites is predominantly male: of the 32 million unique individuals who visited porn sites in September 2003, at least 71 per cent were thought to be male.[20]

Photographs as a complex cultural sign are closely connected to the issue of conventionality. Whilst their indexical dimension 'direct(s) the attention to their objects by blind compulsion', as Charles Sander Peirce puts it, they have also more or less accentuated iconic and symbolic dimensions.[21] As icons they are strongly motivated, that is, they are constrained by the signified. As symbols they are highly conventional.[22] They are constructed on the basis of cultural codes, which, in the context of this book, raises the question: How does one recognise a pornographic image? The Italian philosopher and writer Umberto Eco asked a similar question in 1989 with regard to the pornographic film, and argued that its typical characteristic is dead time, time in which nothing happens. In order to mark the transgression of moral (and aesthetic) norms as such and to awake an interest, the sexual 'transaction' has to be distinguished from the everyday, from 'normality'.[23] Similarly, the performances of sex depicted in pornographic photographs are conventionally situated within rather banal and often bare if not dreary environments. The surround of the 'stage acts' is usually limited to essentials and props required to make the scene (sensually) plausible for the spectator. The camera lens zooms in (almost) exclusively on the (entangled) bodies of the agents, and in particular on their primary and secondary

sexual organs, as well as their (titillating and copulating) actions. The framework of a series of images may put a scant narrative overlay to such an ensemble, but not in Ruff's case. His works are either untitled, as in the book publication, or just numbered as colour prints, making them barely identifiable entities within an enormous and continuously expanding, profitable area of image (and multimedia) (re-)production.

The artist has described his own motivation for this series as a reflection on the genre of nude photography, which is situated within the field of tension of social and moral values on the one hand, and in terms of its pictorial content at the boundary between art historical precedents and mass cultural expressions on the other. His classifying accumulation of 'Nudes' is held together only by the indicative series title, which places the work ambivalently into the proximity of the dynamic and shifting boundaries between mass reprographic genre and art historical precedents. Descriptive in intent, *Nudes* as title serves as euphemism in both directions. In other words, Ruff's already mediated pictorial worlds reference pornographic photography situated in the 'underbelly' of popular culture, a genre that is marked equally by professional investments and by amateur attitude, yet always carried by a calculating, mercantile impetus. Through their format and presentation the appropriated pictures also create a continuity within the domain of 'high art' – a continuity that is as affirming as it is mocking – by pointing to the long history of western representation of the female nude and male heterosexual desire that spans from Titian, Velasquez and Goya via Courbet, Manet and Rodin, to Matisse, Picasso, Freud, Richter and Balthus (and many more); a practice that has been veiled as erotica rather than pornography through the powers and mechanisms of the art institutions and their discursive and critical circuits, as described earlier. Finally, Ruff's appropriation of Internet pornography relies on and is complicit in the economic structure on which the industry is based. Although as an economic sector within the cultural industry web pornography is highly profitable, its professional and amateur actors, predominantly women, are on average not well paid nor do they enjoy (many) social rights in the workplace; their 'creative investment' is unacknowledged and yields no cultural capital (status and prestige). They remain anonymous, 'off-stage'. Ruff takes advantage of this unequal, exploitative power relationship in *Nudes*, accumulating profit and cultural prestige in his signature-artist practice through the appropriation of these anonymous and/or (further) anonymised works.

Ann-Mie Van Kerckhoven's visual strategies are situated in a field of tension similar to Ruff's. They too concern the mobility and dynamics of images across different cultural arenas, from mass media to the museum, from advertisement to the art gallery and return, in conjunction with the respective practices of looking, of consumption, which are informed in and through them. Much more consistently and extensively so than Ruff, her increasingly layered multimedia work also deals with the female nude. Photographic images of females in alluring and tantalising poses from a wide variety of printed mass media have provided the stock for much of Ann-Mie Van Kerckhoven's visual work especially, but not exclusively, since the mid 1990s. The Belgian artist (b. 1951), shows a particular interest in the popular pin-up format. She has been collecting visual representations of women from

magazines, journals and newspapers in an almost compulsive fashion. Her main concerns rest with the objectification and commodification of women in the climate of a growing mediatisation of contemporary life.[24] She has been spoilt for choice as the last century and the beginning of the new millennium have been saturated with pictures of beautiful, highly desirable yet unreachable, intangible and unattainable women. As 'appetisers' for the sale of consumer objects – from cars to sofas – and, as pin-ups, merchandise themselves, they nonetheless illustrate very palpably the commodity character of (the female) body and of sex. Much of the collated material is prosaic rather than poetic, taken from the vernacular of information and communication.

The images – but also words and text fragments – have been compiled, ordered and stored digitally. The artist employs a computer

> to create systems in order to reveal things while working. Thus the information becomes the form, a tool; it becomes the canvas on which I work. The information, the data, becomes the paint, a mixed storage of past, present and future intelligence.[25]

The database is exploited to produce increasingly complex non-linear multimedia narratives consisting of overlays of image, text and video animation. They bring together pictorial fragments that oscillate between graphic design and imaginative figuration, advertisement and textbook illustration. The final outcome takes on a variety of forms: video clip, film, elaborate spatial installation, online display, picture. Mostly, if not exclusively, they are designated for public display in the gallery space.

Over the past decade, Anne-Mie Van Kerckhoven has been committed to her extensive ongoing didactic project *Head Nurse*. Stages of the project are based on material the artist has collected from the 'naked women press' that dates from before the period of sexual liberation. These mass-reproduced images were 'meant to meet men's desire to look at women in different stages of "undress"'.[26] Other parts of this ongoing work in progress appropriate images of women from the 1970s (and later decades), which coincided with their liberation campaign. Yet, as has become quite apparent over time, what had been partially achieved in the West was a female sexual emancipation from the repression of bodily desires, expression and experience. But women's increased sexual freedom and control over their bodies was accomplished mainly on men's terms. It did not mean the end of women's (sexual) domination by men, of unequal gender power relations (inflected by class, race, generation and ability), nor of the patriarchal foundations of society at large. It has, however, effected changes in the methods and forms of male power and control. In some respects they have become more subtle and covert.

Amateur photography is cited, both formally and metaphorically, in an early series under the *Head Nurse* umbrella. Here, photographic images of women have been digitally manipulated in emulation of the contrast-saturated language of graphic design. Through line and simplified, schematised form and colour they bring out those supposedly seductive

gestures and attributes of women in 'different stages of "undress"'. Underpinned by a standard portrait format, the pictures highlight the repetitive principles of camera angle and unimaginative composition. They are accompanied by examples of technical jargon from the domain of photographic process, technology and history such as *polarisation, refraction, reflection, luminescence* and *fluorescence.* Whilst experimenting with the parameters of the apparatus and photo-chemical processes, with light-sensitive material and technical equipment, the illicit and transgressive genre of pornographic photography has sustained its remarkable popularity amongst amateur photographers working 'off-scene': behind the closed doors of the darkroom (and beyond). In the context of amateur photography, perhaps the pornographic images serve as a kind of male trophy.[27]

In another complex part of *Head Nurse*, which includes *Nursing activities, direct, Nursing care+timing* and *Nursing need* (1996–1999), Anne-Mie Van Kerckhoven plays a different game with the conventions of the centrefold spread to unsettle the 'male gaze'. She reduces – applying digital image manipulation processes – the mass-reproduced photographic images of posing female nudes to their outer contours and places them on to a flat, monochrome background. These images are accompanied by text integrated in the pictorial format. Rather than functioning as an explanatory legend or supplement, the text forms an integral part of the work. The chosen phrases themselves are significant, but so is the choice of styles of writing and/or typefaces. The juxtaposition of scribbled handwriting in some of the work with standard print typeface such as Courier pitches different cultural stereotypes and discourses of knowledge, different epistemological systems, authority and power against each other. Read in conjunction with the imagery and the overarching title, *Head Nurse*, this can be understood as exposing and working through binary oppositions on which western thought has been based for so long: mind – body; male – female; science – art; rational – emotive; subject – object; public – private; licit – illicit; formal – informal. And these mark the economy of pornography too. The remediation and denaturalisation of the images over time and space also foreground the complexity and dynamic of contemporary social and cultural practices: that which is and has come out in the open and that which remains hidden away, is marginalised and excluded. *Head Nurse* paints a complicated picture of gradually shifting boundaries between different cultural domains, including those between high art and popular or mass culture, between traditional and new media towards stages and forms of hybridity.

The pin-up culture was built on the putative advertising potential of scarcely clothed or naked women, women who normally remained nameless, or could consider themselves lucky if their assumed stage name or pseudonym was mentioned in the caption. More often than not, they assume or will be given a fictitious name that corresponds and underlines the fabricated erotic/sexual persona suggested through the staged visual images as correlation between model, styles of codes of (un)dress, environment and target audience.[28]

Pin-ups and the communication of advertising, existing in close proximity, share crucial characteristics: both are fictional rather than fictive. That means that the (reference) question regarding truth or falsehood, which is dominant in other discourses, is suspended

in favour of criteria that determine their effect(iveness), their noticeability, their potential to motivate/stimulate, and thus their power of seduction. In order to be effective, they are always required to exist in the here and now; they need to appeal to the Zeitgeist; they have to be in tune with the ruling fashions and predilections. In response to these criteria, aesthetic strategies are functionally employed to produce contemporary 'artefictions', which read as contemporary 'artefacts'. In other words, the constructed images have to display a developed degree of cultural plausibility and pragmatic persuasion that assures they fit neatly into the pretence of a specific socio-cultural mentality and reality. That means, that the representation/simulation of female nudes is always marked by continuity – the conventions of this genre, its purpose and the (male) viewers' expectation and accepted power relations – as well as rupture – the need to capture the attention and imagination of the onlooker through a degree of extraordinariness in exposure and/or suggestive narrative and/or formal novelty, supported by different modes of meaning making in multimedia productions.

In other words, the genre of the pin-up is accompanied by processes of translation, adaptation and remediation of codes and styles to suit different cultural realities, depending, for instance, whether they seek to appeal to the respective viewer/reader of *The Sun*, *GQ*, *Hustler*, *Playboy* or *Penthouse*, and their equivalent in the realm of the World Wide Web, comic magazines, poster books and other printed erotica.[29] In its high-art variation, this genre featured prominently in the work of photographers Helmut Newton, Bill Brandt and Irving Penn, among many others. It was also explored forcefully by American (pop-)artist Tom Wesselmann in his series of *American Nude(s)* for instance. Significantly, he made a self-portrait in which not only half of his head 'fell victim' to the form of a female breast, but where he placed himself drawing under/in an abstracted woman's crotch, in 1983.

On the other hand, artists such as Ghada Amer (b. 1963) use the language of the pin-up girl and sex display as means, it could be argued, of provoking the viewer, of brushing against their expectations and assumptions. The Egyptian artist operates with the graphic contours of her photographic source material and translates them into large-scale embroidery. The stitching maps the simplified contours of an accumulation of female bodies that stretch across the fabric in all directions. In the lattice of stitches the viewer gradually deciphers that there are women engrossed in masturbation and same-sex gratification. An explosion of female lust grabs hold of them.

These pleasure-scapes could be read as candid, liberated and confident assertions of women's (right to their) own sexual desires and experience beyond the confines of social norms. Amer's images, however, placed in relation to her native cultural background and history and its constructed perception in the West, appear to play on and with male fantasies of a harem of lusty playmates, directed by and ready to satisfy the master's desires. As such, needlework as the chosen medium of expression operates as a determining factor: it is women's work that demands a high degree of dexterity and diligence for its execution as well as a refined taste when it comes to the choice of subject and its realisation through embroidery. As embellishment, it transforms the fabric into a luxury and/or symbolic

object for the adornment of its owner or wearer. In this visual and textual economy, class and power relations become part of the equation: who made the fabric and for whom. As in Grayson Perry's ceramic work, discussed earlier, the preciousness of the material and the skill and effort involved in its one-off 'transformation' clashes deliberately with the seemingly inappropriate obscene subject matter depicted, as the latter would be more readily associated with cheap, mass produced objects.

Van Kerckhoven's collection of pin-up material demonstrates vividly the cultural/ stylistic/pragmatic changes that have occurred over time as well as the continuities within the category of sex object and 'mass commodity' in a climate where the rise of new technologies has lead to an increased prominence of pornography in all spheres of cultural activity. Whilst the technical qualities of images may have radically improved, their themes, motifs and stereotypes, have become ever more repetitive.

In Van Kerckhoven's chosen imagery, the body functions as a socio-cultural 'design product': a perfect physique accomplished through a regime of diet, exercise and/or surgery; beautiful features drawn out with the help of make-up, manicure, hair and body styling and/or enhanced through syringe and scalpel. And as such it is naturalised. Yet, its staging in front of the camera lens (and under the influence of the airbrush etc.) accentuates precisely the manufactured character of the performing body and the body performance as an enticing 'wrapper' for equally manufactured and exploited human desires.[30] Under current cultural conditions and prevailing value systems, the discipline that is required and expended in attaining and maintaining a body that is regarded as flawless, perfect and thus presentable seems to be diametrically opposed to the transgression and excess that are linked with notions of pornography and sexual gratification. However, within and beyond the realm of advertising, the erotically charged pin-ups, as well as the increasingly more explicit and daring representations/simulations of nudes, interacting and copulating bodies, serve – undoubtedly – as 'energy conductors'. Whilst they fuel the senses they do not hold the promise of satisfying the awakened (carnal) desires. Instead, the energy they generate is sublimated into the urge to buy, into an addiction to media consumption including pornography, or it is employed for ideological propaganda – to promote the liberalism of western society for instance.

In order to function in this way, pin-ups have essentially to be of a deictic nature. Deixis means a reference to an external context on which the interpretation of the expression depends. Deictic words indicate, for instance, who is speaking (I or you or they), the place and time (here and now, there and then) often in relation to a situation or the unfolding of an event that is being referred to in the utterance (through a verb's tense for instance), and so on. Pin-ups are constructed with a clear person deixis: they address in the second-person mode. They also have a clear social deixis, insofar as the images are on familiar rather than polite (second-person) terms with the addressee, which equates to the 'du' in German or the 'tu' in French. The pretended, externalised 'close-up and personal' delivery, the exhibition of intimacy has traditionally been the underwriting principle of this genre, as shown above. Their nature is erotic rather than pornographic, with a pronounced

emphasis on titillating posing rather than the enactment of sex. In reality, to maintain their full potential as emotional and bodily sublimative force, their gesture must remain a soliloquy, an imagined gestural conversation in solitude.

The incessant de-contextualisation, recombination and 'reverse' manipulation of the recycled reproductions of women's staged bodies transform them from 'visual bait' into an 'anti-force'. Van Kerckhoven's imaginative treatment of the visual vocabulary of exhibiting explores the viewers' relationship to the visual representation of bodies that they are more accustomed to viewing in objectified form. As analytic rather than synthetic procedure, it breaks down the spectator's 'voyeuristic inclinations' and includes their observation as subject of this cultural interrogation. Alongside the technical implications at work both in analogue and digital photography, her pictures generate a 'twist' on photography's claim to objectivity and authenticity. They expose the 'malleability' of the photograph and thus reveal the shaky foundations on which these cultural assumptions stand in light of the potentials and pitfalls of digital information and communication technologies, their simulation of desire and reality rather than representation. In this way, *Head Nurse* engages in a critique on the role of photography in the production of knowledge. It seeks to accomplish its implicit aim to influence, adjust and change ways of seeing, habits of imagination and patterns of thought.

Such an attitude resonates in Fiona Banner's facetted work too. In *Arsewoman in Wonderland* (2001–2002), the British artist (b. 1966) attempts to translate a 1998 porn movie in its entirety into a 'still-film' by giving a description of the act(ion) in her own words displayed as 'dysfunctional screen-print' or in fittingly glow-pink lettering on billboard posters. Banner's take on the American film *Asswoman in Wonderland*, a directing debut by its main protagonist, porn-star Tiffany Minx, is one of a number of 'blow-by-blow accounts' of feature films or sequences of events, as in *The Nam, Hunt for Red* and *Point Break*. The narratives take the form of solid single blocks of text often simulating a cinema screen in format and size. The small point size of the typeface and the density of the lines that cover a substantial area of wall space put up considerable obstacles for the linear reading of the text. Instead the eyes are continuously distracted following the unfolding of the factual account. They wander off into the instantaneity of the image-scanning mode only to pick out another constellation of coupling bodies, another fantasy of sexual desire, in an attempt to somehow get a visual hold on the vast surface. The sex acts in this fractured sensual experience become almost interchangeable, similar to Ruff's and Van Kerckhoven's pictures, yet their principle remains the same: penetration and ejaculation – consummation in whatever way is the ultimate aim. It is conveyed with some detail: as much as necessary and as little as possible. The 'compulsive repetitiveness' and starved narrative of the source-material is brought out even further through Banner's unadorned graphic verbal description, which in its factual austerity oscillates between the utterly boring and trivial, and the extremely obsessive and fascinating. The 'muting' of the visual element undoes the link between simultaneous image scanning and sequential reading or listening, between looking, listening and doing. Banner has generated an aporetic work

– neither image nor text, both image and text – that provides proof, if proof was ever needed, for Marcuse's argument that obscenity appeals as much to the imagination as it does to the embodied eyes first and foremost (and to the ears).[31] This raises, of course, the question of whether it can equally stimulate the sense of touch, or smell, or taste.

In a similar move, the artist has produced a voice recording of herself reading her own sober, true-to-life account of the actions in *Asswoman*. Instead of recording it onto a twelve-inch vinyl record, Banner has chosen to use non-standard fourteen-inch lacquer discs. The LP is played on an 'adapted turntable', which sits on top of a plinth with mirrored sides in the gallery space. In order to listen to it, the spectator has to operate the turntable first.

The work's title, *My Plinth Is Your Lap* (2002), echoes the rhetoric and gesture of poster-like work by American artist Barbara Kruger with their programmatic and didactic gender juxtaposition between 'I' and 'you'. The first person signifies in general terms 'woman', and the second person symbolises 'man' in a highly universalised fashion. Like Kruger, Banner conflates 'discourses of art and sexuality' in her work, which has been largely influenced by the bold language of graphic design.[32] In Kruger's combination of image fragments (blown up and cropped photographs often of (representations of) women, and short, exclamatory or laconic statements, the text provides a commentary that conflicts and subverts the visual message:

> She emphasises the way in which language manipulates, and undermines the assumptions of masculine control over language and viewing, through her refusal of completion and her assertion of a position of 'otherness'.[33]

In Banner's work, it seems that what you hear or see is what you get. The rendering of the descriptive account of the sex scenes is detached, fast, restless. A 'stream of language', it lacks pauses, pacing or silences, all those elements that make up a dramatised, emotive delivery. The detailed description of the string of sexual incidents at a pace that keeps up with real-time unfolding in the film develops a disconcerting rhythm that emanates from the intersection of the word sound and its resonances in the artist's body as she speaks them one after another. As its rhythm

> asserts itself the listener finds it increasingly easy to recognise that the descriptive language is far from being anodyne. Certain features of lighting, particular actors, specific aspects of the body, clothing or background detail are repeatedly singled out as the focus of attention. Banner's response to the film starts to take over from her account of it. Bodily fluids – sweat and saliva as much as semen – are brought to our attention, as is hair, especially when plastered against flesh by those fluids, or when, in that incessantly reiterated gesture in porn films, it is moved 'out off the way' so that the camera can maintain its uninterrupted view of the action.[34]

Language is transformed from a plain depiction tool that supplements and is legitimised by the unfolding configuration of moving images on the screen into the singular, embodied tool for the listener's imagination. This counteracts palpable currents not only of an objectification of the sexual actors and their 'enactments' but of their dematerialisation – a phenomenon that is also very tangible in the 'billboard' text version of the work. The latter is echoed in the dissolution of the plinth's physicality due to the reflections of the gallery environment on its mirror-plated exterior.

The incessant, undynamic flow of Banner's text, both in its spoken and in its written form, points implicitly to Julia Kristeva's critique on language as the symbolic system of the father, that does not provide a space for the Other, for woman's subjectivity. Ways to undermine the signifying, rational, communicative (symbolic) language in order to open up spaces for women's expression of subjective experience (or more broadly for an expression of subjectivity that breaks with its biological basis, i.e. being determined by maleness or femaleness) have been seen in an emphasis on the materiality of language and the inscription of the body in language and through it. The possibility of such an inscription is located in an operation with those (semiotic) elements of language that cannot be reduced to its symbolic order and a fixed meaning: rhythm, intonation, pitch, silences, exclamations, etc.[35] *My Plinth is your Lap* does not provide these 'interstitial spaces', quite the opposite, so that Banner's approach to a linguistic remediation of a porn movie strangely highlights the lack of (female) subjectivity within pornographic representations. In this respect, it may not be taken too far off the mark to consider the plinth on which the turntable sits as a phallic symbol – both literally and metaphorically. The needle that works its way through the grooves of the lacquer disc and produces the sound may also be (naively) read in this way and understood as a juxtaposition between the linear unfolding of the story as man's time, and of the turning of the lacquer disc as cyclical time, that is, as 'woman's time'.[36]

On the issue of movement in time, Georges Bataille, in his essay *Solar Anus*, operates with the opposition between the two principal forms of linear and circular movement, which can be found in the life-creating circular movement of the earth and the back-and-forth movement of sexual intercourse. These two forms of motion, as the British art critic Michael Archer stresses, 'are linked to the pistons and wheels of a steam engine: fucking makes the world to turn just as the world's turning leads to fucking.'[37] Not incidentally, Banner calls another work component that relates to *Asswoman in Wonderland* after Bataille's essay. It consists of two small prints. In these *Solar Anus* prints, text that recalls the movie is written in red ink and coils from the proximity of one of the sheet's edges to the middle of the square format. The closer the spiralling line of text gets to the centre the more the writing converges to create a hole which seems to 'suck in the words and the story they tell.

However, the fragile quality of the lacquer disc does no lend itself to many replays. Gradual degradation is built into the work, loss of potency and power, which 'disappoints' expectations of durability and permanence that have traditionally been associated with

'high' art and its economic value as much as they have been considered as the Other of ephemeral popular trash.

The location of the 'spectacle' – the gallery space – causes unease as pornography is momentarily brought out of the closet – brought out from under the cover of the brown bag or the back aisle of the video rental/ shop. It generates a confrontational situation in which the spectators have to face their own (hidden or overt) desires and moral stance.

In *Concrete Poetry* (2002), the artist filled the floor space of the gallery in Dundee Contemporary Arts with jagged three-dimensional derogatory words that have derived from a recollection of all the insults ever levelled at the artist. 'Wordscapes' such as 'cunt',

'tit', 'pig', etc. are cut out of polystyrene, smoothed over and coloured cement-grey blending in with the venue's floor. The appellative character of the utterances dies away in the exhibition space. Without any additional explanation about the work and the artist's intention for the work, the addressee of the insults remains deliberately unclear. Potentially, the derogatives could be hurled at any spectator, or all of them. They may provoke (part) identification, or unpleasant resonances. They may conjure up one's own experiences of having been the object of slander or even using those terms against others. However, it remains

29. Fiona Banner, *Concrete Poetry* (2002).

crucial to note that, through their transcription and de-contextualised presentation, they leave out a crucial moment of abuse and dirty speech: its direct address. Its expressive potential and effect depends not only on those who make such utterances, but also on the effect it has on the recipient of that 'expressive act'. Therefore, in a roundabout way, Banner's display draws attention to the process of abuse, the objectification and codification contained in it and its direct nature. Abuse, whether verbal, visual or physical, is not confined to and defined by specific social groups. It is situated socially and culturally in its concrete expressivity and pragmatics. It is marked and nuanced by class, age, gender and ethnic inscriptions and cultural affiliation and preferences.

Banner's work, it can be argued, is didactic in its effect (rather than its intent). It dwells on the tensions and frictions between private vernacular and intimate attitudes, and collective rules and perceptions. The reworking and (retroactive) remediation of overtly excessive material and obscene discourses reveals the intersecting and fluid boundaries of personal and public morality. It creates moments of emotive and intellectual unease.

Banner's art, like Ruff's and Van Kerckhoven's, thematises the relationship between art and its re-mediation by engaging with pornography, a cultural practice that has been frequently cited as proof for technology's ability to immerse the viewer closer and

ever more directly and authentically into different spheres and facets of reality. Their strategies play out the tension between the artwork's existence in a mediated world and its immediate appeal to and engagement with the spectator. Their creative strategies have to be considered in a social and cultural situation that is marked through the move from mass-reproduction and mass media to a global, all encompassing, omnipresent media economy, which renders the former term obsolete. This has inevitably led to the much-debated over-saturation with visual images and the (potential) deflation of their meaning and value. But neither, it seems, has an 'image-logged' culture lessen the marketable potency of pornography nor does it decrease the widespread – if controversial and contradictory – fascination with the obscene. Pornography as a key aspect of obscenity constitutes a crucial part of contemporary cultural discourse (and economy), and that is what these three artists are ultimately dealing with: the concept of sexuality and sexual 'transaction' as a product of discourse.

# Chapter 11

# Cyber-(ob)scene

Virtual-sex
programs featuring
every simulated sound
and sensation are not likely
to be better in many ways than
the real thing, for future generations
they may become the real thing.
   *Jeffrey Deitch[1]*

Pornography in dreams
Pornography in books
Pornography in cars
Pornography in Advertising
And everywhere repression
Repressed livings as the expression of everyday life
Free your mind and your ass will follow
Pick it up, let it move, make it happen
Go with the code
Arm yourself with drugs, magic and computing
Fuck with fucking and drift into abstraction
Zeros and ones turn me on
   *Florian Cramer and Stewart Home[2]*

This final chapter concludes the discussion of how notions of the obscene operate in relation to contemporary art within the context of the 'digital ether'. The Internet has 'exposed' an expanded territory for the display of pornography, violence and disease. The World Wide Web is abundant with news groups for 'salacious' pictures and 'dirty' talk,

for the display of violence, whether real or simulated ever more realistically in computer games, and in the increased distribution of feature films, 'documentary' and real-time material through these new digital channels. Although, much of what is available through the Internet (and other forms of digital information distribution) already exists in other media such as magazines, videos or on CD and DVDs, the Internet offers a particularly convenient, anonymous and discrete access to these products. This, as has already been discussed, includes the advertisement, merchandising and purchase of 'explicit' material. Besides, since digital technology has become more widely and inexpensively available, a shift has taken place from the mere consumption of obscene material to its 'recreational' production. A new 'amateur' industry has emerged, which appears to be at least as vibrant as the amateur production of risqué photography during the later nineteenth and early twentieth century, if not more so.[3] The growing popularity of web cameras at home, as well as the weblog and the virtual chatroom, supports the production and distribution of a 'direct-to-audience' pornography in the service of a more diverse and 'specialised' consumer. And, of course, the (desired and real) effects of those encounters and exchanges rely upon and promote forms of voyeurism. However, the unprecedented opportunity to display sex and violence and, even more, the compulsion to confess the sexual (and the violent) are connected first and foremost to a 'discursive exploration' of sex (and aggression) and not necessarily to a liberation of existing taboos.[4] In fact, it could be argued that the attraction and recent success of the Internet in this area has – to a considerable extent – been generated by the still existing and in many ways closely guarded repression of sexuality (and violence) in society at large, in particular minority and 'deviant' practices.

Catherine MacKinnoch, one of the leading American anti-porn campaigners in the name of feminism, claims that 'pornography in cyberspace is pornography in society, just broader, deeper, worse and more of it.'[5] MacKinnoch is fervently and indiscriminately against all forms of explicit representation of sexual transactions on the grounds of their inherent exploitation and degradation, particularly of women. Her position has not just been met with broad approval but also invited equally strong criticism from feminists and beyond. However, her observation fits, insofar as it concerns the qualitative commonalities between pornography in the digital ether and pornography in analogue modes. This could also be said to be the case with other procedures that are deemed to be obscene. The way society deals with forms of excess may reveal the boundaries of contemporary morality regulated and maintained by a dynamic legal framework. For instance, the obscenity legislation in the UK, 'was amended in 1994 to take into account sexually explicit content in data format ... but still, the application of UK obscenity standards to a borderless medium like the Internet has its difficulties and limitations',[6] aside from the issue whether or not it is meaningful and functional to enforce national standards on a global medium.

The digital realm has not only stimulated the sexual imagination in more 'futuristic ways' by making possible relatively low-risk experiments in virtual reality with 'sex without sex': from virtual love to any permutations of simulated sexual penetration without (real) bodies: human copulation, sodomy, cyborg and machinist 'intercourse'. It has also fuelled

fantasies of violence in the virtual domain, whether they involve simulated humans, aggressive animals, monsters, out-of-control robots or extraterrestrials and other figments of the imagination. Whilst Virtual Reality, more than any other medium, and – with ever greater technological capabilities – increasingly convincingly, offers the illusion of total immersion, it cannot get rid of the human body as viewing, interacting and feeling body in front of the computer screen, using the keyboard or joystick or as wearer of electronic body amour, visor, glove(s), etc. As such, any claims of disembodiment must – for the time being at least – remain within the realm of fiction.

It is the desire for immediacy, experiment and control that makes virtual sexual encounters interesting and popular even in its technologically simple form – the chatroom or the Multi-User-Domain (MUD) – as Bolter and Grusin assert:

> It may be obvious why sex in chatrooms and MUDs is so common, or at least why it is so widely advertised and discussed, for these textually mediated encounters offer adventure within safe limits. But it is also worth noting that such sex is an extreme form of remediation. At least since the nineteenth century, sex has been represented in both visual and textual media (also in music) as perfect immediacy. Sexual encounters in MUDs and chatrooms offer the challenge of achieving immediacy through first acknowledging and trying to erase the medium [which could also be said for telephone sex]. MUD sex is a chance to rewrite the pornographic novel, with the object of desire providing his or her own responses.[7]

But just how controversial such encounters can be is demonstrated by an infamous and much-discussed case in a MUD called LamdaMOO in 1992. In the text-based encounter between characters, one player found 'a way to control the actions of another player' and could 'thus "force" that character to have sex' through alterations in the programming code. The characters' actions, described in prose, were no longer under their own control. Not only did these descriptions appeared on the screens of the characters themselves but anyone else in the room at the time became witness to excessive 'seduction' and violent intercourse. The debate that followed the incident questioned whether one could be raped and experience other forms of violence in cyberspace.[8] Rape in this situation, Bolter and Grusin maintain

> can only occur in exactly the same sense that rapes occur in films or novels: rape in a MUD can mean only that the participants became unwilling rather than willing remediators of the pornographic novel. The victims, however, experienced the rape as a serious and real violation of self precisely because their selves were constructed and maintained through the text that now betrayed them.[9]

Let's look further at those artists who explore the Internet as the foremost domain for the production, display and exchange of obscene material for private and public consumption.

American artist Julia Scher (b. 1954) has participated in and critiqued the surveillance of public and private spaces, the 'horrors of the "high security society"' in her art practice since the mid 1980s. She has been using the Internet since the mid 1990s, when she ran a virtual sado-masochist club on the electronic bulletin board *The Thing*, called *Madame J's Dungeon – online sexclub*. The virtual 'establishment' operates as a MUD and evolved from Scher's own preoccupation with s/m practices:

> I was very involved with s&m at the time, and it was great to have an online environment where all the issues around sexuality and dominance could be played out in a virtual realm. It was a perfect way to design a sexy, emotional space. There, people would be motivated by desire and play roles. At that time I performed in sex clubs and also in a joint called Jackie 60s. Dominatrixes in their full regalia hung out there. That created an atmosphere where people could shout about what I would do to them and what they would have to do. What I did on 'The Thing' was seen as reproducing these kinds of places.[10]

There are striking similarities between a sado-mascochist sex club and the operation of Bulletin Boards like *The Thing*: behaviour in both is governed by the structures and rules that constitute the respective system in computer-based interaction. And the protocols for both spaces are very strict. Codes, i.e. the consensual and ritualistic practices, do not just govern the s/m dungeon but programming code is the foundation for the functioning of the MUD. Any trespassing of rules set up by the Dungeon Master is persecuted and may lead to exclusion from the sex club. In an analogous manner, any failing to adhere to the conventions and codes that underwrite the operations of a Bulletin Board either leads to a breakdown in communication and/or is subject to a ban from the MUD.[11] Scher's work exploits the potential of the 'digital ether' for 'anonymous' role-play, for the performance of multiple identities and the experimentation with anti-normative sexuality. She reflects this as follows:

> The idea for the Dungeon was not to jerk off in front of others, but to enhance the notion of sexuality transitioning from physical space into Net space. You are certainly bringing your own physicality to the computer – even if it is just text as it was with The Thing in the early days. ... What happened when you took these places online, was that people started playing with this kind of language and with the codes of these cultural practices.[12]

The capacity of Internet-based communication to simulate or enact different personas and practices from a variety of perspectives requires and promotes empathy. In fact, empathy

through its immediacy, embodiment and emotional and cultural determinations, becomes a crucial means of knowing and understanding, which may erode any notion of the sexual obscene even further. Turning his back on the Renaissance idea of art as a window into the world, Roy Ascott, the British pioneer of interactive computer art, contends that in the telematic age, where telecommunication and information processing converge:

> art itself becomes, not a discrete set of entities, but rather a web of relationships between ideas and images in constant flux, to which no single authorship is attributable, and whose meanings depend on the active participation of whoever enters the network ... To engage in telematic communications is to be at once everywhere and nowhere. In this, it is subversive. It subverts the idea of the individual ownership of the works of imagination. It replaces the brick and mortar of institutions of culture and learning with an invisible college and a floating museum, the reach of which is always expanding to include new possibilities of mind and new intimations of reality.[13]

During the past decade, art has become increasingly concerned with processes of dialogue and exchange, rather then aiming chiefly at the production of aesthetic objects. This shift has been expressed by the French curator Nicolas Bourriaud in the concept of relational aesthetics and is manifest in dialogic and participatory art models. These models are based upon and require the negotiation of principles of individual and collective conduct and responsibility in civil society (and their underlying ideological perspectives and ethical values) within a framework in which the intersection of the aesthetic with the ethical is foregrounded and thematised. Beside the recognition of the responsibilities of all involved in such a process of creative exchange and transaction, dialogic art pronounces the principle of a negotiated, temporary (and dynamic) consensus. Such relational aesthetic manoeuvres put resistance to and dissolve the elitist and didactic stance of high art/culture. Moreover, with the erosion of the (post-)modernist art model, the rules for the aesthetic exchange and interaction have to be reset and agreed, potentially for every creative process. They work not unlike computer games, such as *SimCity*, that test and train individuals' decision making capacity, and levels of morality and responsibility, though computer games have built in the race against tight time limits in which the player has to react as one instrument of pleasurable pressure and competition (amongst others). Relational aesthetic constellations aim at and are situated in the real world, where they potentially seek to challenge and defy paternalist and repressive interventions of the state and the powers of global capitalism, such as censorship. As with postmodern art itself, anything goes, as long as those participating in (and are exposed to) the aesthetic operation in question are agreeable, or does it?

    The popular and commercial success of the Internet and the personal computer has been powered to a great extent by the porn industry and its desire to open up a greater circulation radius for their products combined with a more discreet, 'safe' and easy access.

The gross revenue of the sex business on the Internet ranks third after online trading and e-commerce. And it is one of the economic areas that still guaranties enormous growth in profits. The virtual sex '[o]ffers available on the Internet are taking money away from the "real" business of prostitution; since the Web has become widespread, declining revenues are evident'.[14]

It is not surprising, perhaps, that new media artists have scrutinised this territory and are continuing to explore it. Russian art activist Alexei Shulgin (b. 1963) has created a 'dual-party Internet remote intercourse tool' with his website *FuckU® Fuckme*.[15] The product information states:

> The basic FuckU-FuckMe(tm) kit consists of two hardware units and an accompanying software interface. The genitalDrive is an internal device in a standard case that can be installed in any free 5.25" slot of your PC. The FuckU-FuckMe software connects your genitalDrive with a corresponding unit on a remote PC using TCP/IP protocol. When you start remote sexual intercourse with your partner using FuckU-FuckMe(tm) the system will transmit all your actions to his/her genitalDrive and precisely reproduce them in real time. The system has [an] intuitive interface and allows you to entirely concentrate on remote communication.[16]

Devised for the Windows operation system and advertised as '[t]he ultimate remote sex solution', it comes along with all the other rigmaroles that have become the standard for commercial Internet sites: order forms, specifications, technical illustrations, FAQ, technical support, warranty – everything except the price. The cost to the potential buyer for his/her PC to virtually penetrate another PC will be emailed once s/he has registered an interest. Getting sexually satisfied by remote control, as this 'over-hyped' project proposes hypothetically – a form of post-human cybersex – calls into mind Stelarc's experimentations with external body control and manipulation through constructed human-machine interfaces that 'incorporate robotics, prosthetics, and the Internet'.[17] Shulgin, like the sex industry, seamlessly conjoins a candid language, that appeals to and lures the potential pleasure-seeking clients to the website, and the virtual shopping model in which factual information-giving is married to the persuasive sales tactics aimed at the creation of desire. Although placing his tongue-in-cheek project within the wider parameters of the art domain, his work shifts its actual emphasis from the symbols of art to the objects of commerce. One system provides the code to reveal the operations of another system. Art is just another commodity and transaction, like sex, in capitalist society. Human interrelationships in the virtual are reduced here to self-gratifying gadgets and the manufacturing of affects that reach beyond aesthetics.

UK-based network artist and webcast engineer Rachel Baker (b. 1970) exploits the appeal of the Internet for the discerning sex consumer and has constructed and uploaded a website that persuades its 'vuser' to fill in their details in return for pornographic

pictures.[18] What the customer actually receives are mono-coloured drawings by number, i.e. a connect-the-dots image. The consumer can then print out the page and link up the dots to get the representation of a sexual interaction.[19] The 'vuser' can also click on the dots, which are hypertext links. These connect to various pages from which, as indicated by the text, it appears as if an image is available for download and offline viewing. Whilst the highly mediated, incomplete dot images toy with the potentially false promises, the 'frustrated desires' and unreliable business partners that have become a plaguing side effect of the Internet, the hyperlink strategy emulates and demonstrates how pornography on the Internet is frequently distributed and consumed.

In the manifesto-style text *Pornography Coding* (2005), Florian Cramer, writer and net theorist/activist, and Stuart Homes, controversial co-founder of Neoism and cultural activist,[20] equate the principle of pornography with the principle of digital programming as they are both founded upon an incessant repetition of the same. Adapting and repeating Neoist slogans, they preface their programmatic text as follows:

> Program code is like pornography. It has a linear logic, but no meaning. There
> is an accumulation of things already known. The focus is always on the same
> explicit facts. Repetition and boredom rule.
> Art is sanctioned pornography.[21]

Whilst the latter provocation is based on a superficial, phenomenal comparison between art and sex display, the former hits at the essence of pornographic and digital coding. Sex and sexual display have always been symbolically coded within and across historically determined and dynamic cultural fields and frameworks of representation. The legitimation of sexual practices and positions – the significance, for example, of the 'missionary position' – and the visual composition of explicit images – the money shot for example – can serve as potent indicators for the social and cultural coding of sex as much as for the presence of programming in human history. For Cramer and Homes, it is not the re-combinations of pornography but the permutations of digital programme code that provide a potent contemporary tool with which to 'investigate our own minds while turning our bodies into one vast erogenous zone'.[22]

In an oversaturated and over-commodified capitalist society, human imagination is under constant attack, threatened with destruction through the 'frenzy of the visible', they argue. Everything is placed before the eyes, readily available – no need to use one's powers of imagination to bring matters to life. Their stance resonates with Baudrillard's sentiment that such situation is obscene. In *Fatal Strategies* (1983), Baudrillard proclaims from a technologically deterministic and sceptical perspective:

> This is obscene: the truer than true, the fullness of sex, the ecstasy of sex,
> pure and empty form, the truly tautological form of sexuality ... the joining of
> same to same. ... what is obscene is not the copulation of bodies, but rather

the mental redundancy of sex, the escalation of truth which leads to the cold vertigo of the pornographic.[23]

'The scene,' in his view, 'is the order of the visible. But there is no longer a scene of the obscene; there is nothing but the dilation of the visibility of all things to the point of ecstasy.' He continues:

> In our culture everything is sexualized before disappearing. This is no longer sacred prostitution but a sort of spectral lewdness taking hold of idols, signs, institutions, discourses; the allusion, the obscene inflection that takes hold of every discourse, is the surest sign of their disappearance.[24]

The pornographic display is not obscene, but obscenity means that 'all secrets, spaces and scenes [are] abolished in a single dimension of information.'[25] It is a condition of 'perfect transparency', as the American philosopher Mark C. Taylor argues in relation to Baudrillard:

> In a world of invisible databanks, genetic engineering, and nanotechnology, inside and outside are thoroughly confounded in such a way that the private is public and every secret is told. Baudrillard longs for what he realizes is impossible: the decoding of the real. To decode, in this context, does not mean to render transparent but to free the real from the codes that seem to destroy it. Digital technologies become repressive when they absorb everything once believed to be real.[26]

The demise and annihilation of the real through 'digital technologies that absorb everything once believed real', also affects the resources for resistance. These sources of opposition and confrontation seem to vanish too and reduce to an 'idle dream' the opportunity for change. However, 'the [digital] code is not as seamless as it often appears ... lingering vestiges of the real appear in most unlikely places.'[27]

Cramer and Home proclaim the sameness of unrepressed sex and the imagination. To achieve a heightened and expanded consciousness, a trance-like, liberated state of being, they propose hacking into computers and so submitting oneself to the frenzy of manipulating and penetrating the respective (protective) program codes. To them, hacking is like having sex, like rocking the body rhythmically to/in a sexual ecstasy. Instead of sexual penetration, the hacker copulates orgasmically with his fellow hackers and submerges and dissolves in a 'total fucking zero and one pornography'. Given that hacking program codes aim at the violation of virtual 'bodies' of information, the metaphor of 'rape' rather then copulation may be more appropriate in this context. And, with reference to a seminal essay by American art historian Linda Nochlin of 1971,[28] the question occurs: Why have there been no (great) female hackers?

Pornography, which copiously occupies the digital ether, nurtures much of its appeal from its inherent claim of authenticity, and thus of providing evidence of real sexual transaction, as from its aura of freedom from social control. By using its textual terminology in programming code, this attraction is transferred to the dry realm of digital software. The source code of the kernel of the Linux operation programme, for instance 'contains the word "fuck" fifty-six times'; and the 'image rendering component of the free Mozilla browser' was originally called 'librOn, prOn being hacker code speak for porn'. Yet the invasion of obscene vocabulary at the 'non-operational code-level' does not necessarily mean that the operations created from this software are obscene.[29]

As content on the Internet is (to a varied extent from country to country) policed by the state, a considerable number of virtual search machines have disabled 'offensive vocabulary' from their search menu. Programming artists and activists as much as the porn industry itself have found ways and means to infiltrate and permeate the 'clean sheets' of the World Wide Web, amongst others, through the modification of offensive terminology (for instance, 'pron' instead of 'porn'; see the supervert.com or pervscan.com sites) so that it is legally acceptable for public consumption and yet remains indicative of the site's 'suggestive' content, and through the use of 'cookies', which are implanted into 'innocent' virtual locations. Cookies are electronic messages that a web server gives to (and stores in) a web browser. These messages serve to identify the web users and their interests. Each time a browser with the cookie requests a web page from the server, the cookie is activated and triggers the (unsolicited) sending of customised web pages to the web user.

A number of artists have adopted a strategy similar to the infiltration of obscene jargon into software programming. They seek to lure the viewer by giving their art operations lascivious titles in the knowledge that contemporary western society has not only become more sexually permissive, but that sex triggers attention and commercial turnover. Istvan Kantor, for instance, calls his 'interactive transmission machinery', an elaborate 'kinesonic' installation of computer-networked filing cabinets, *Intercourse*. Here, 'robotic sculpture and interactive video' are combined to

> connect old office furniture and new electronics. The simple act of opening/ closing drawers of a file cabinet sets off a reaction in the other furnishing throughout the room. as the machinery of office furniture sculptures comes to life, so do the screened images of a naked body hooked up to electrodes.[30]

Other artists use the imaging potential of digital software and hardware to ponder on the possibilities of genetic engineering for the sexes. Austrian artist Dieter Huber (b. 1962) has created a series of computer-generated photographs as visual reflections on the potential and pitfalls of biotechnology for the social norm of sexuality and the respective naturalised gendered identity/ies. In *Landscapes* (1994) he presents cloned female and male organs in a number of permutations that contravene conventionalised sexual difference. Huber's digital manipulations range from doubled male and female genitals, to penises

growing out of or converging with the clitoris or the vagina to the fusion of tongues in an exaggerated heterosexual French kiss. Needless to say, the material on display is extremely explicit and appears disconcertingly real in these slick high-resolution images. The project's motivation in the scientific discourse on biotechnologies, virtual sex and prosthetic bodies/cyberbodies, and its proximity to respective sociological and cultural debates, as suggested in the explanatory commentaries provided with the work, do not deaden the impact of the obscene at the level of representing the subject matter. Neither does the artful classical composition of his images lessen their somatic effects.[31]

Pornographic display and 'non-operational' written computer instructions, i.e alphanumeric codes, converge in typograms that have emerged in the ASCII prOn genre. The ubiquitous code ASCII stands for *American Standard Code for Information Interchange*, in which English characters are represented by numbers ranging from 0 to 127. 'Originally a hack to bring visual pornography into the world of alphanumerical computer terminals, they became ironic retro chic in 1990s net art, above all in *Deep ASCII*, a typographic rendering of the porn movie *Deep Throat*.' The work was created by the ASCII Art Ensemble around Vuc Cosic and Luka Frehli.[32] Typograms, i.e. shapes generated through the aggregation of letters and numbers, in this context operate as a retroactive remediation. They parade their origin in the typed page, and comically invalidate the *raison d'être* of the (at times parodied) filmic source material such as *Deep Throat*: the film's quest for a high degree of 'transparent immediacy. In the context of these rather abstract 'typographic' images, Cramer and Home argue that the less is offered to the imagination the more subversive is the cultural product. In that, mainstream pop acts and commercial pornography are more successful than indie pop and indie porn, as the former try to be realer than real. From such position the authors of *Pornographic Coding* demand:

A digital pornography that would strive for true honesty and imagination should reduce rather than increase its visual imagination. In the end, it should present itself as nothing but code, teaching us to get off on mere zeros and ones, thus overcoming the false dichotomy of the artificial and the authentic ... we demand a truly independent, open source pornography. Pornography should be made by all, a radically populist pornography of collectively produced, purely formal codes. This pornography will reconcile rationality and instinct and overcome alienation because the codes will have to be reconstituted into sexual imaginations by the right side of the brain. Software, reconceived as a dirty code crossbred of formalism and subjectivity will be the paradigm of this pornography, a code that sets processes into motion.[33]

By accepting and affirming pornography as one of the main release valves of contemporary society they forget to ask the absolutely crucial question: pornography for whom and by whom. They ignore the exploitative character of pornography, the political and visual economy of this social practice within global capitalism. They shut out the slavery of girls

and women, the human trade and sex tourism that is part and parcel of this trade. From an extreme masculinist position, pornography is unrepentantly equated with the unrepressed articulation of sexuality outside of the power relations on which it is based and which it re-produces. Considered purely as a discharge of vital energies, they transpose the pornographic practice from its social and cultural context of hacker-topia, to the realm of cyber-utopian pseudo-democracy. Their polemic, tongue-in-cheek vision neglects crucial issues such as the socially and culturally determined access to digital technology and the levels of digital literacy, which are still powerfully marked by the gender, generation, class, ability and geography of the user of digital technologies. Like much of the current reasoning on techno-culture and cyberspace, Cramer and Home's provocative and frenzied 'dance with the obscene' embraces more the realm of 'hacktivism', i.e. hacker activists, and 'tele-epistemology', knowledge produced through telecommunication and information technologies, than that of radical political activism.

From 1991 to 1997, the Australian artists group VNS Matrix took on and took issue with the gendered dominance and control of the new technologies, with the confidence and aggression with which those were marketed. In their own account, 'VNS Matrix emerged from the cyberswamp during a southern Australian summer circa 1991, on a mission to highjack the toys from technocowboys and to remap cyberculture with a feminist bend.'[34] The group of four female artists – Francesca da Rimini, Julieanne Pierce, Josephine Starr and Virginia Barrett – is particularly concerned with the role of women in technology and art. Their activist practice was driven by the observation that women as makers and users of digital technologies are underrepresented. Moreover, on the Internet and in digital imaging, women are predominantly depicted as objects, 'as fetishistic stereotypes of femininity'.[35] (More recently, one only needs to think of the appeal and commercial success of virtual action heroine and monstrous supermodel Lara Croft in the *Tomb Raider* series of video games.)

VNS Matrix has developed an aggressive counter-strategy to unmask and redefine the role of women in art and technologies. In their work *Cybermanifesto for the 21st Century* (fig. 29), they celebrate women's creativity and productivity in a reversal of the concept of the male genius. Launching a verbal onslaught against the patriarchal symbolic order and its foremost signifier, the phallus, they reject all those ideas and values that are underwritten by this order: reason, discipline, repressive morals. Reiterating the binary oppositions – male/female, mind/body, rationality/emotionality, pleasure/discipline – that

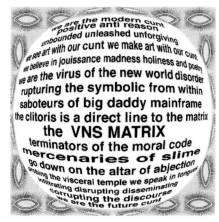

30. VNS Matrix, *Cyberfeminist Manifesto for the 21st Century* (1991).

have defined western thought for centuries, they put in place of the old masculine bifurcation a feminine matrix, based on the powers of the cunt and the clitoris. With it, they rejoice in the potential of the body, embrace the visceral and abject, those 'untamed' and 'disruptive' areas and elements that 'sabotage' the 'Big Daddy mainframe'.

Their stance echoes feminist positions that were developed by, above all, Julia Kristeva, Luce Irigaray and Hélène Cixous in France during the 1980s and 1990s and which came to inform much thought especially in the Anglo-Saxon countries since. Yet, admittedly, theirs is an ambiguous and controversial ricochet, as it celebrates and promotes women's irrationality and emotionality, thus reaffirming duality and woman as Other. As much of the digital media art and technological imaginations during the 1990s were in their essence a remediation of older resources of representation (the painting, the book, the video, etc.), ideologically many of those novel in(ter)ventions still reiterated modernist and above all gendered myth of the artist-genius and the autonomous work of art. Employing and revaluing common derogative terms used by men to denigrate women on the basis of their (negatively perceived) sexuality and thus to define their own superior identity, VNS Matrix holds out the red rag and grabs the bull by its horns: they re-turn terms like 'cunt' and 'slut' into positive denotations for women's technological and, moreover, imaginative and creative capabilities.

The manifesto, devised for the Internet, was smuggled into various websites, but also circulated through the use of other media: 'placed in the printed advertisements of magazines, broadcast over radio and on television, and posted in public spaces'.[36] What offends and can be regarded as obscene is their deliberate slippage in register in the use of language within the domain of bourgeois aesthetic refinement. Where the on-screen visual repertoire follows conventionalised notions of beauty, the terminology brings in the vernacular of the street, of what has been considered exterior (and masculine) to the preserve of art in the service of feminist political activism.

In the era of ubiquitous computers and distributed cognition, art continues to fulfil a crucial function, to critically use and examine the new and emergent technologies. Experimenting with new imaging technologies, practices of looking (perceiving) and ways of seeing, it also critically reflects and comments upon cultural changes and shifting values. As never before, the increasing medi(atis)ation of reality has fuelled the desire to grasp what is real and authentic, and what is simulated. The pornographic display, first and foremost, has come to be taken as prime indicator of the authentic and immediate. And this desire for immediacy has in turn acted as a powerful driver for the unremitting advancement of digital technologies, to achieve total transparency, to erase the screen, to make fully oblivious the media(ting) technological interface.

In parallel, the boundaries between the private and the public that lie at the bottom of bourgeois society have been increasingly blurred and eroded, and pose a challenge for existing moral codes and legislative frameworks. Art, as a vibrant, invigorating and broad arena of experimentation, play and projection, has a crucial function in scrutinising this interface, testing and redefining its parameters and, significantly, unveiling their cultural

and political functions. In that, though it may not look and operate as we know it, art will continue to confront and to renegotiate prevailing notions of the obscene which are in themselves historically and socially defined and thus subject to change. Galvanised by the immense mobility and fluidity of images across different cultural domains, art is informed by and converges with other forms of meaning making and pragmatic purposes. Determined by the actual context(s) in which the artwork is situated, the dynamic settings of its production, circulation and consumption, it is read and understood in different ways by different viewers at different times. Such cultural dynamics shape the modes of experiencing the work, and thus the relationship between the aesthetic and its Other. In mapping key operations of the obscene in relation to contemporary art, this book has sought to contribute to an informed discussion about the values and functions, limitations and blind spots of art as practice within a complex cultural situation.

# Notes

## Introduction

1. Peter Gorsen, *Sexualästhetik: Grenzformen der Sinnlichkeit im 20 Jahrhundert* (Reinbek, Hamburg, 1987), p. 23.
2. Joanna Bourke, 'Torture as pornography', *The Guardian*, 7 May 2004.

## Chapter 1. 'I Know It When I See It'

1. Marquis de Sade, *The 120 Days of Sodom*, trans. Richard Seavers; Austyn Wainhouse (2002), http://www.supervert.com, p. 23 of 391 (25 August 2005).
2. Carol Mavor, 'Obscenity', in Michael Kelly (ed.), *Encyclopedia of Aesthetics* (New York, London, 1998), vol. 3, p. 387.
3. See *Oxford English Dictionary*; also Linda Williams, *Hard Core: Power, Pleasure and 'The Frenzy of the Visible'* (Berkeley, 1989), pp. 282–7.
4. For an insightful account of the historical development of a sense of shame and modesty, see Jean-Claude Bologne, *Histoire de la pudeur* (Paris, 1999), and Norbert Elias, *The Civilising Process* (Oxford, 2000).
5. Quoted in Peter Gorsen, *Sexualästhetik* (Reinbek, Hamburg, 1987), pp. 20–1.
6. Quoted in Carol Mavor, 'Obscenity', p. 386.
7. Potter Stewart, quoted at http://en.wikipedia.org/wiki/Potter_Stewart (6 September 2005).
8. Michel Foucault, *The History of Sexuality, Volume 1: The Will to Knowledge* (London, 1998), p. 18.
9. Ibid.
10. Ibid.
11. Ibid. p. 57.
12. Ibid. p. 58.
13. See ibid. pp. 56–70.
14. Ludwig Marcuse, *Obzön, Geschichte einer Entrüstung* (Munich, 1962), p. 14.
15. See Lynn Hunt (ed.), *Eroticism and the Body Politic* (Baltimore, London, 1992), pp. 3–4.
16. Walter Kendrick, *The Secret Museum* (Berkeley, LA and London, 1996), p.33.
17. Marcuse, *Obzön*, p.15.
18. Federick S. Lane III, *Obscene Profits: The Entrepreneur of Pornography in the Cyber Age* (New York, London, 2000), p. 2.
19. Linda Williams, 'Porn Studies: Proliferating Pornographies On/Scene: An Introduction', in Linda Williams (ed.), *Porn Studies* (Durham, London, 2004), p. 2.
20. Lane III, *Obscene Profits*, p. xiv.
21. Walter Kendrick, *The Secret Museum*, p. 33.
22. Brian McNair, *Mediated Sex: Pornography and Postmodern Culture* (London, 1996), p. iii.

23. Williams, *Hard Core*, p. 283.

24. Ibid.

25. Edward Lucie-Smith, *Ars Erotica: An Arousing History of Erotic Art* (New York, 1997), p. 15.

26. Lynda Nead, *The Female Nude: Art, Obscenity and Sexuality* (London, 1993), p. 104.

27. Umberto Eco, 'Wie man einen Pornofilm erkennt', in *Umberto Eco: Sämtliche Glossen und Parodien, 1963–2000* (Frankfurt, Main, 2001), pp. 321–3.

28. Lucie-Smith, *Ars Erotica*, p. 7.

29. Peter Webb, *The Erotic Arts* (London, 1975), p. 9.

30. See *Tate Collection: British art and international modern and contemporary art*, http://www.tate.org.uk/servlet/ViewWork?cgroupid=999999961&workid=22017&searchid=7972&currow=9&maxrows=11 (28 October 2005).

31. For a fuller discussion of these objects, see Georges Didi-Huberman, *Ähnlichkeit und Berührung: Archäologie, Anachronismus und Modernität des Abdrucks* (Cologne, 1999), pp. 133–66.

32. Peter Gorsen, *Sexualästhetik*, p. 121.

33. Ibid. p. 124.

34. Lynda Nead, *The Female Nude*, p. 147; see also Susan Sontag, 'The Pornographic Imagination', in Georges Bataille, *The Story of the Eye*, trans. Joachim Neugroschal (London, 2001), pp. 83–119.

35. Nead, *The Female Nude*, pp. 284–5.

36. John Waters and Bruce Hainley, *Art: A Sex Book* (London, 2003), p. 7.

37. Ibid.

38. Ibid.

## Chapter 2. Transgressive Rituals

1. Monique Wittig, 'Les Guérrillères', in Hilary Robinson (ed.), *Feminism–Art–Theory* (Oxford, 2001), p. 581.

2. Herman Nitsch, cited in *Body Art and Performance: The Body as Language* (Milan, 2000), p. 177.

3. See Stephen Barber, *The Art of Deconstruction: The Films of the Vienna Action Group* (London, 2004), p. 5.

4. Otto Muehl, *Mama & Papa: Materialaktionen 63–69* (Frankfurt/M., 1969), p. 11.

5. Karl Ruhrberg et al. (eds.), *Kunst des 20 Jarhunderts* (Cologne, 2000), pp. 584–5.

6. Barber, *The Art of Deconstruction*, p. 10.

7. See Anja Zimmermann, *Skandalöse Bilder, Skandalöse Körper: Abject Art vom Surrealism bis zu den Culture Wars* (Berlin, 2001), p. 99.

8. See Carolee Schneemann, *More than Meat Joy: Complete Performance Works and Selected Writings* (New York, 1979), pp. 52–3.

9. Rebecca Schneider, *The Explicit Body in Performance* (London and New York, 1997), p. 132.

10. Griselda Pollock, 'Feminism and Modernism', in Roszika Parker and Griselda Pollock (eds.), *Framing Feminism: Art and the Women's Movement, 1970–1985* (London, 1987), p. 93.

11. Aviva Rahmani, 'A Conversation on Censorship with Carolee Schneemann' (1989), cited in Robinson (ed.), *Feminism–Art–Theory 1968–2000* (Oxford, 2001), p. 149.

12. Karl Ruhrberg, et al. (eds.), *Kunst des 20 Jarhunderts*, p. 674.

13. Schneider, *The Explicit Body in Performance*, p. 35.

14. See Lucy R. Lippard, 'The Pains and Pleasures of Rebirth: European and American Women's Body Art', in *From the Center: Feminist Essays on Women's Art* (New York, 1976), pp. 125–6; and Kristine Stiles, 'Schlaget Auf: The Problem with Carolee Schneemann's Nude Body in Her Work', in *Up To and Including Her Limits* (New York, 1996), pp. 15–25.

15. For a fuller summary of the controversial readings of those works by Acconci, see Anja Zimmermann, *Skandalöse Bilder, Skandalöse Körper*, pp. 93–6.

16. Anne Raine, 'Embodied Geographies: Subjectivity and Materiality in the Work of Ana Mendieta', in Griselda Pollock (ed.), *Generations and Geographies in the Visual Arts: Feminist Readings* (London and New York, 1996), p. 238.

17. Laura Mulvey, 'Some Thoughts on Theories of Fetishism in the Context of Contemporary Culture', in *October*, vol. 65 (Summer, 1993), pp. 3–4.

18. Gorsen, *Sexualästhetik*, 1987), p. 163.

19. Ibid. p. 149.

20. As notions of a 'healthy sex life' style have come to increasingly permeate all spheres of consumptive culture since the 1970s, propelled by advertising and other public media, that pleasure-seeking Pop Art approach reverberates tangibly in a grittier way and often interwoven with an ironic slant or parodistic stance – yet just as shallow in the critical and engaging department – in quite a few works by the so-called young British artists (yBas) in the late 1980s and 1990s. Those work emerged publicly around the market-and audience-producing activities of Charles Saatchi, the main private collector of contemporary art in the UK during this period.

21. Gorsen, *Sexualästhetik*, p. 408.

22. Schneider, *The Explicit Body in Performance*, p. 36.

23. Alexandra Munroe, 'Obsession, Fantasy and Outrage: The Art of Yayoi Kusama', in Bhupendra Karia (ed.), *Yayoi Kusama: A Retrospective* (New York, 1989), p. 29.

24. Ibid. pp. 29–30.

25. Ibid. p. 13.

26. Ibid. p. 12.

## Chapter 3. Abjection and Dis-ease

1. Jeannette Winterson, *Written on the Body* (London, 1993), p. 119.

2. Bataille, *Essais de sociologie*, quoted in Julia Kristeva, *Powers of Horror* (New York, 1982), p. 57.

3. See for instance Apinan Poshyananda, 'The Celtic Slant', in John O'Regan (ed.), *Amanda Coogan: A Brick in the Handbag* (Oysterhaven, Co. Cork, 2005), pp. 11–12.

4. Kristeva, *Powers of Horror*, p. 75.

5. Ibid. p. 3.

6. Ibid. p. 4.

7. Hal Foster, *The Return of the Real* (Cambridge, MA, 1996), p. 153.

8. Kristeva, *Powers of Horror*, p. 9.

9. Kristeva also considers the maternal body in its originary signification 'to be prior to signification itself; hence it becomes impossible within her framework to consider the maternal itself as signification [as cultural construction], open to cultural variability.' See Judith Butler, *Gender Trouble* (New York, 1990), p. 91.

10. Butler, *Gender Trouble*, p. 87.

11. Kristeva, *Powers of Horror*, p. 5.

12. Ibid. p. 17.

13. Foster, *The Return of the Real*, p. 156.

14. Ibid. p. 156.

15. Ibid. p. 156; Foster also writes: 'To be abject is to be incapable of abjection, and to be completely incapable of abjection is to be dead, which makes the corpse the ultimate (non)subject of abjection. P. 270, note 52.

16. Ibid. p. 156.

17. Arthur Danto, *Mapplethorpe* (London, 1992), p. 330.

18. Kristeva, *Powers of Horror*, p. 91.

19. Bataille, quoted in Foster, *The Return of the Real*, p. 156.

20. Jacques Lacan, *The Four Fundamental Concept of Psycho-Analysis*, trans. Alan Sheridan, (London, 1994) p. 103.

21. Foster, *The Return of the Real*, p. 141.

22. Lacan, p. 73.

23. Foster, *The Return of the Real*, p. 141.

24. See Wolfgang Iser, *How to Do Theory* (London, 2006), p. 98.

25. Lacan, p. 103. See also Iser, *How to Do Theory*, pp. 98–9.
26. Foster, *The Return of the Real*, p. 140.
27. Iser, *How to Do Theory*, p. 102.
28. Butler, *Gender Trouble*, p. 132.
29. Ibid. pp. 133–4.
30. Ibid. p. 133.
31. Ibid. p. 132.
32. See 'Profile Jeff Koons', http://www.jahsonic.com/JeffKoons.html (5 September 2003).
33. See also Zimmermann, *Skandalöse Körper*, pp.69–85.
34. Karl Rosenkranz, *Ästhetik des Häßlichen* (Leipzig, 1996), p. 252.
35. Ibid. p. 252.
36. Kristeva, *Powers of Horror*, p. 69.
37. Ibid. p. 71.
38. Rosalind Krauss, 'The Destiny of the Informé', in Yves-Alan Bois and Rosalind Krauss (eds.), *Formless: A User's Guide* (New York, 1997), p. 242.
39. Laura Mulvey, 'A Phantasmagoria of the Female Body: The Work of Cindy Sherman', in *New Left Review*, no. 188 (July–August), p. 145. See also Anja Zimmermann, *Skandalöse Bilder, Skandalöse Körper* (Berlin, 2001), pp. 83–4.
40. Lynda Nead, *Female Nude: Art, Obscenity and Sexuality* (London, New York, 1982), p. 23.
41. See Chris Townsend, *Vile Bodies* (Munich1998), p. 73.
42. Anja Zimmermann, *Skandalöse Bilder, Skandalöse Körper*, p. 116–17.
43. Barbara Rose, 'Is it Art? Orlan and Transgressive Art', *Art in America*, vol. 81, no. 2 (1993), p. 85, cited in Philip Auslander, *From Acting to Performance* (London, New York, 1997), p. 128.
44. Auslander, *From Acting to Performance*, p. 129.
45. Eckhart Gillen, 'Dies Lebenden Stinken', in Eckhart Gillen (ed.), *Deutschlandbilder: Kunst aus einem geteilten Land* (Berlin and Cologne, 1997), pp. 355–6.
46. Durs Grünbein, cited in Gillen, 'Die Lebenden Stinken', p. 356.
47. Hans-Joachim Maaz, *Der Gefühlsstau: Ein Psychogramm der DDR* (Berlin, 1990).
48. Gillen, 'Die Lebenden Stinken', pp. 356–7.
49. Bataille, 'The Solar Anus', http://societyofcontrol.com/library/literatur/bataille_solaranus_e.txt (15 September 2005).
50. See Mary Richards, 'Ron Athey, A.I.D.S. and the Politics of Pain', http://people.brunel.ac.uk/bst/3no2/papers/mary%20richards.htm (5 May 2005).

## Chapter 4. Violent Images

1. Bret Easton Ellis, *American Psycho* (London, 1991), p. 304.
2. The Tech, 'American Psycho more than it seems', http://www-tech.mit.edu/V111/N18/jackso.18o.html (4 September 2005).
3. Bataille, *Eroticism* (London, New York, 1987), pp. 167–9.
4. See Rudolf Maresch, 'Medien der Gewalt–Gewalt der Medien', in Florian Roetzer (ed.), *Virtuelle Welten: Reale Gewalten* (Hanover, 2003), p. 169.
5. Quoted in Martin Jay, *Refractions of Violence* (New York, London, 2003), p. 182.
6. Detlef Kremer, 'Gewalt und Grotesque bei David Lynch and Francis Bacon', in Rolf Grimminger (ed.), *Kunst-Macht-Gewalt. Der Ästhetische Ort der Agressivität* (Munich, 2000), p. 209.
7. *Lexikon der Antike* (Leipzig, 1984), p. 588; and 'Of Gods and Men', version 3.0: http://www.newmanjunior.wa.edu.au/gods/NA8.htm (8 September 2005).
8. Jay, *Refraction of Violence*, p. 182.
9. Walter Benjamin, *Critique of Violence*, quoted in Martin Jay, *Refraction of Violence*, p. 182.
10. See for instance Friedrich Hacker, *Aggression: Die Brutalisierung der modernen Welt* (Munich, 1985).

# Notes

11. See Norbert Elias, *The Civilising Process*, trans. Edmund Jephcott (Oxford, Malden, 2000).
12. Rudolf Maresch, 'Medien der Gewalt–Gewalt der Medien', pp. 170–1.
13. The notion of 'original' is problematic in print graphic and other art media where multiples of an original matrix or mould are being made. Original in such context cannot be divorced from the concept of authority, signified through the artist's monogram or the 'actions' by an authorised individual or body. But again, authority and authorisation in art and beyond remain problematic.
14. Boris Groys, *Kunst-Kommentare* (Vienna, 1997), p. 29 (my translation).
15. Ibid. p. 29.
16. Ibid. p. 30.
17. Ibid. 32–4.
18. Grayson Perry, *Cycle of Violence* (London, 2002).
19. http://www.tate.org.uk/britain/turnerprize/2003/perry.htm (4 September 2005).
20. Perry, *Cycle of Violence*.
21. See also http://ohno.itgo.com/minutemenbeanspill.htm (5 September 2005).
22. See Robert Orth, 'Einige Verlassene Jahrzehnte', in Raymond Pettibon, *Raymond Pettibon: Aus dem Archiv der Hefte* (Cologne, 2000), pp. 5–71.
23. Description by Kristin Schmidt, in Yilmaz Dziewior (ed.), *Paul McCarthy, Videos 1970–1997* (Hamburg, Cologne, 2003), p. 110–11.
24. Michael Stoeber, 'Paul McCarthy', in *Kunstforum*, vol. 158 (January–March 2002), p. 294.
25. See Ulrike Groos, in *Paul McCarthy, Videos 1970–1997*, pp. 141–2.
26. In *Kunst des 20 Jarhunderts*, p. 571.
27. Mike Kelley, *The Uncanny*, ed. Christoph Grunenberg (Liverpool, Cologne, 2004).
28. Sigmund Freud, 'The Uncanny', in *The Penguin Freud Library*, vol. 14: *Art and Literature*, ed. Albert Dickson, trans. James Strachey (London, 1990), p. 339.
29. Ibid. p. 345.
30. Ibid. pp. 366–7.
31. See also Christoph Grunenberg, 'Life in a Dead Circus. The Spectacle of the Real', in Kelley, *The Uncanny* (Liverpool, Cologne, 2004), p. 57.
32. See also John C. Welchman, 'The Uncanny', in Kelley, *The Uncanny*, pp. 39–40.
33. See *Rohkunstbau 12*, curated by Mark Gisbourne, Groß Leuthen, Germany, 2005.
34. Foster, *The Return of the Real*, p. 128.
35. Ibid. p. 128.
36. Ibid. p. 130.
37. Ibid. p. 131.
38. Ibid.
39. Ibid. p. 132.
40. Ibid.
41. Ibid.
42. Sven Drühl, 'Absenter versus präsenter Tod', in *Kunstforum*, vol. 153 (January–March 2001), p. 111.
43. Elisabeth Bronfen, *Over Her Dead Body* (Manchester, 1992), pp. 39–58.
44. Sven Drühl distinguishes between present death, where the corpse is being represented, and absent death, that operates with clues that seek induce the imagination to invoke, associate the violent event and its victims. See Drühl, 'Absenter versus präsenter Tod', pp. 109–17.
45. See also Ingo F. Walther (ed.), *Art of the 20th Century* (New York, 2000), pp. 675–6.
46. See Susanne Boecker, 'Zeitgenössische japanische Fotografie', in *Kunstforum*, vol. 168 (January–March 2004), pp. 210–11.
47. For a pervasive discussion of this interrelation, see Bronfen, *Over Her Dead Body*.

## Chapter 5. 'Playing with the Dead'

1. Kristeva, *Powers of Horror*, p. 3.
2. Gottfried Benn, 'Little Aster', in David Miller and Stephen Watts (eds.), *Music While Drowning: German Expressionist Poetry* (London, 2003), p. 60.
3. Bataille, *Eroticism*, p. 45.
4. Ibid. p. 47.
5. Ibid. p. 57.
6. Ibid.
7. See also Chris Townsend, *Vile Bodies* (Munich, New York, 1998), pp. 132–3.
8. Guy Debord, *Society of the Spectacle* (Detroit, 1983), paragraph 1, unpaginated.
9. Gunter von Hagens, *Anatomy Art* (Heidelberg, 2000).
10. Ibid. p. 33.
11. Ibid. p. 34.
12. Ibid. p. 34.
13. See Jürgen Habermas, *The Structural Transformation of the Public Sphere: An Inquiry into the Category of Bourgeois Society*, trans. Thomas Burger and Frederick Lawrence (Cambridge, MA, 1989).
14. See for instance Martin Kemp and Marina Wallace, *Spectacular Bodies* (London, 2000).
15. Mikhail Bakhtin, *Rabelais and His World* (Bloomington, Indiana, 1984), particularly.
16. See Kemp and Wallace, *Spectacular Bodies*, pp. 23–68.
17. Bataille, *Eroticism*, p. 63.
18. Roland Barthes, *Camera Lucida* (London, 1993), pp. 92.
19. Ibid. pp. 92–3.
20. Bronfen, *Over Her Dead Body*, p. 39.

## Chapter 6. Anti-Normative Acts

1. Gertrude Stein, *Q.E.D.* (London, 1995), p. 102.
2. James Baldwin, *Giovanni's Room* (New York, 1956), p. 86.
3. Kobena Mercer, 'Ethnicity and Internationality: New British Art and Diaspora-Based Blackness', in Nicholas Mirzoeff (ed.), *The Visual Culture Reader* (2nd edition, London, New York, 2002), p. 193.
4. Ibid.
5. Allen Ellenzweig and George Stambolian, *The Homoerotic Photograph* (New York, 1992), p. 2.
6. See Lacan, 'The Signification of the Phallus', in *Ecrits: A Selection*, trans. Alan Sheridan (New York, 1976), pp. 281–91.
7. See Bataille, *Eroticism*.
8. Steven Nelson, 'Transgressive Transcendence in the Photographs of Rotimi Fani-Kayode', *Art Journal* (Spring, 2005), http://www.findarticles.com/p/articles/mi_m0425/is_1_64/ai_n13807669 (30 September 2005).
9. Butler, *Gender Trouble*, p. 132.
10. Ibid. p. 133.
11. See Schneider, *The Explicit Body in Performance*, pp. 66–7 and Zimmermann, *Skandalöse Bilder, Skandalöse Körper*, pp. 226–33.
12. Schneider, *The Explicit Body in Performance*, pp. 14–15.
13. Kobena Mercer, 'Mortal Coil: Eros and Diaspora in the Photographs of Rotimi Fani-Kayode', in Carol Squiers (ed.), *Overexposed: Essays on Contemporary Photography* (New York, 1999), p. 184.
14. Isaac Julien, 'Creolizing Vision', in Okwui Enwezor et. al. (eds.), *Créolité and Creolization: Documenta 11_Platform 3* (Kassel, 2003), p. 149.
15. Ibid. p. 150.
16. Moira Roth, 'Reading between the Lines: The Imprinted Spaces of Sutapa Biswas', in Katy Deepwell (ed.), *New Feminist Art Criticism* (Manchester and New York, 1995), p. 39.

# Notes 165

17. See Tessa Boffin and Jean Fraser, *Stolen Glances: Lesbians take Photographs* (London, 1991), p. 19.
18. Ibid. p. 14.
19. Dominic van den Boogerd, 'My Pleasure, Your Delight: Regarding the M D-Light Series of Marlene Dumas', in Mariska van den Berg and Marlene Dumas (eds.), *MD* (Amsterdam, 1998), p. 39.
20. Mary-Rose Hendrikse, 'Beyond Possession: Marlene Dumas and the Mobilization of Subject, Paint and Meaning,' http://www.unisa.ac.za/Default.asp?Cmd=ViewContent&ContentID=7233 (30 September 2005).

## Chapter 7. Obscenity and the Documentary Tradition

1. Edmund Burke, *A Philosophical Enquiry into the Origins of Our ideas of the Sublime and Beautiful*, cited in Sontag, *Regarding the Pain of Others* (London, 2003), p. 85.
2. Irvine Welsh, *Porno* (London, 2002), p. 358.
3. Sontag, *Regarding the Pain of Others*, p. 88.
4. Anne von der Heiden, 'Von dem was der Fall ist: Case History von Boris Mikhailov', *Kunstforum*, vol. 153 (January–March 2001), p. 118.
5. Boris Mikhailov, *Case History* (Zurich, Berlin, New York, 1999), p. 4.
6. W. J. T. Mitchell, 'Benjamin and the Political Economy of the Photograph', in Liz Wells (ed.), *The Photography Reader* (London and New York, 2003) p. 55.
7. Mikhailov, *Case History*, pp. 5–6.
8. Von der Heiden, 'Von dem was der Fall ist', p. 119.
9. Mikhailov, *Case History*, p. 5.
10. Von der Heiden, 'Von dem was der Fall ist', p. 119.
11. See von der Heiden, 'Von dem was der Fall ist', p. 119.

## Chapter 8. Recycled Fantasies

1. Barbara Cartland, *Love on the Wind* (London, 1982), cited in http://www.kirjasto.sci.fi/bcartlan.htm (25 September 2005).
2. Angela Carter, 'Bloody Chamber', in Id, *The Bloody Chamber and Other Stories* (London, 1979), p. 39.
3. For an influential modernist perspective on kitsch, see for instance Clement Greenberg, 'Avant-garde and Kitsch' (1939), reprinted in: Charles Harrison and Paul Wood (eds.), *Art in Theory 1900–2000: An Anthology* (Oxford and Malden, 2003), pp. 539–49.
4. Gordon C. F. Barnes, 'Kitsch,' in Michael Kelly (ed.), *Encyclopedia of Aesthetics* (New York, London, 1998), vol. 3, p. 68.
5. Emmanuel Cooper, *The Sexual Perspective: Homosexuality and Art in the last 100 Years* (2nd edition, London, New York, 1994), p. 236.
6. See Lucia Saks and Daniel Herwitz, 'Camp', in Kelly (ed.), *Encyclopedia of Aesthetics*, vol. 1, pp. 327–31.
7. Sontag, 'Notes on Camp', in Id, *Against Interpretation and Other Essays* (New York, 1966), p. 287.
8. See Saks and Herwitz, 'Camp', p. 329.
9. John Kendrick, 'A History of the Musical Burlesque', http://www.musicals101.com/burlesque.htm (3 October 2005).
10. See also Harald Hellmann, 'Introduction', in Harald Hellmann (ed.), *1000 Pin-Up Girls* (Cologne 2002), unpaginated.
11. Peter Greenaway, cited in Alan Woods, *Being Naked Playing Dead* (Manchester, 1996), p. 158.
12. Ralph Rumney, cited in Woods, *Being Naked Playing Dead*, p. 157.
13. The creative partnership of Michael Flanders and Donald Swann started in 1939. They came to the fore during the 1950s and 1960s with their revue songs and performances. Eric Morecambe and Ernie Wise were one of the most popular comedy double acts in the UK from their first TV appearance in the mid 1960s, working successfully on stage and in film too. For more than a decade their puns, jokes and catchphrases became engrained in the cultural fabric of Britain. I would like to thank Alison Rowley and Terry Wright for their informative advice on this point.

14. Nancy Spector, 'Only the Perverse Fantasy Can Still Serve Us', in Matthew Barney, *The Cremaster Cycle* (New York, 2002), pp. 6–7.

15. *Webster's Third New International Dictionary of the English Language*, unabridged (Springfield, MA, Cologne, 1993), p. 534.

16. Spector, 'Only the Perverse Fantasy Can Still Serve Us', p. 33.

17. Ibid. p. 35.

## Chapter 9. 'Know Thyself'?

1. Francesca Alfano Migiletti (FAM), *Extreme Bodies: The Use and Abuse of the Body in Art* (Milan, 2003), p. 152.

2. D. H. Lawrence, 'Pornography and Obscenity', in *Selected Critical Writings* (London, 1998), p. 297.

3. Eric Kroll, '"Natacha Downloads": Introducing Natacha', in: Natacha Merritt, *Digital Diaries* (Cologne, 2000), p. 8.

4. Ibid.

5. Ibid. p. 9.

6. See: Christian Hansen, Catherine Needham and Bill Nichols, 'Pornography, Ethnography and the Discourses of Power', in: Bill Nichols (ed.), *Representing Reality: Issues and Concepts in the Documentary* (Bloomington and Indianapolis, 1991), p. 212.

7. See Richard Dyer, 'Idol Thoughts: Orgasm and Self-Reflexivity in Gay Pornography', in Nicholas Mirzoeff (ed.), *Visual Culture Reader* (London and New York, 1998), p. 505.

8. Williams 'Corporealized Observers: Visual Pornographies and the "Carnal Density of Vision"', in Patrice Petro (ed.), *Fugitive Images: From Photography to Video* (Bloomington and Indianapolis, 1995), pp. 28–9.

9. Williams, *Hard Core*, p. 49; and Williams, 'Corporealized Observers', pp. 28–9.

10. Hansen, Needham and Nichols, 'Pornography, Ethnography and the Discourses of Power', p. 137.

11. See Andreas Springer, *Pipilotti Rist: Werkmonografie* (Karlsruhe, 2002), dissertation, pp. 44–6.

12. Linda Williams, 'Corporealized Observers: Visual Pornographics and the "Carnal Density of Vision"', in Patrice Petro (ed.), *Fugitive Images: From Photography to Video*, (Bloomington, Indiana, 1995), p. 27.

13. Hansen, Needham and Nichols, 'Pornography, Ethnography and the Discourses of Power', p. 138.

14. Susanne Boecker, 'Zeitgenössische japanische Fotografie', *Kunstforum*, vol. 168 (January–February 2004), p. 198.

15. Nicholas Bornoff, 'Sex and Consumerism: The Japanese State of the Arts', in Fran Lloyd (ed.), *Consuming Bodies: Sex and Contemporary Japanese Art* (London, 2002), p. 60.

16. Ibid.

17. Ibid.

18. Akihito Yasumi, 'The Photographer between a Man and a Woman', in *Araki: Tokyo Lucky Hole* (Cologne, 1997), p. 6.

19. Bornoff, 'Sex and Consumerism', p. 60.

20. Yasumi, 'The Photographer between a Man and a Woman', pp. 8–9.

21. This is Andrew Hurle's summary of Merritt's work, developed in a discussion of her work at the international conference 'Inscriptions in the Sand 05', Eastern Mediterranean University, Famagusta, Northern Cyprus, 12–13 May 2005.

22. Though Taschen lists Merritt's book in its sex section, the publishing house's access to the main art book sellers and its position in the market along with the blurred boundaries between what counts as *ars erotica* and pornography made it easy for the *Digital Diaries* to be sold alongside the many publications on contemporary and historical art.

23. Jay David Bolter and Richard Grusin, *Remediation: Understanding New Media* (Cambridge, Mass., 2000), p. 100.

24. Ibid.

25. Sheila Marie Thomas, 'Speaking the Unspeakable', quoted in Gabrielle Cody (ed.), *Hardcore from the Heart: The Pleasures, Profit and Politics of Sex in Performance/Annie Sprinke Solo* (London and New York, 2001), p. 9.

26. Sheila Marie Thomas and Linda Williams, quoted in Rebecca Schneider, *The Explicit Body in Performance*, p.58.
27. George W. S. Bailey, 'Dickie, George', in Kelley (ed.), *Encyclopedia of Aesthetics*, vol. 2, pp. 30–5.
28. Cody (ed.), *Hardcore from the Heart*, p. 4.
29. Ibid. pp. 6–7.
30. Ibid. p. 7.
31. Robert Ayers, 'Sprinkle: Listening to Annie Sprinkle', in: *transcript*, vol. 3/3, 1999, p. 104.
32. Cody (ed.), *Hardcore from the Heart*, p. 3.
33. Myra Macdonald, *Representing Women: Myths of Femininity in Popular Media* (London, New York, Sydney, Auckland, 1995), p. 165.
34. Ibid. p. 166.
35. Ibid. pp. 166–9.
36. Cody (ed.), *Hardcore from the Heart*, p. 18.

## Chapter 10. Digital (Counter-)Currents

1. Ute Eskildsen, 'Technology Picture Function', in Matthias Winzen (ed.), *Thomas Ruff: Photographs 1979 to the Present* (Cologne, 2002), p. 163.
2. Ibid. p. 161.
3. Whilst obscene material accessed via the PC comes closer to the reception experience of the traditional book format, particularly the 'coffee-table book', the laptop with its higher degree of portability and comfortable 'handiness' (or even more so the new generation of mobile phones with still and moving imaging capability) bears a greater proximity to the magazine pages or the (annotated) amateur photo(album)s that more or less clandestinely change hands, and that can be 'devoured' and 'used' in almost any private or public place. (I would like to thank Alison Rowley for her helpful comments on this point.)
4. Bolter and Grusin: *Remediation*, p. 31.
5. Ibid.
6. Ibid. p. 45.
7. Ibid. p. 53.
8. Ibid. p. 21.
9. Winzen, *Thomas Ruff*, p. 148.
10. Williams, 'Corporealized Observers', p. 37.
11. The term 'vuser' (viewer+user) was coined by Bill Seaman in his work on *Recombinant Poetics*; for details, see 'Recombinant Poetics: Bill Seaman in Discussion with Yvonne Spielmann', in Simon Yuill and Kerstin Mey (eds.), *Cross-Wired: Communication, Interface, Locality* (Manchester, 2004), p. 9. Bill Seaman argues that in hypermedia each of the interlaced media-elements, i.e. text, images sound, etc., remains 'of-itself'. 'In a time-based media environment, each set of varying media elements contributes their own particular force. A participant brings their embodied pattern history (mind set) as it relates to each of the differing kinds of media. An ongoing meaning summing is performed where the forces contribute to an overall meaning.' (Bill Seaman, 'Pattern Flows | Hybrid Accretive Processes Informing Identity Construction', in *Convergence*, vol. 11 (Winter 2005), p. 18.
12. Winzen, 'A Credible Invention of Reality', in Winzen (ed.), *Thomas Ruff*, p. 149.
13. Williams, 'Corporealized Observers'; and Jonathan Crary, 'Modernizing Vision', in Hal Foster (ed.), *Vision and Visuality* (New York, 1988), pp. 29–44.
14. Winzen, 'A Credible Invention of Reality', p. 150.
15. Ibid. p. 151.
16. Thomas Ruff, *Nudes*, with 'Cléopâtre' by Michel Houellebecq (Munich, 2003).
17. Multiple-channel distribution strategies not just for contemporary art had been adopted across the art market for some time (see also for instance Natacha Merritt, *Digital Diaries*, Chapter 10).

18. Daniel Chandler, *Semiotics for Beginners* (1994), http://www.aber.ac.uk/media/Documents/S4B/sem02.html (5 Aril 2005).

19. For a detailed discussion of the potential of the photographic apparatus and characteristics its outcomes, the photograph see for instance Vilém Flusser, *Towards a Philosophy of Photography* (London, 2000).

20. Figures taken from www.protectkids.com/dangers/stats.htm (5 April 2005). The site draws on reliable web statistics provided by Nielsen//NetRatings and net security provider N2H2/Secure Computing.

21. Quoted in Chandler, *Semiotics for Beginners*.

22. Ibid.

23. Umberto Eco, 'Wie man einen Pornofilm erkennt', in: Umberto Eco, *Sämtliche Glossen und Parodien 1963–2000* (Frankfurt/Main, 2001), pp. 321–3.

24. See Anne-Mie Van Kerckhoven, 'On women images ', in Anne-Mie Van Kerckhoven, *Beauty, Therapeutic Use of*, ed. Ronald Van de Sompel (Antwerp, 1999), p. 84.

25. Ibid. p. 82.

26. Ibid.

27. I would like to thank Jonathan Robertson for his valuable comment on amateur photography.

28. Harald Hellmann, 'Preface', in Burkhard Riemschneider (ed.), *Pin-up Girls* (Cologne, 2002), unpaginated.

29. It should not be forgotten that there also exists a whole plethora of pin-ups of men predominantly directed at homosexual clients (see Mapplethorpe, Chapter 7). Again, there the material is marked by cultural inscriptions such as class and race based on the social and cultural aspirations of the image producer and ideal or real target readership.

30. Siegfried J. Schmidt, 'Werbekörper: Plurale Artefiktionen', in Angela Krewani (ed.), *Artefakte Artefiktionen: Transformationsprozesse zeitgenössischer Literaturen, Medien, Künste, Architekturen = artefacts artefictions* (Heidelberg, 2000), p. 56.

31. The issue of sound in pornographic film and video has not been widely discussed. The release of music from the 1970s adult cinema (see for instance *Deep Note* OST7569 and *Inside Deep Note* OST7469) demonstrate the sexually stimulating influences of soundtracks and soundscapes particularly through (repetitive) rhythms that are closely modelled on the rhythm of the human body (in action), enticing tonality and enveloping timbre. Another case in point is popular music's play on and as sexual lure. One only needs to think of Frankie Goes to Hollywood's bombastic fuck rhythm in 'Relax', or Serge Gainsbourg's and Jane Birkin's orgiastic '*Je t'aime*', or the Doors' *Light My Fire*, to name but a very few.

32. Whitney Chadwick, *Women, Art and Society* (London, 1990), p. 356.

33. Ibid.

34. Michael Archer, 'My Plinth Is Your Lap', in Dundee Contemporary Arts, Neuer Aachener Kunstverein and Revolver, Archiv für aktuelle Kunst, Frankfurt/Main (eds.), *Banner* (Dundee, Aachen, Frankfurt/Main), p. 61.

35. See Kristeva, *Revolution in Poetic Language* (New York, Columbia University, 1984); and Toril Moi (ed.), *The Kristeva Reader* (Oxford, 1986), particularly pp. 86–136.

36. See Toril Moi, *The Kristeva Reader*, pp. 187–213.

37. Archer, 'My Plinth is Your Lap', p. 62.

## Chapter 11. Cyber-(ob)scene

1. Jeffrey Deitsch, *Posthuman* (New York, Amsterdam, 1992), p. 26.

2. Florian Cramer and Stewart Home, *Pornographic Coding*, http://plot.bek.no/%7Ecrash2005/pornographic-coding.pdf (10 September 2005).

3. For a description of key changes between cultural industry and amateur producers in the USA in the wake of digitisation, see, for example, Lane III, *Obscene Profits* (New York, London, 2000).

4. Williams, *Hard Core*, p. 283.

5. Catherine MacKinnoch, 'Vindication and Resistance: A response to the Carnegie Mellon "Study of Pornography in Cyberspace"', *Georgetown Law Journal*, vol. 83, no. 6 (1995), p. 1959.

6. Yaman Akendiz, *Sex on the Net: The Dilemma of Policing Cyberspace* (Reading, 1999), p. 17.

7.   Bolter and Grusin, *Remediation*, p. 260.

8.   See Julian Dibbel, 'Rape in Cyberspace', *Village Voice* (21 December 1993), p. 38, cited in Sherry Turkle, *Life on the Screen* (New York, 1995), p. 252.

9.   Bolter and Grusin, *Remediation*, p. 260.

10.  Julia Scher interviewed by Tilman Baumgaertel, in Tilman Baungärtel (ed.), *net.art* (Nuremberg, 1999), p. 71.

11.  See Julia Scher, http://www.thephotographyinstitute.org/www/journals/1998/julia_scher.html (7 September 2005).

12.  Julia Scher interviewed by Tilman Baumgaertel, p. 71.

13.  Roy Ascott, *Telematic Embrace: Visionary Theories of Art, Technology and Consensus* (Berkeley, London, 2003), p. 199.

14.  Stadtwerkstadt, 'Social Club at Next Sex Projects', in Gerfried Stocker and Christine Schöpf (eds.), *Next Sex: Ars Electronica 2000* (Vienna/New York, 2000), p. 280.

15.  Alexei Shulgin, 'FUCKU® FUCKME', http://www.fu-fme.com/faq.html (10 September 2005).

16.  Alexei Shulgin, 'FUCKU® FUCKME'.

17.  See for instance Christiane Paul, *Digital Art* (London, 2003), pp. 168–9.

18.  See Rachel Baker, 'Dot2Dot', http://www.irational.org/tm/dot2dot/ (11 September 2005).

19.  See Baker, 'Dot2Dot'.

20.  Neoism evolved in the late 1970s from subcultural performance and art interventions, thought and life style of a group of activists in an attempt to rebel against any categorisation and historicisation of art by the cultural establishment and thus to resist its appropriation and commodification. Neoist practice was founded on shared artistic identities, plagiarist practices across different creative territories, practical jokes and contradictory utterances.

21.  Cramer and Home, *Pornographic Coding*, p. 1.

22.  Ibid.

23.  Jean Baudrillard, *Fatal Strategies*, trans. Philip Beitchman and W. G. J. Niesluchowski, ed. Jim Fleming (New York, 1990), p. 54.

24.  Ibid. p. 55–6.

25.  Baudrillard, *The Ecstasy of Communication*, trans. Bernhard and Caroline Schutze (New York, 1987), p. 155; cited in Mark C. Taylor, *The Moment of Complexity* (Chicago, 2001), p. 70.

26.  Taylor, *The Moment of Complexity*, pp. 69–70.

27.  Ibid. p. 70.

28.  See Linda Nochlin, 'Why Have There Been No Great Women Artists?', reprinted in *Women, Art, and Power and Other Essays* (Boulder, CO, 1988), pp. 145–78.

29.  Cramer and Home, *Pornographic Coding*, pp. 4–5.

30.  Istvan Kantor, 'Intercourse: Interactive Transmission Machinery in Progress', in Stocker and Schöpf (eds.), *Next Sex*, p. 288.

31.  See Dieter Huber and Heimo Ranzenbacher, 'Klones', in Stocker and Schöpf (eds.), *Next Sex*, pp. 265–9.

32.  Cramer and Home, *Pornographic Coding*, p. 5.

33.  Ibid. p. 8.

34.  VNS Matrix, 'Nothing is Certain: Flesh, the Postbody and Cyberfeminism. VNS Matrix in Conversation with Nora Delahunty', in Stocker and Schöpf (eds.), *Memesis: The Future of Evolution, ARS Electronica '96* (Vienna, New York, 1996), p. 181.

35.  See Verena Cuni, 'Die Flanerin im Datennetz: Wege und Fragen zum Cyberfeminismus', in Sigrid Schade-Tholen, Georg Christoph Tholen (eds.), *Konfigurationen: Zwischen Kunst und Medien* (Munich, 1999), p. 472.

36.  Ibid.

# Bibliography

Acconci, Vito and Ulrich Krempel, *Sex and Crime: Von den Verhältnissen der Menschen* (Hannover, 1996)

Akendiz, Yaman, *Sex on the Net. The Dilemma of policing cyberspace* (Reading, 1999)

Ascott, Roy, *Telematic Embrace: Visionary Theories of Art, Technology and Consensus* (Berkeley, London, 2003)

Ashford, Robert, *Erotique: Masterpieces of Erotic Photography* (Carlton Books, 2001)

Auslander, Philip, *From Acting to Performance* (London, New York, 1997)

Bakhtin, Mikhail, *Rabelais and His World* (Bloomington, Ind., 1984)

Bal, Mieke, *Double Exposure: The Subject of Cultural Analysis* (New York and London, 1996)

Baldwin, James, *Giovanni's Room* (New York, 1956)

Barber, Stephen, *The Art of Destruction: The films of the Vienna Action group* (London, 2004)

Bataille, George, 'The Solar Anus,' <http://societyofcontrol.com/library/literatur/bataille_solaranus_e.txt>

Bataille, George, *Story of the Eye* (London, 2001)

Bataille, George, *Eroticism* (London and New York, 1998)

Baudrillard, Jean, *Fatal Strategies* , trans. Philip Beitchman and W. G. J. Niesluchowski, ed. Jim Fleming (New York, 1990)

Baumgärtel, Tilman (ed.), *net.art.* (Nuremberg, 1999)

Berg, Mariska van den; Dumas, Marlene (eds.), *MD* (Amsterdam, 1998)

Blickle, Ursula, *Exotik Erotik: Vier Positionen zur Sexualität in der Kunst der 90er Jahre* (Krachtal and Bremen, 1996)

Boecker, Susanne, 'Zeitgenössische japanische Fotografie,' in *Kunstforum*, vol. 168 (Jan-March, 2004), pp193-247

Boffin, Theresa; Fraser, Jean (eds.), *Stolen Glances: Lesbians take Photographs* (London, 1991)

Bois, Yves-Alan and Rosalind Krauss, *Formless: A User's Guide* (New York, 1997)

Bologne, Jean-Claude, *Histoire de la pudeur* (Paris, 1999)

Bousteau, Fabrice, *Sexes: Images – practiques et pensées contemporaines* (Paris, 2002)

Brennan, Teresa and Martin Jay (eds.), *Vision in Context: Historical and Contemporary Perspectives on Sight* (New York, 1996)

Butler, Judith, *Gender Trouble* (New York; London, 1992)

Carey-Thomas, Lizzie and Katharine Stout, Rachel Tant, et. al, *Turner Prize 2003* (London, 2003)

Carter, Angela, *The Bloody Chamber* (London, 1981)

Cartland, Barbara, *Love on the Wind* (London, 1982)

Cartwright, Lisa, '"Emergencies of Survival". Moral Spectatorship and the "New Vision of the Child" in Postwar Child Psychoanalysis', in *Journal of Visual Culture* 3/1 (2004), pp. 37–49

Case, Sue-Ellen and Phillip Brett, Susan Leigh Foster (eds.), *Cruising the Performative: Interventions into the Representation of Ethnicity, Nationality and Sexuality* (Bloomington and Indianapolis, 1995)

Chancer, Lynn S., *Reconcilable Difference: Confronting Beauty, Pornography and the Future of Feminism* (Berkeley and Los Angeles, 1998)

Chapman, Jake and Dinos, *Insult to Injury* (Göttingen, 2003)

Chicago, Judy, *Beyond the Flower: The Autobiography of a Feminist Artist* (New York, 1996)

Christov-Bakargiev, Carolyn (ed.), *John Wesley* (New York, 2000)

Cody, Gabrielle (ed.), *Hardcore from the Heart: The Pleasures, Profits and Politics of sex in Performance – Annie Sprinkle Solo* (London and New York, 2001)

Cooper, Emmanuel, *The Sexual Perspective: Homosexuality and Art in the Last 100 Years in the West* (London, 1986)

Cramer, Florian; Home, Stuart, 'Pornographic Coding,' <http://plot.bek.no/%7Ecrash2005/pornographic-coding. pdf> (10 September 2005)

Danto, Arthur, 'Playing with the Edge. The Photographic Achievement of Robert Mapplethorpe,' in: Mapplethorpe, Robert, *Mapplethorpe* (New York, 1992).

Davis, Kathy (ed.), *Embodied Practices: Feminist Perspectives on the Body* (London, Thousand Oaks, New Delhi, 1997)

Deitsch, Jeffrey, *Posthuman* (New York, Amsterdam, 1992)

De Jean, Joan E., *The Reinvention of Obscenity: Sex, Lies and Tabloids in Early Modern France* (Chicago, 2002)

Dekkers, Midas, *Dearest Pet: On Bestiality*, trans. Paul Vincent (London and New York, 1994)

Dekkers, Midas, *The Way of All Flesh: A Celebration of Decay* (London, 2000)

Denzin, Norman K., *Images of Postmodern Society: Social Theory and Contemporary Cinema* (London and Thousand Oaks, 1995)

Didi-Huberman, Georges, *Ähnlichkeit und Berührung: Archäologie, Anachronismus und Modernität des Abdrucks* (Cologne, 1999)

Dixon, Wheeler Winston, *It Looks at You: The Return of the Gaze of Cinema* (New York, 1995)

Drühl, Sven, 'Absenter versus präsenter Tod', *Kunstforum: Choreografie der Gewalt*, vol. 153 (Jan–March 2001), pp. 109 –116

Douzinas, Costas, Nead, Lynda and Hal Foster (eds.), *Law and the Image: The Authority of Art and the Aesthetics of Flaw* (Chicago, 1999)

Downs, Donald Alexander, *The New Politics of Pornography* (Chicago, 1989)

Drühl, Sven, 'Absenter versus präsenter Tod', in *Kunstforum International* 153 (Jan–March 2001), pp. 109–116

Duerr, Hans Peter, *Der Erotische Leib* (Frankfurt, 1999)

Dundee Contemporary Arts, Neuer Aachener Kunstverein and Revolver – Archiv für Aktuelle Kunst, Farnkfurt/Main, *Banner* (Dundee, Aachen and Frankfurt/Main, 2002)

Dworkin, Andrea, *Pornography: Men Possessing Women* (New York, 1981)

Dziewior, Yilmaz, *Paul McCarthy: Videos 1970–1997* (Cologne, 2002)

Eco, Umberto, 'Wie man einen Pornofilm erkennt', in *Umberto Eco: Sämtliche Glossen und Parodien 1963–2000*, Frankfurt/Main, 2001), pp. 321–3

Ehrlicher, Hanno, *Die Kunst der Zerstörung* (Berlin, 2001)

Elias, Norbert, *The Civilising Process*, trans. Edmund Jephcott (Oxford, Malden, 2000)

Ellenzweig, Allen; Stambolian, George, *The Homoerotic Photograph* (New York, 1992)

Ellis, Breat Easton, *American Psycho* (London, 1991)

Ellis, Kate and Beth Jake, Nan D. Hunter et. al., *Caught Looking: Feminism, Pornography and Censorship* (Seattle, 1988)

Enwezor, Okwui, et. al. (eds.), *Créolité and Creolization: Documenta 11_Platform 3* (Kassel, 2003)

Eskildsen, Ute, 'Technology, Picture, Fiction', in *Thomas Ruff 1979 to the Present* (Cologne, 2003), pp. 161–167

Ewing, William A., *The Body: Photoworks of the Human Form* (London, 1994)

Familistère 1. *Young Greek Artists in Berlin* (Berlin 2002)

Faulstich, Werner, *Die Kultur der Pornographie: Kleine Einführung in Geschichte, Medien, Ästhetik, Markt und Bedeutung* (Bardowick, 1994)

Fayet, Roger (ed.), *Gewaltbilder: Zur Ästhetik der Gegenwart* (Zurich, 2002)

Foster, Hal (ed.), *Vision and Visuality* (New York, 1988)

Foster, Hal, *The Return of the Real* (Cambridge, Mass., 1996)

Foucault, Michel, *The History of Sexuality*, vols. 1–3 (London, 1978, 1984, 1986)

Freud, Sigmund, 'The Uncanny,' in *The Penguin Freud Library*, vol. 14, *Art and Literature*, ed. Albert Dickson, trans. James Strachey (London, 1990)

Fuchs, Elionor, 'Staging the Obscene Body', *Drama Review* 33/1 (Spring, 1998), pp. 33–58

Gamman, Lorraine and Margaret Marshment (eds.), *The Female Gaze: Women as Viewers of Popular Culture* (London, 1988)

Gerig, Manfred, 'Mit Gewalt', in *Gewaltbilder: Zur Ästhetik der Gewalt*, ed. by Roger Fayet (Bellerive, 2002)

Gehrke, Claudia, *Frauen & Pornografie* (Tübingen, 1988)

Gillen, Eckhart, 'Die Lebenden Stinken', in *Deutschlandbilder: Kunst aus einem geteilten Land* (Berlin, Cologne, 1997), pp. 356–63.

Goodrow Gérard A., *Exotik Erotik: Vier Positionen zur Sexualität in der Kunst der Neunziger Jahre* (Kraichtal-Unteröwisheim, 1996)

Gorsen, Peter, *Sexualästhetik: Grenzformen der Sinnlichkeit im 20: Jahrhundert* (Reinbek near Hamburg, 1987)

Gorsen, Peter, 'Das Prinzip Obszön und die verlorene Subversion', in *Kunstforum International 162* (Nov–Dec 2002), pp. 385–391

Grimmiger, Rolf (ed.), *Kunst – Macht – Gewalt: Der Ästhetische Ort der Agressivität* (Munich, 2000)

Groys, Boris, *Kunstkommentare* (Vienna, 1997)

Gubar, Susan and Joan Hoff (eds.), *For Adult Users Only* (Bloomington, Indiana, 1989)

Habermas, Jürgen, *The Structural Transformation of the Public Sphere: An Inquiry into the Category of Bourgeois Society*, trans. Thomas Burger and Frederick Lawrence (Cambridge, MA, 1989)

Hacker, Friedrich, *Aggression: Die Brutalisierung der modernen Welt* (Munich, 1985).

Hagens, Gunther von and Angelina Whalley, *Anatomy Art* (Heidelberg, 2000)

Harrison, Charles and Paul Wood, *Art in Theory 1900–2000: An Anthology of Changing Ideas* (Oxford and Malden, 2003)

Heath, Stephen, *The Sexual Fix* (London, 1982)

Heiden, Anne von der, 'Von dem, was der Fall ist. Case History von Boris Michailov', in *Kunstforum International* 153 (Jan–March 2001), pp. 117–131

Heinzius, Barbara, *Feminismus oder Pornograhie? Zur Darstellung von Erotik und Sexualität im Werk Dacia Marainis* (St. Ingbert, 1995)

Hellmann, Harald, *1000 Pin-Up Girls* (Cologne, 2002)

Hendrikse, Mary-Rose, 'Beyond possession. Marlene Dumas and the mobilization of subject, paint and meaning,' <http://www.unisa.ac.za/Default.asp?Cmd=ViewContent&ContentID=7233> (30 September 2005).

Herbert-Muthesius, Angelika, *Erotik in der Kunst des 20: Jahrhunderts* (Cologne, 1992)

Home, Peter and Reina Lewis, *Outlooks: Lesbian and Gay Sexualities and Visual Cultures* (London, 1996)

Holborn, Mark and Dimitri Levas (eds.) *Robert Mapplethorpe: Altars* (Munich, Paris and London, 1995)

Holmberg, Carl B., *Sexualities in Popular Culture* (Thousand Oaks, London and new Delhi, 1998)

hooks, bell, *reel to real: race, sex and class in the movies* (New York and London, 1996)

Hunt, Lynn (ed.), *Eroticism and the Body Politics* (Baltimore, 1991)

Hunt, Lynn, *The Invention of Pornography: Obscenity and the Origins of Modernity, 1500–1800* (New York, 1993)

Innes, Sherrie A., *Tough Girls: Women Warriors and Wonder Women in Popular Culture* (Philadelphia, 1999)

Irmscher, Johannes (ed.), *Lexikon der Antike* (Leipzig, 1984)

Jay, Martin, *Downcast Eyes. The Denigration of Vision in Twentieth Century French Thought* (Berkeley, 1994)

Jay, Martin, *Refractions of Violence* (New York and London, 2003)

Jones, Amelia, 'Intra-Venus and Hannah Wilke's Feminist Narcissism', in *Intra Venus* (New York, 1995)

Jones, Amelia, 'Tracing the Subject with Cindy Sherman', in *Cindy Sherman Retrospective* (New York, 1997), pp. 33–53

Jones, Amelia, *Body Art/Performing the Subject* (Minneapolis, 1998)

Jones, Amelia and Andrew Stephenson, *Performing the Body/Performing the Text* (London, 1999)

Kappeler, Susan, *The Pornography of Representation* (London, 1986)

Kauffman, Linda S., *Bad Girls and Sick Boys: Fantasies in Contemporary Art and Culture* (Berkeley, Los Angeles, London, 1998)

Kelly, Michael (ed.), *Encyclopedia of Aesthetics* (New York, London , 1998), vols. 1–4

Kelley, Mike, *The Uncanny*, ed. Christoph Grunenberg (Liverpool, Cologne, 2004)

Kemp, Martin and Marina Wallace (eds.), *Spectacular Bodies* (Berkeley, Los Angeles and London, 2000)

Kendrick, John, 'A History of the Musical Burlesque,' <http://www.musicals101.com/burlesque.htm> (3 October 2005)

Kendrick, Walter, *The Secret Museum: Pornography in Modern Culture* (Berkeley, Los Angeles, London, 1996)

Kiedan, Louis; Morgan, Stuart and Nicholas Sinclair, *Franko B* (London, 1997)

Kleinhans, Chuck, 'Virtual Child Porn. The Law and the Semiotics of the Image', in *Journal of Visual Culture* 3/1 (2004), pp. 17–34

Krauss, Rosalind E. and Jane Livingstone, *L'amour fou: Photography and Surrealism* (New York, 1985)

Kravagna, Christian, *Real Sex, Real Real, Real Aids – Real Text* (Klagenfurt, 1994)

Krewani, Angela (ed.), *Artefakte Artefiktionen: Transformationsprozesse Zeitgenössischer Kunst* (Heidelberg, 2000)

Kristeva, Julia, *Powers of Horror: An Essay on Abjection* (New York, 1982)

Kroll, Eric, *Fetish Girls* (Cologne, 2002)

Lacan, Jacques, 'The Signification of the Phallus,' in *Ecrits: A Selection*, trans. Alan Sheridan (New York, 1976), pp. 281–291

Lacan, Jacques, *The Four Fundamental Concepts of Psychoanalysis* (London, 1994)

Lane, Federick S. III, *Obscene Profits: The Entrepreneur of Pornography in the Cyber Age* (New York, London, 2000)

Laqueur, Thomas, *Making Sex: Body and Gender from the Greeks to Freud* (Cambridge, Mass. and London, 1990)

Lawrence, D. H., 'Pornography and Obscenity,' in *Selected Critical Writings* (London, 1998)

Levinas, Emmanuel, *Entre Nous: On Thinking-of-the-Other*, trans. Michael B. Smith; Barbara Harshav (London, 1998)

Lieberman, Janice S., *Body Talk: Looking and being Looked at in Psychotherapy* (North Bergen, N.J., 2000)

Lloyd, Fran (ed.), *Consuming Bodies: Sex and Contemporary Japanese Art* (London, 2002)

Lucie-Smith, Edward, *Sexuality in Western Art* (London, 1991)

Lucie-Smith, Edward, *Ars Erotica: An Arousing History of Erotic Art* (New York, 1997)

Maaz, Hans-Joachim, *Der Gefühlsstau – ein Psychogramm der DDR* (Berlin, 1990).

Macdonald, Myra, *Representing Women: Myths of Femininity in the Popular Media* (London, New York, Sydney, Aukland, 1995)

MacKinnoch, Catherine, 'Vindication and Resistance. A response to the Carnegie Mellon "Study of Pornography in Cyberspace",' in *Georgetown Law Journal*, vol. 83, no 6 (1995)

Marcuse, Ludwig, *Obszön, Geschichte einer Entrüstung* (Munich, 1962)

*Matthew Barney: The Cremaster Cycle* (New York, 2002), introduction by Nancy Spector

McDonald, Helen, *Erotic Ambiguities: The Female Nude in Art* (London and New York, 2001)

McNairn, Brian, *Mediated Sex: Pornography and Postmodern Culture* (London and New York, 1996)

Merritt, Natacha, *Digital Diaries* (Cologne, 2000)

Meyer, Moe (ed.), *The Politics and Poetics of Camp* (London and New York, 1994)

Miglietti, Francesca Alfano (FAM), *Extreme Bodies: The Use and Abuse of the Body in Art* (Turin, 2003)

Mikhailov, Boris, *Case History* (Zurich, Berlin and New York, 1999)

Miller, David and Stephen Watts (eds.), *Music While Drowning: German Expressionist Poetry* (London, 2003)

Mirzoeff, Nicholas, *Bodyscape: Art, Modernity and the Ideal Figure* (London and New York, 1995)

Mirzoeff, Nicholas (ed.), *The Visual Culture Reader*, 2nd ed. (London and New York, 2002)

Morse, Margaret, *Virtualities: Television, Media Art and Cyberculture* (Bloomington, Indiana, 1998)

Muehl, Otto, *Mama & Papa: Materialaktionen 63–69* (Frankfurt/M., 1969)

Munroe, Alexandra, 'Obsession, Fantasy and Outrage. The Art of Yayoi Kusama', in *Yayoi Kusama: A Retrospective*, ed. by Bhupendra Karia (New York, 1989)

Nead, Lynda, *The Female Nude: Art, Obscenity and Sexuality* (London and New York, 1992)

Nelson, Steven, 'Transgressive transcendence in the photographs of Rotimi Fani-Kayode,' Art Journal (Spring, 2005), <http://www.findarticles.com/p/articles/mi_m0425/is_1_64/ai_n13807669> (30 September 2005)

Nicholls, Bill, Representing Reality: Issues and Concepts in Documentary (Bloomington, 1991)

Nochlin, Linda, 'Why have there been No Great Women Artists?', reprinted in Women, Art, and Power and Other Essays (Boulder, CO, 1988), 145-78

Nochlin, Linda, The Body in Pieces: The Fragment as a Metaphor of Modernity (London, 1994)

Ohmer, Antje, Gefährliche Bücher? Zeitgenössische Literatur im Spannungsfeld zwischen Kunst und Zensur (Baden-Baden, 2000)

O'Regan, John (ed.), Amanda Coogan: A brick in the handbag (Oysterhaven, Co. Cork, 2005)

O'Toole, Lawrence, Pornocopia: Porn, Sex, Technology and Desire (London, 1998)

Parker, Roszika and Griselda Pollock (eds.), Framing Feminism: Art and the Women's Movement 1970–1985 (London, 1987)

Pearse, Allison, Modernism, Mass Culture and the Aesthetics of Obscenity (Cambridge, 2000)

Peckham, Morse, Art and Pornography (New York, 1969)

Perry, Grayson, Cycle of Violence (London, 2002)

Petro, Patrice (ed.), Fugitive Images: From Photography to Video (Indiana and Bloomington, 1995)

Pettibon, Raymond, Raymond Pettibon: Aus dem Archiv der Hefte (Cologne, 2000)

Pierre et Gilles (Paris, Vienna, 2001/2)

Randall, Richard S., Freedom and Taboo (Berkeley and Los Angeles, 1989)

Raine, Anne, Embodied geographies. Subjectivity and materiality in the work of Ana Mendieta,' in Generations and Geographies in the Visual Arts: Feminist Readings, ed. Griselda Pollock (London and New York, 1996)

Rapping, Elayne, Media-tions: Forays into the Culture and Gender Wars (Boston, 1994).

Regis, Michel, Posséder et détruire: Strategies sexuelles dans l'art d'occident (Paris, 2000)

Rheims, Bettina and Serge Bramly, Chambre Close (Munich, 1992)

Richards, Mary, 'Ron Athey, A.I.D.S. and the Politics of Pain,' <http://people.brunel.ac.uk/bst/3no2/papers/mary%20richards.htm> (5 May 2005)

Robinson, Hilary, Feminism–Art–Theory: An Anthology 1968–2000 (Oxford and Malden, 2001)

Roetzer, Florian (ed.), Virtuelle Welten – Reale Gewalten (Hannover, 2003)

Rosenkranz, Karl, Ästhetik des Häßlichen (Leipzig, 1990)

Ruff, Thomas, Nudes (Munich, 2003) with a text by Michel Houellebecq

Russo, Mary, The Female Grotesque: Risk, Excess and Modernity (London and New York, 1994)

Sade, Marquis de, The 120 Days of Sodom, trans. Richard Seavers; Austyn Wainhouse (2002), <http://www.supervert.com> (30 September 2005)

Salecl, Renata (ed.), Sexuation (Durham and London, 2000)

Sanders, Mark, Poynter, Phil and David James (eds.), Dazed/Confused (London, 1999)

Sappington, Rodney and Tyler Stalling, Uncontrollable Bodies: Testimonies of Identity and Culture (Seattle, 1994)

Saslow, James M., Pictures and Passions: A History of Homosexuality in the Visual Arts (London, 1998)

Schade-Tholen, Sigrid; Tholen, Christoph (eds.), Konfigurationen: Zwischen Kunst und Medien (Munich, 1999)

Schneemann, Carolee, More than Meat Joy: Complete performance works and selected writings (New York, 1979)

Schneider, Rebecca, The Explicit Body in Performance (London, New York, 1997)

Simpson, Pat, 'Sex, Death and Shopping. The Commodification of Taboo in the Contemporary Art Market?', in Culture in Britain 4/2 (2003), pp. 93–108

Smith, Alison, The Victorian Nude: Sexuality, Morality and Art (Manchester, 1996)

Soble, Alan, Pornography, Sex and Feminism (Amherst, New York, 2002)

Solomon-Godeau, Abigail, Photography on the Dock: Essays on Photographic History, Institutions and Practices (Minneapolis, 1991)

Solomon-Godeau, Abigail, Male Trouble: A Crisis in Representation (London, 1997)

Sontag, Susan, Regarding the Pain of Others (London, 2003)

Sontag, Susan, 'The Pornographic Imagination', in George Bataille, The Story of the Eye (London, 2001), pp. 83-118

Sontag, Susan, *Against Interpretation and Other Essays* (New York, 1966)

Sprinkle, Annie, *Post Porn Modernist* (Amsterdam, 1991)

Sprinkle, Annie with Katharine Gates, *Annie Sprinkle's Postmodern Pin-Ups Bio Booklet*, ed. by Constance Jones (Richmond, VA, 1995)

Squiers, Carol (ed.), *Over Exposed: Essays on Contemporary Photography* (New York, 1999)

Stein, Gertrude, *Fernhurst, Q.E.D: and Other Early Writings* (London, 1995)

Steiner, Wendy, *The Trouble with Beauty* (London, 2001)

Stocker, Gerfried; Schöpf, Christine (eds.), *Next Sex: Ars Electronica 2000* (Vienna, New York, 2000)

Stocker, Gerfried; Schöpf, Christine (eds.), *Memesis: The Future of Evolution, ARS Electronica '96* (Vienna/New York, 1996)

Stolzenburg (ed.), *Schaulust: Erotik und Pornografie in den Medien* (Opladen, 1997)

Strunk, Marion, *Gender Game* (Tübingen, 2002)

Studio Tom Hingston, *Porn?* (London, 2002)

Sturken, Marita and Lisa Cartwright, *Practices of Looking: An Introduction to Visual Culture* (Oxford, 2001)

Suleiman, Susan Rubin, *Subversive Intent: Gender, Politics and the Avant-Garde* (Cambridge, Mass. 1990)

Taylor, Sue, *Hans Bellmer: The Anatomy of Anxiety* (Cambridge, Mass., 2000)

Thomas, Julia (ed.), *Reading Images* (Basingstoke, 2001)

Townsend, Chris, *Vile Bodies: Photography and the Crisis of Looking* (Munich, 1998)

Travis, Alan, *Bound and Gagged: A Secret History of Obscenity in Britain* (London, 2000)

Turkle, Sherry, *Life on the Screen: Identity in the Age of the Internet* (New York, 1995)

Vergin, Lea, *Body Art and Performance: The Body as Language* (Turin, 2000)

Vinken, Barbara, 'Einleitung. Cover up – Die nackte Wahrheit der Pornographie', in Die Nackte Wahrheit. *Zur Pronographie und zur Rolle des Obszönen in der Gegenwart*, ed. Barbara Vinken (Munich, 1997), pp. 7–22

Walther, Ingo F. (ed.), *Art of the 20<sup>th</sup> Century* (New York, 2000)

Warr, Tracey and Amelia Jones, *The Artist's Body* (London, 2000)

Waters, John and Bruce Hainley, *Art – A Sex Book* (London, 2003)

Webb, Peter, *The Erotic Arts* (London, 1975)

*Webster's Third New International Dictionary of the English Language, unabridged* (Springfield, MA, Cologne, 1993)

Weeks, Jeffrey, *Sex, Politics and Society since 1800* (London and New York, 1981)

Weibel, Peter and Timothey Druckrey (eds.), *net_condition: art and global media* (Cambridge, MA., 2000)

Weibel, Peter (ed.), *Phantom der Lust: Visionen des Masochismus*, 2 vols. (Graz, 2003)

Wells, Liz (ed.) *The Photography Reader* (London and New York, 2003)

Welsch, Wofgang, *Ästhetisches Denken* (Stuttgart, 1990)

Williams, Linda, *Hard Core: Power: Pleasure and the Frenzy of the Visible* (Berkeley and Los Angeles, 1989)

Williams, Linda, 'Corporealized Observers. Visual Pornographies and the "Carnal Density of Vision"', in *Fugitive Images: From Photography to Video*, ed. by Patrice Petro (Bloomington, Indiana, 1995), pp. 3–41.

Williams, Linda (ed.), *Porn Studies* (Durham and London, 2004)

Winterson, Jeanette, *Written on the Body* (London, 1993)

Winzen, Matthias, 'A Credible Invention of Reality', in *Thomas Ruff 1979 to the Present*, ed. by Matthias Winzen (Cologne, 2003), pp. 132–150

Woods, Alan, *Being Naked Playing Dead: The Art of Peter Greenaway* (Manchester, 1996)

Yuill, Simon and Kerstin Mey, *Cross-wired: Communication – Interface – Locality* (Manchester, 2004)

Zimmermann, Anja, *Skandalöse Bilder – Skandalöse Körper: Abject Art vom Surrealismus bis zu den Culture Wars* (Berlin, 2001)

Zimmermann, Ulrike, 'Ein Beitrag zur Entmystifizierung der Pornografie', in *Frauen & Pornographie*, ed. by Claudia Gehrke (Tübingen, undated), pp. 123–144

# Index